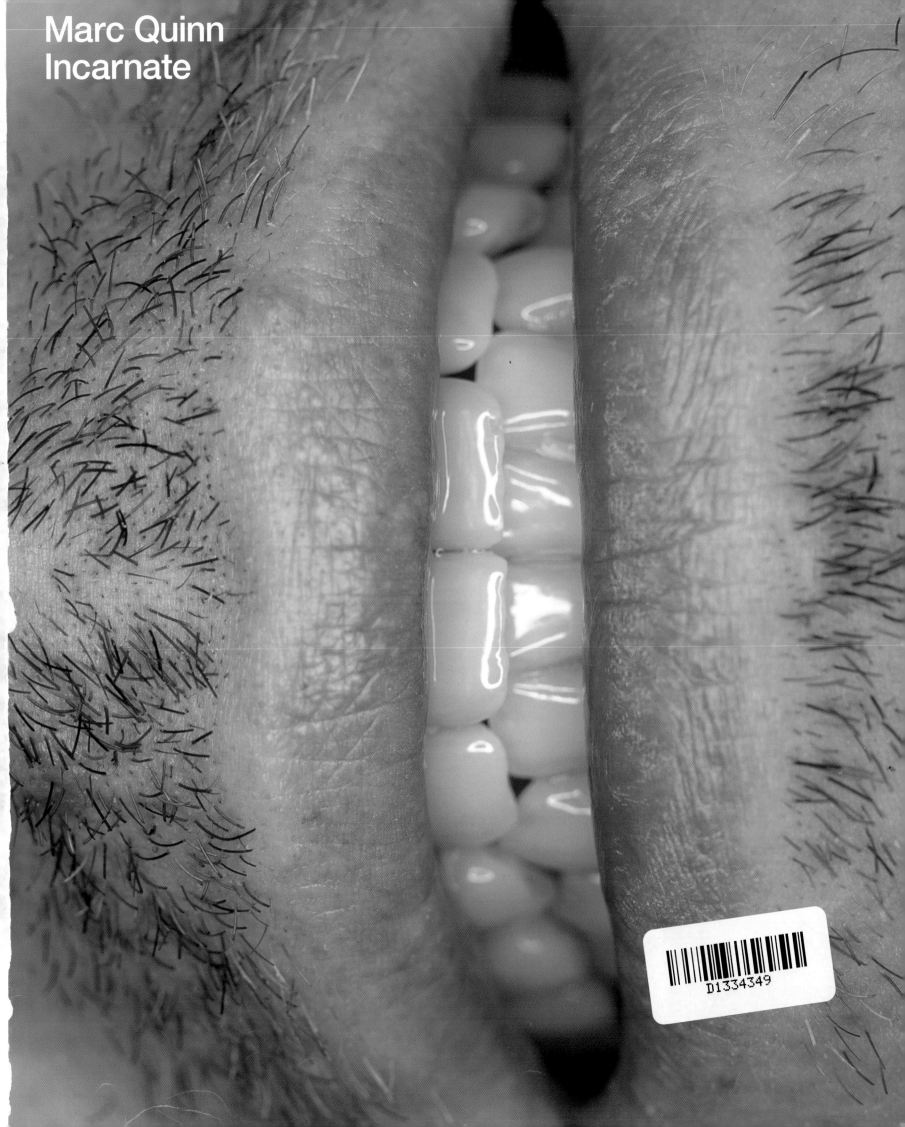

Marc Quinn
Incarnate

Incarnate is published
on the occasion of
the exhibition
Marc Quinn
May 30 – July 4 1998
Gagosian Gallery
New York

Telephone conversation
Brian Eno
and Marc Quinn

Story
Will Self

Essays
David Thorp
Mark Gisbourne

Managing Editor
Diana Allan

Editorial Assistance
Honey Luard

Book Design
North

First published 1998 by
Booth-Clibborn Editions
12 Percy Street
London W1P 9FB
E-mail info@internos.co.uk
Internet www.booth-clibborn-editions.co.uk

ISBN 1 86154 048 5

Printed in Hong Kong

Marc Quinn is represented by
Jay Jopling/White Cube
44 Duke Street
St James's
London SW1Y 6DD

With thanks to

Georgia Byng
Tiger Chadwick
T.J.Q.
R.M.Q.
N.R.Q.

Chris and Gaby Nash,
Noel Condon,
Nick, Clovis and Elsa
at Arch Foundry

Chris Miller at ESI

Pino Signorretto,
Alessia, Amber and all
at Signorretto Vitteria

Jonathan, Paul
and Philip at the Icebox

All at LTI and John 'O's

Alan Gardiner, Geoff,
Michelle and Paul
at London Engineering

Richard and everyone
at Martinspeed

Mollie Dent-Brocklehurst,
Larry Gagosian
and Ealan Wingate
at Gagosian Gallery

Brad Barnes
Irene Bradbury
Daniela Gareh
Aileen Hovanessian
Honey Luard
Julia Royse
Annouska Shani
Mark Watkins
and Jay Jopling
at White Cube

North

Martin Barr
Brian Eno
Mark Derbyshire
Charlotte Skene-Catling
Peter Fleissig
Michael Gormley
Jack 'Randy' Lane
Adrian Mullish
James Puttnam
Will Self
Johnnie Shand Kydd
James Tate
Sam Taylor-Wood
Robert Timms
James Viollette

1 Faust
1988
Cast lead and grog
Height 59.7cm

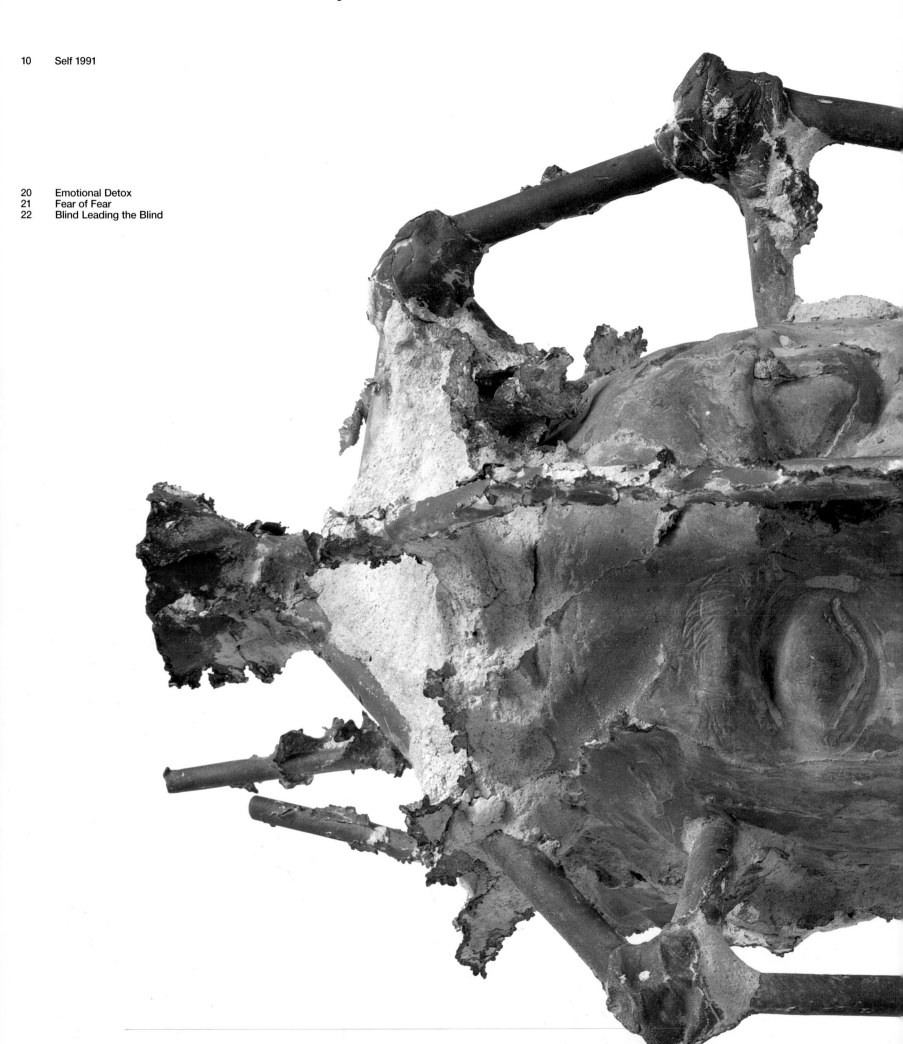

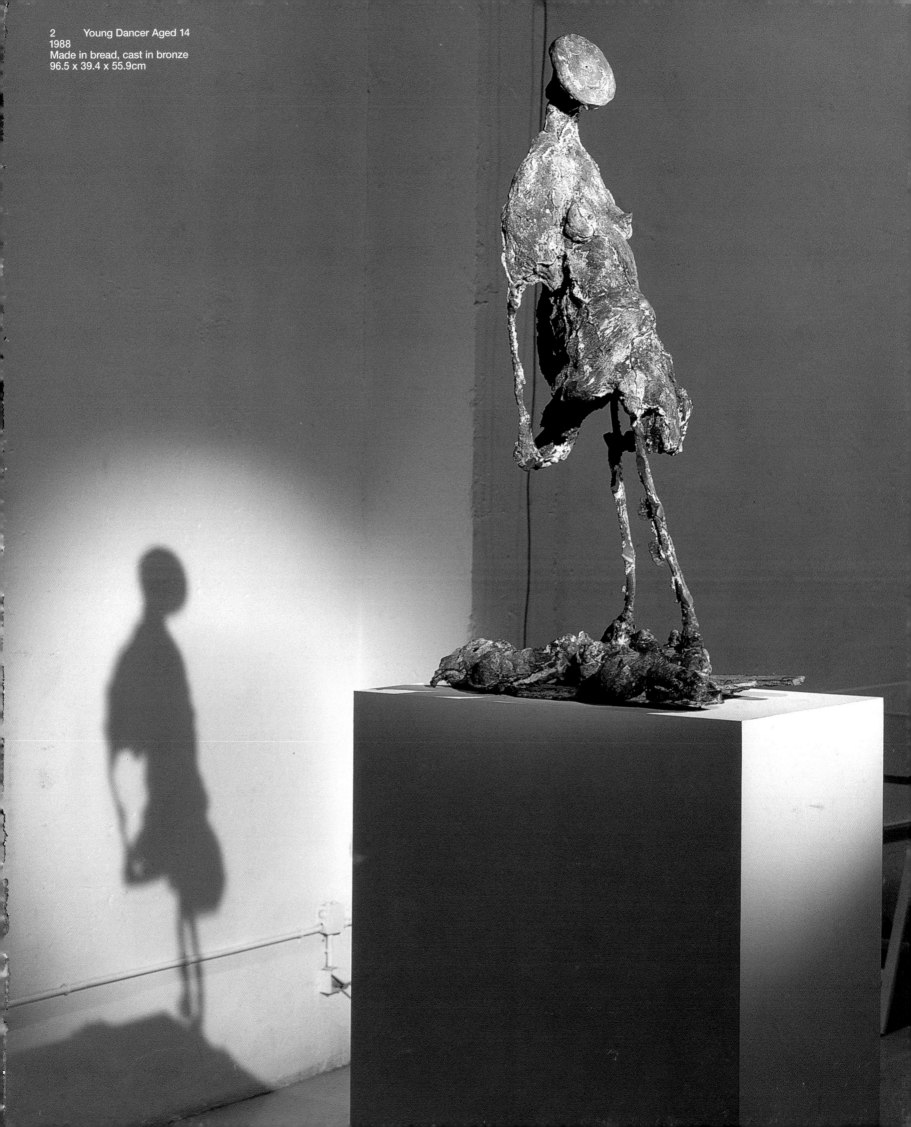

2 Young Dancer Aged 14
1988
Made in bread, cast in bronze
96.5 x 39.4 x 55.9cm

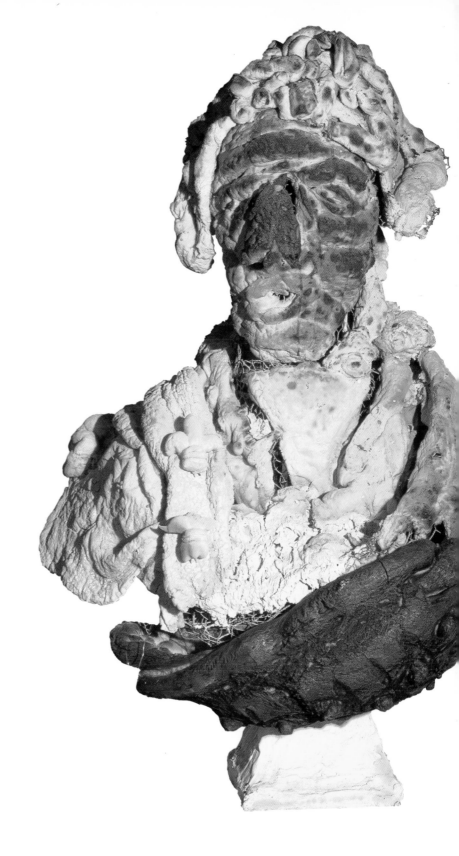

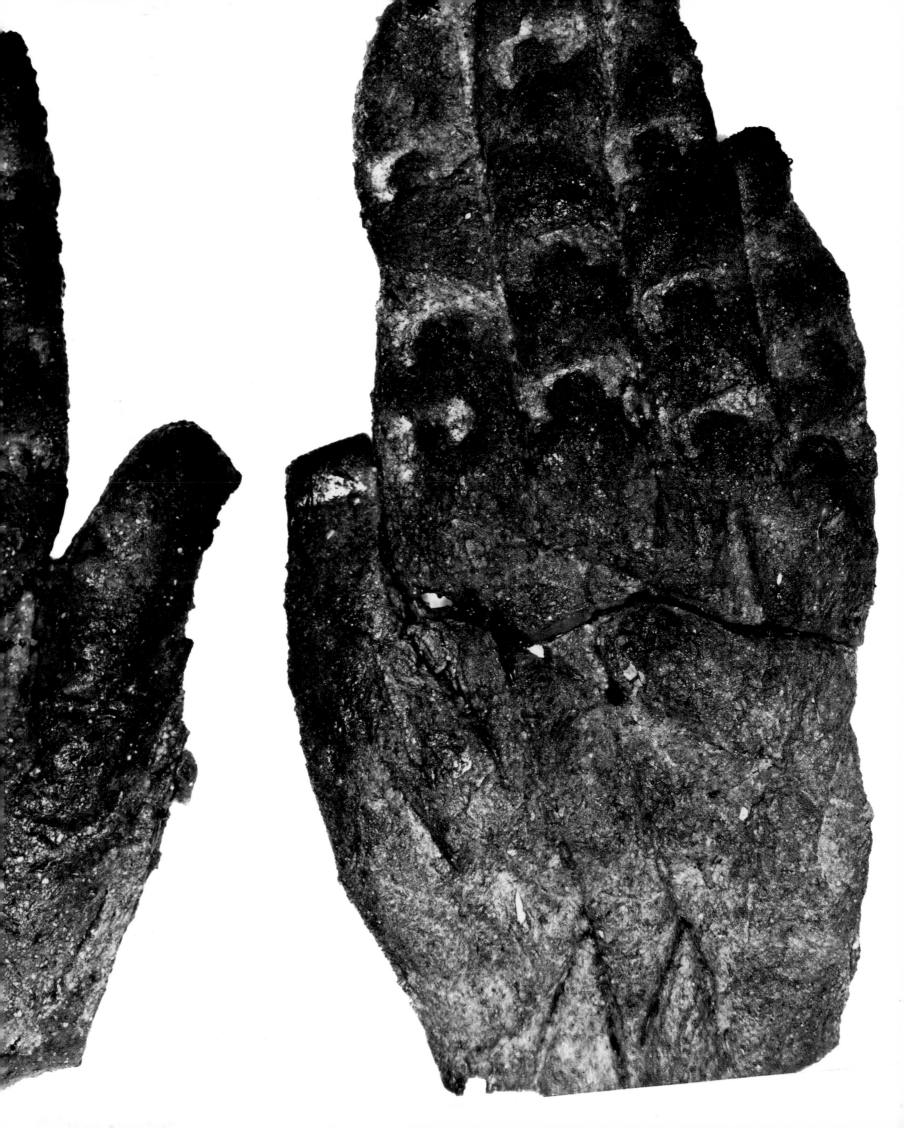

8 Character Head I
1990
Made in bread, cast in lead
71.1 x 31.8 x 35.6cm

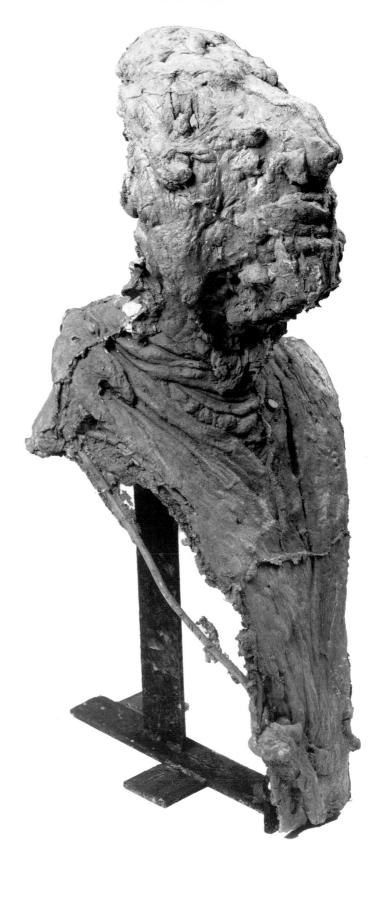

8 Character Head II
1990
Made in bread, cast in lead
62.2 x 35.6 x 30.5cm

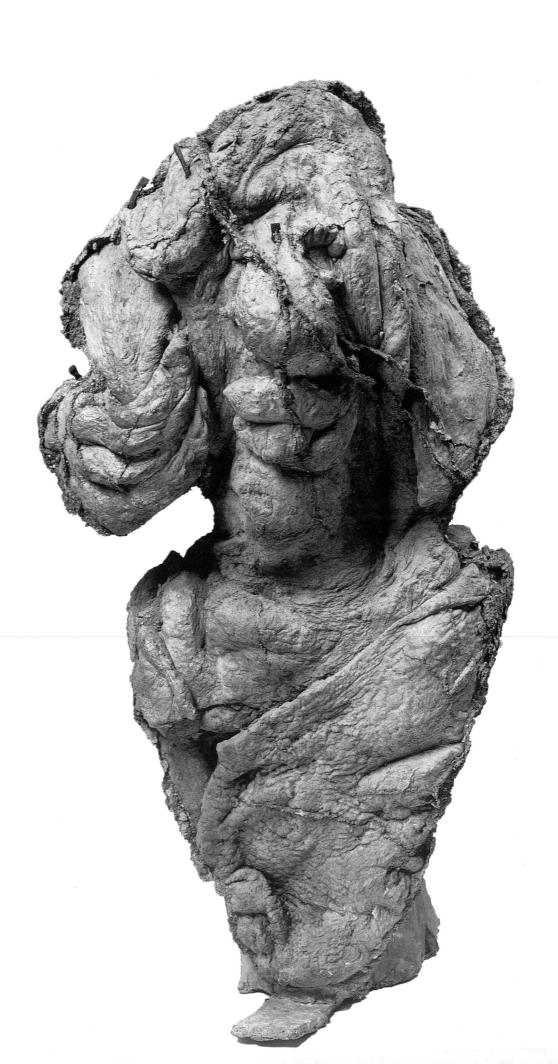

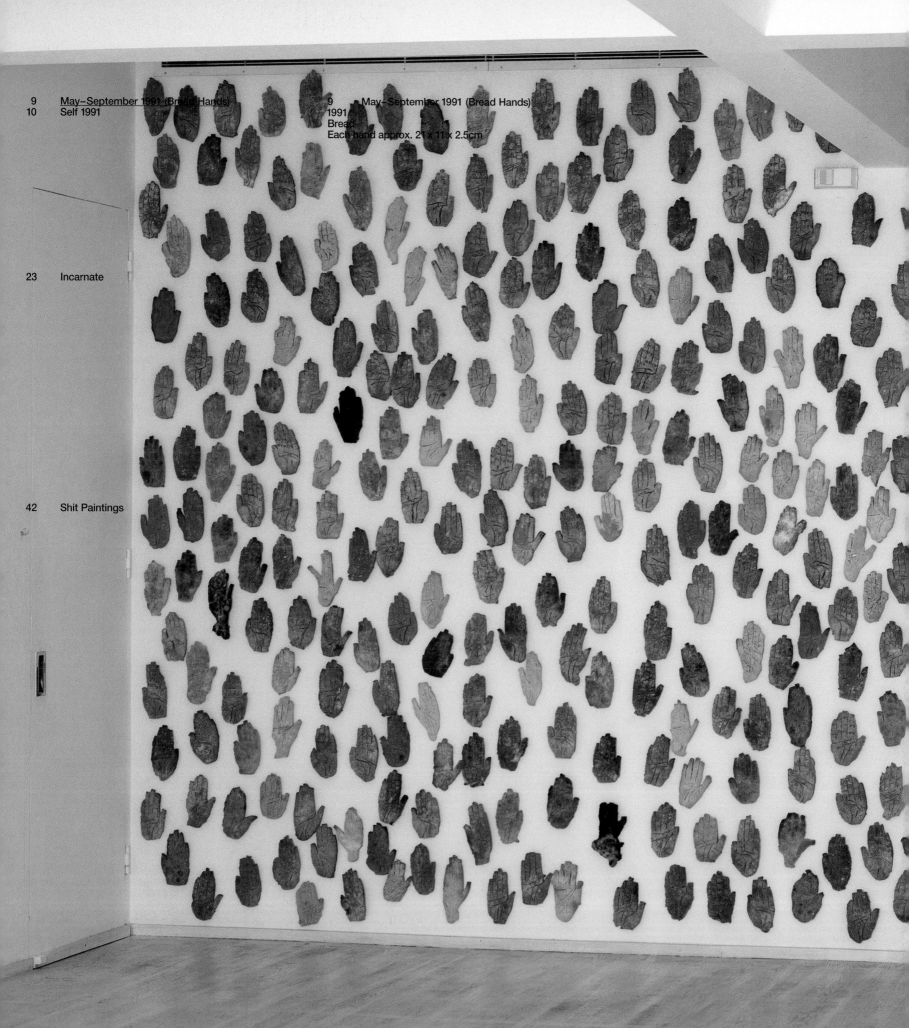

9 May–September 1991 (Bread Hands)
1991
Bread
Each hand approx. 21 x 11 x 2.5cm

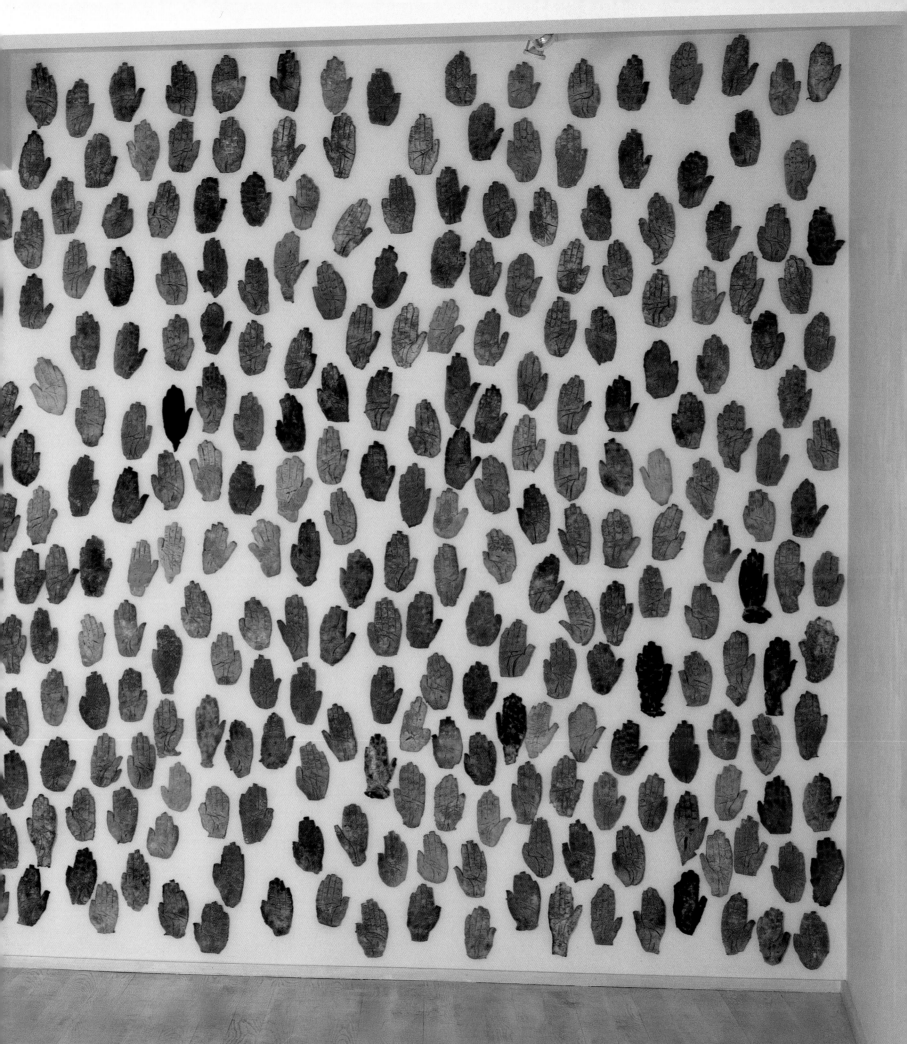

10 Self 1991
1991
Artist's blood, stainless steel,
perspex and refrigeration equipment
208 x 63 x 63cm

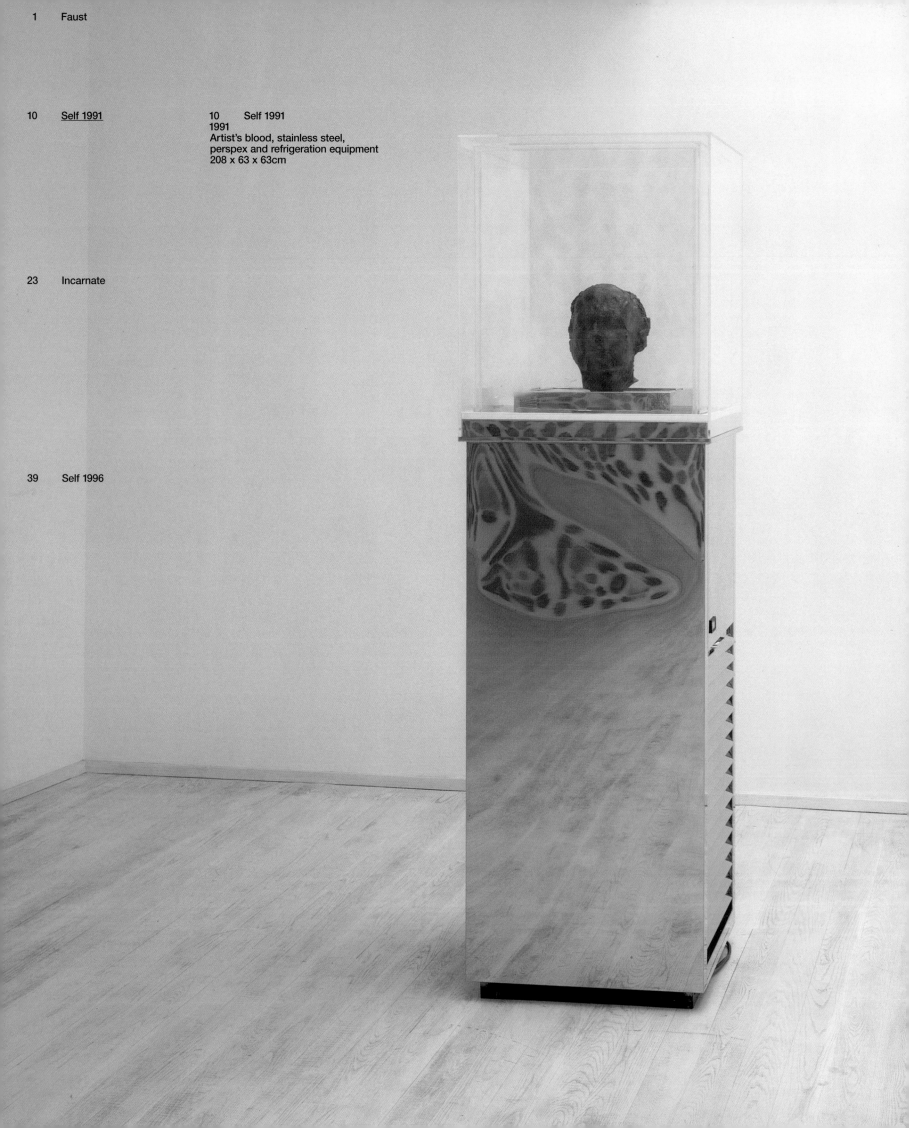

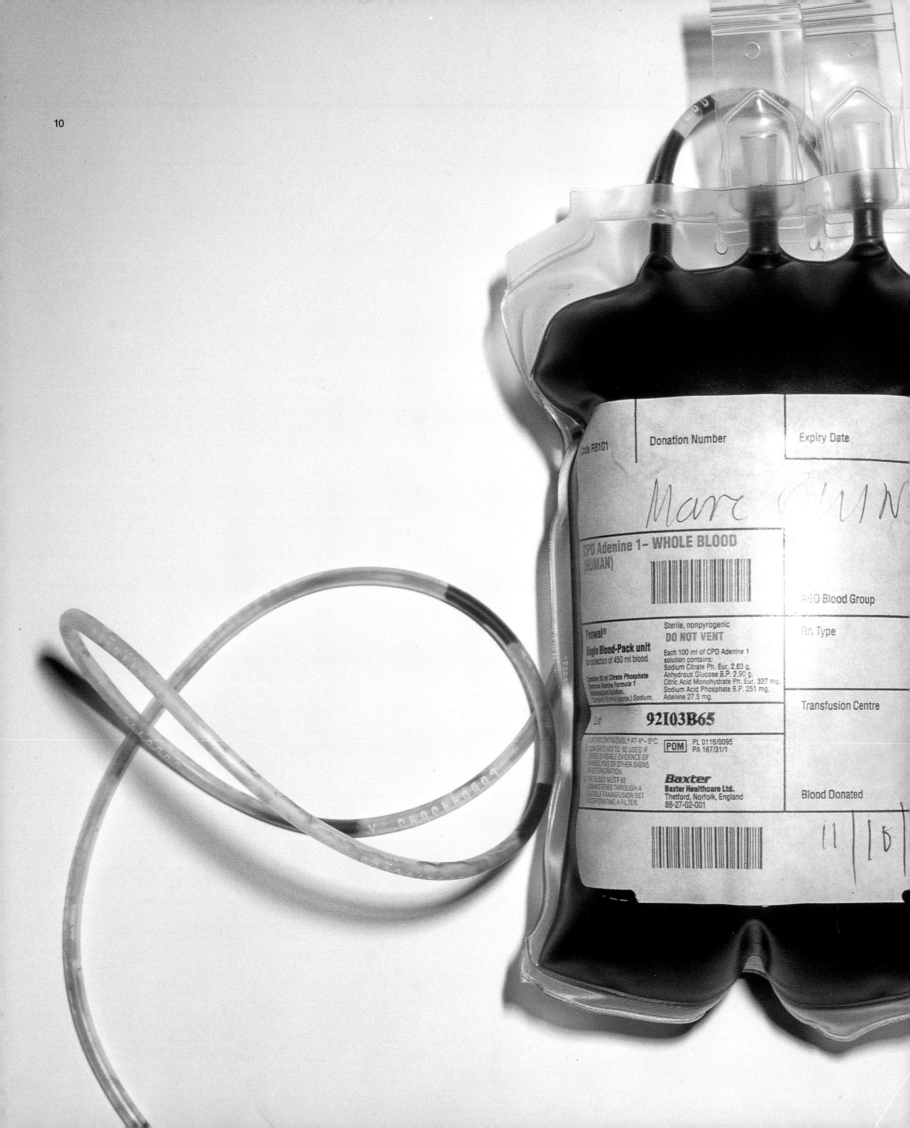

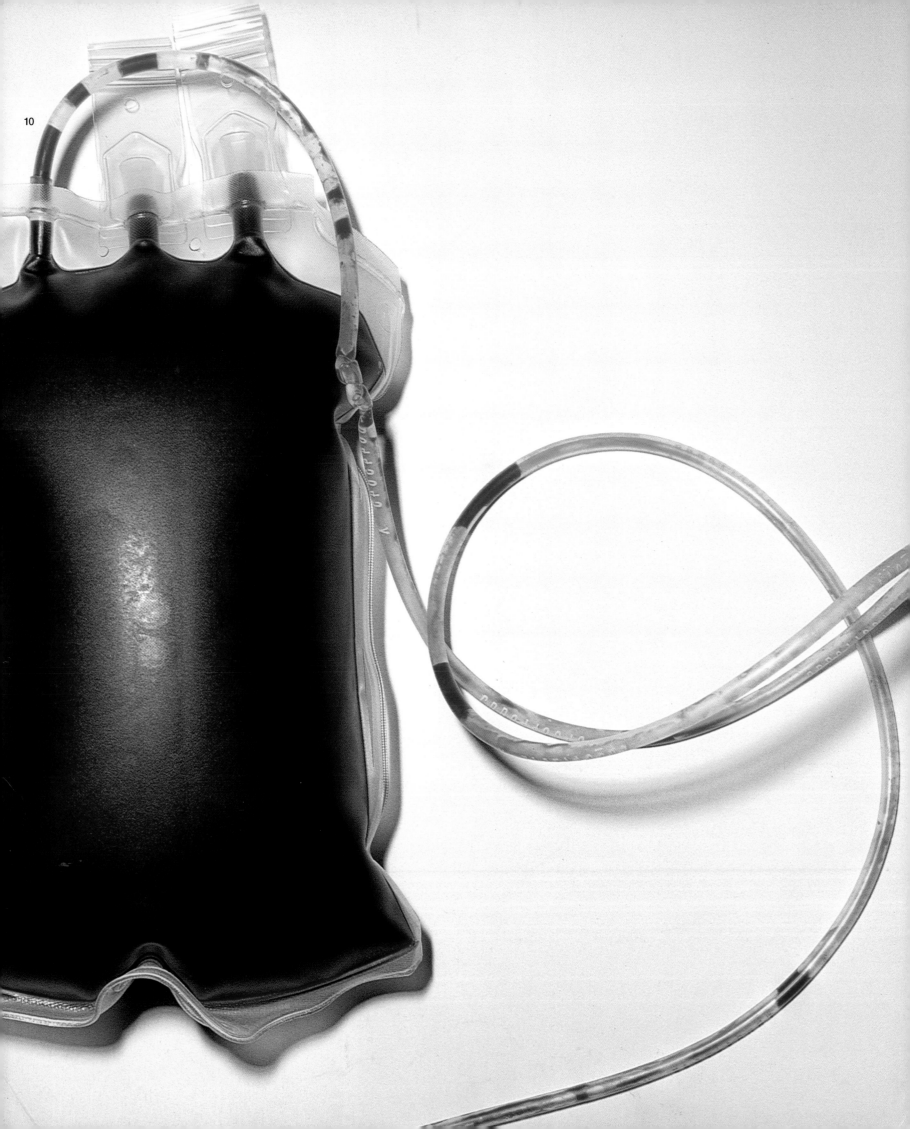

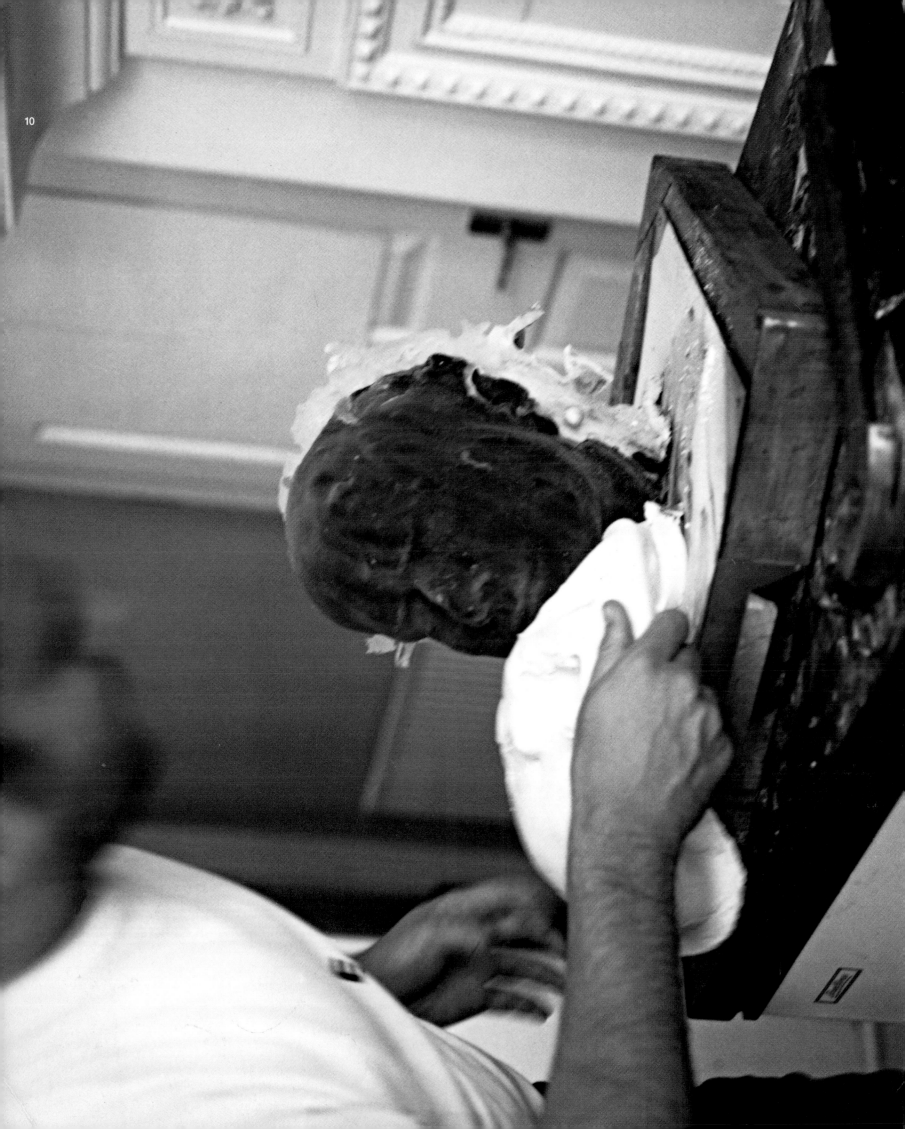

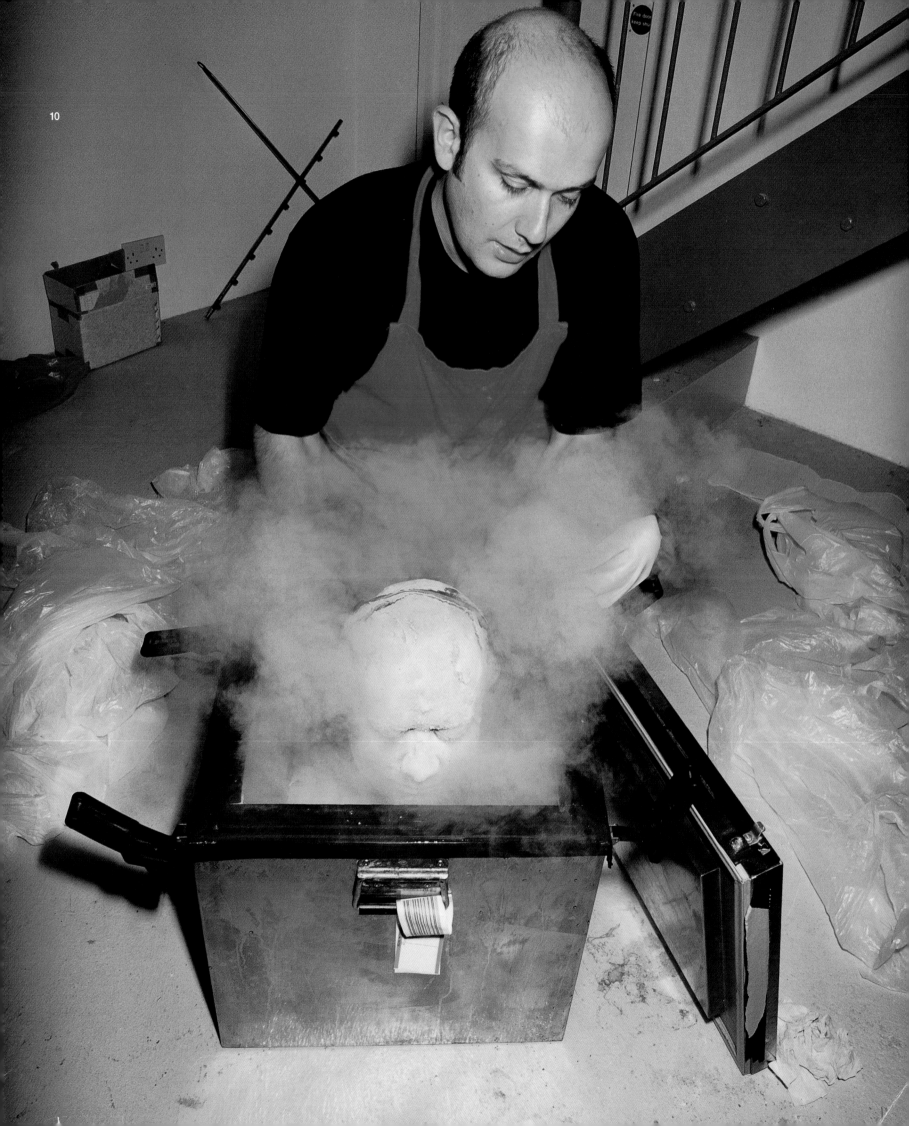

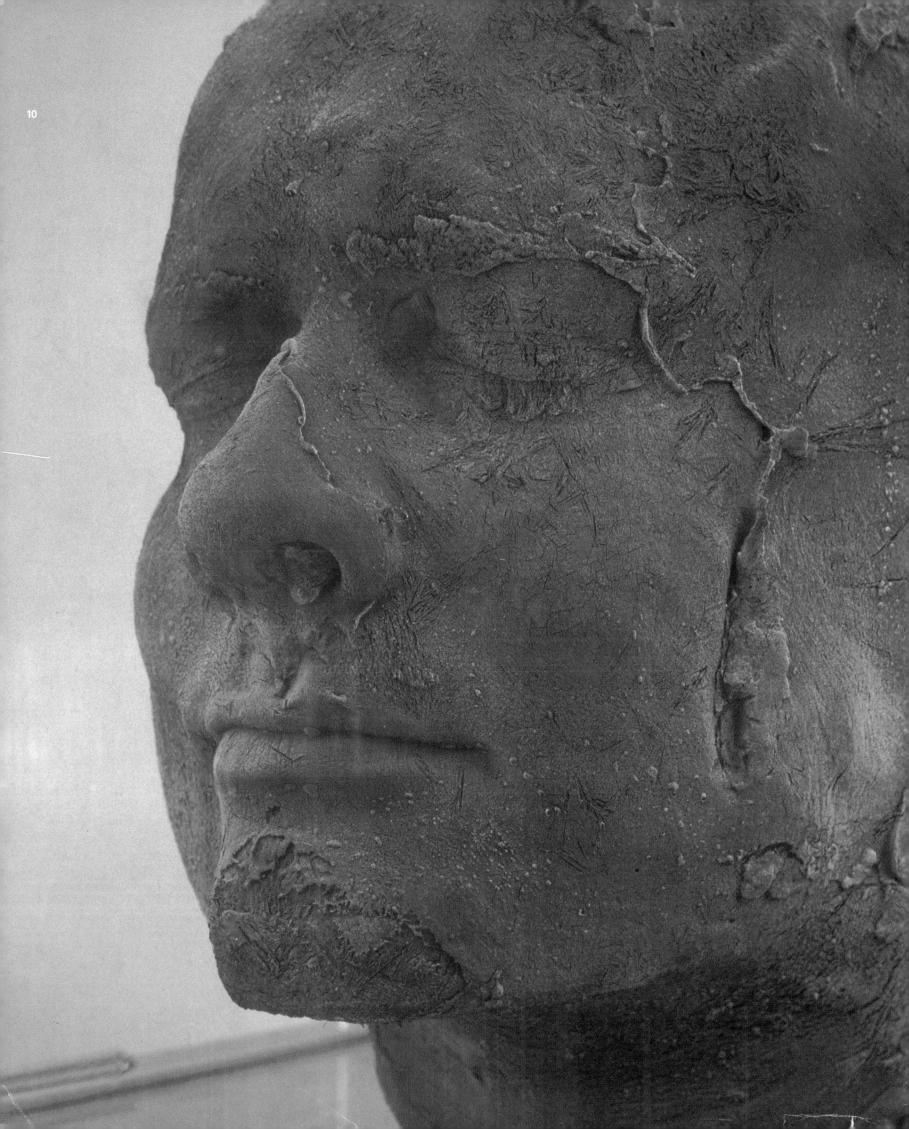

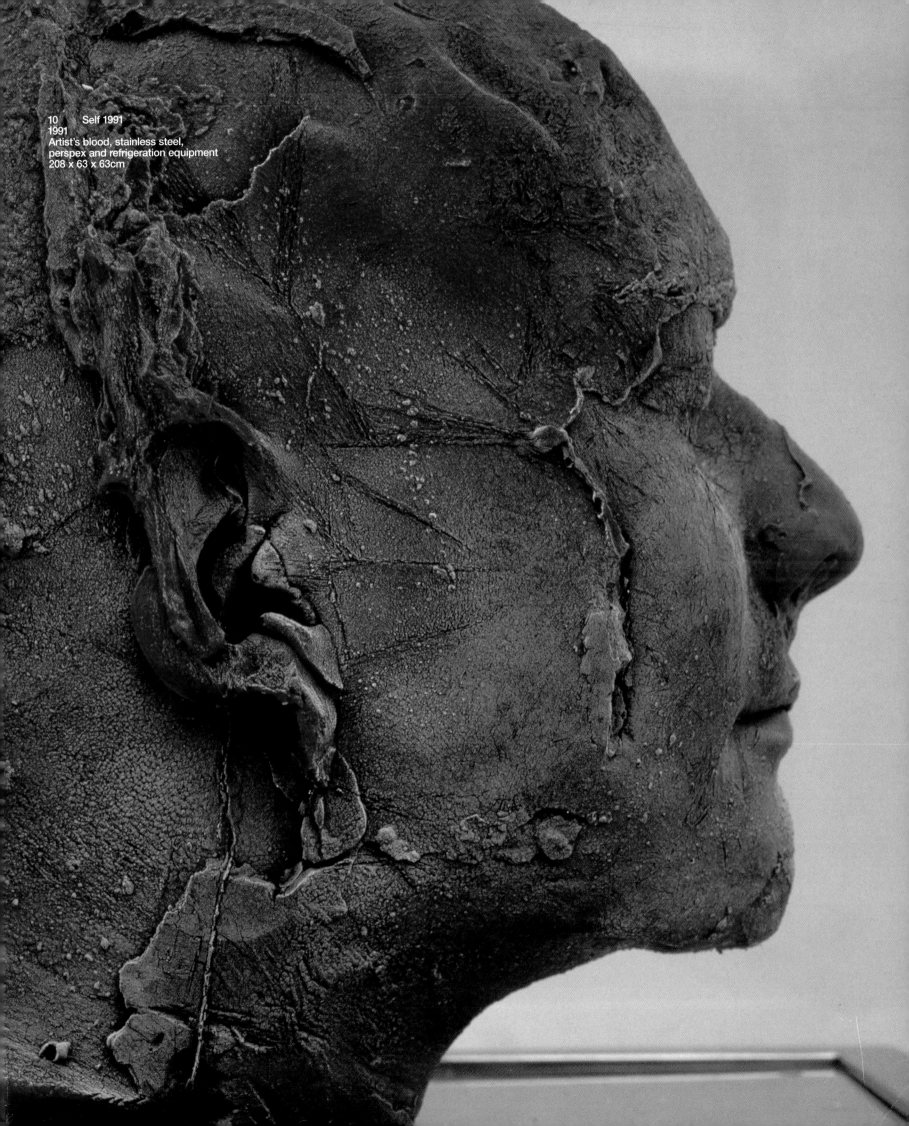

10 Self 1991
1991
Artist's blood, stainless steel,
perspex and refrigeration equipment
208 x 63 x 63cm

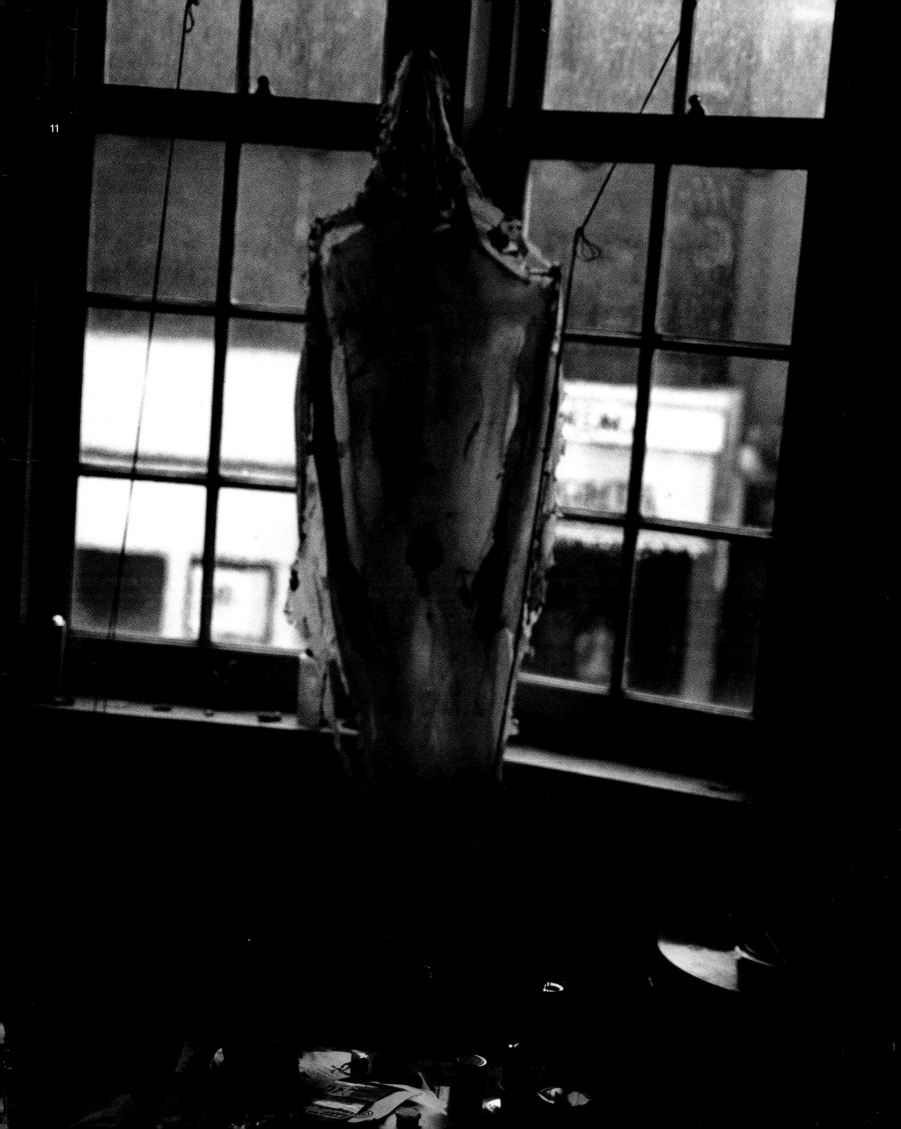

11 You Take My Breath Away
1992
Synthetic latex rubber
Height 180cm

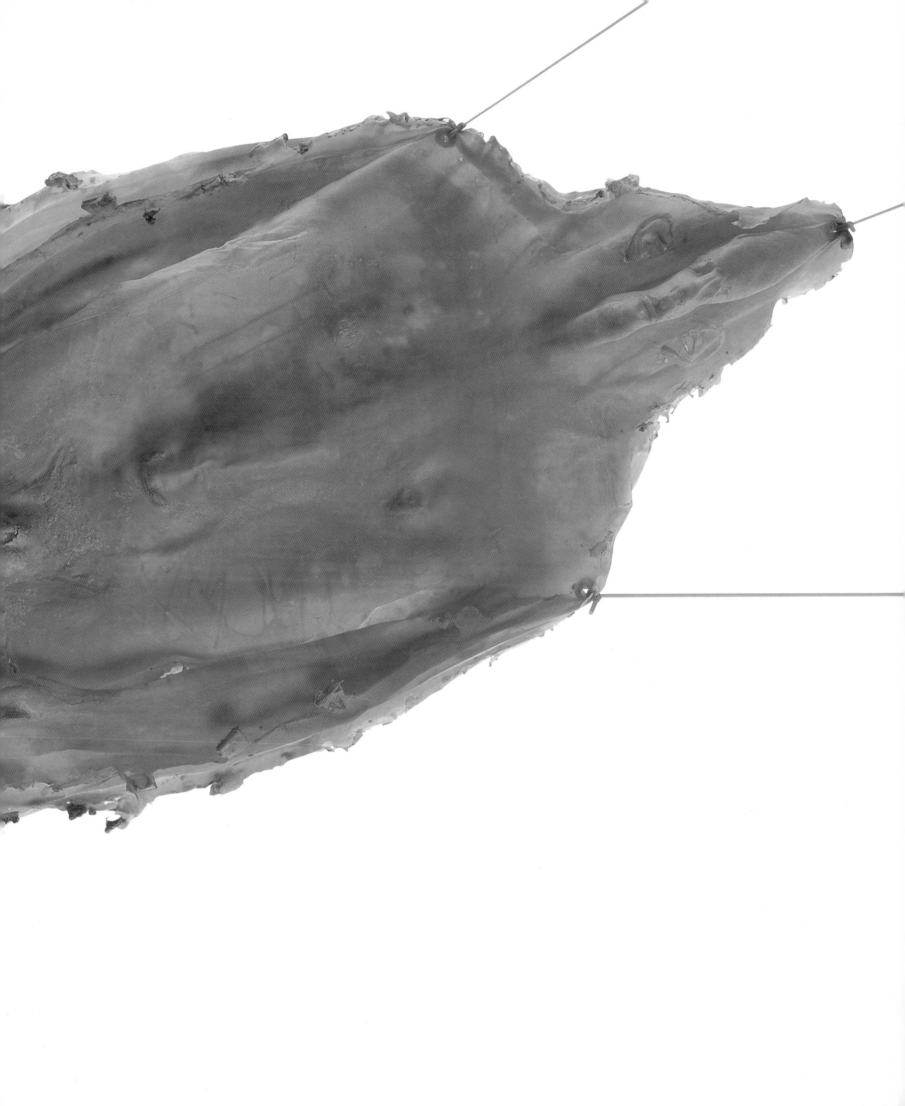

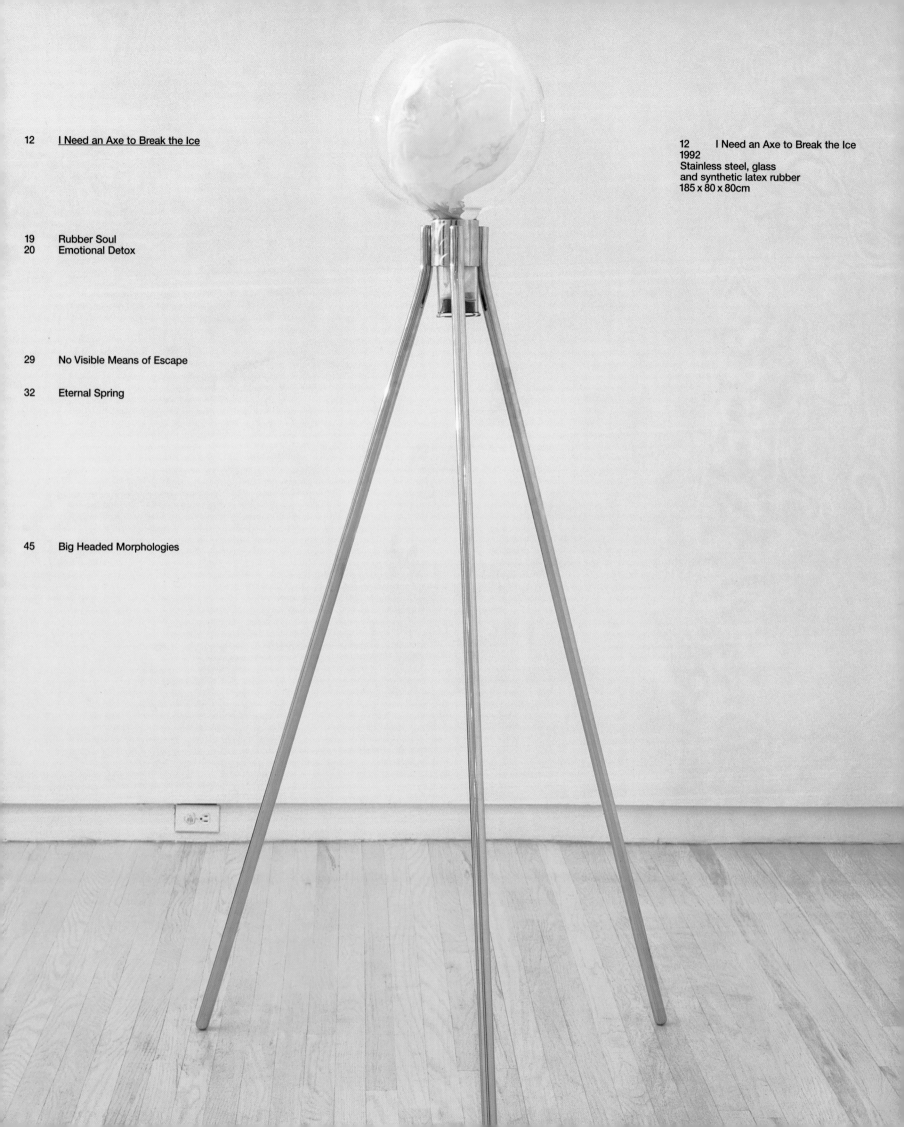

12 I Need an Axe to Break the Ice
1992
Stainless steel, glass
and synthetic latex rubber
185 x 80 x 80cm

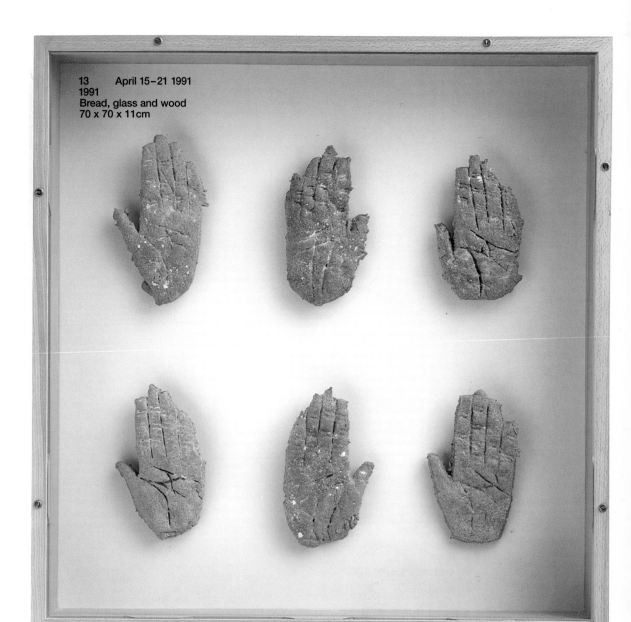

13 April 15–21 1991
1991
Bread, glass and wood
70 x 70 x 11cm

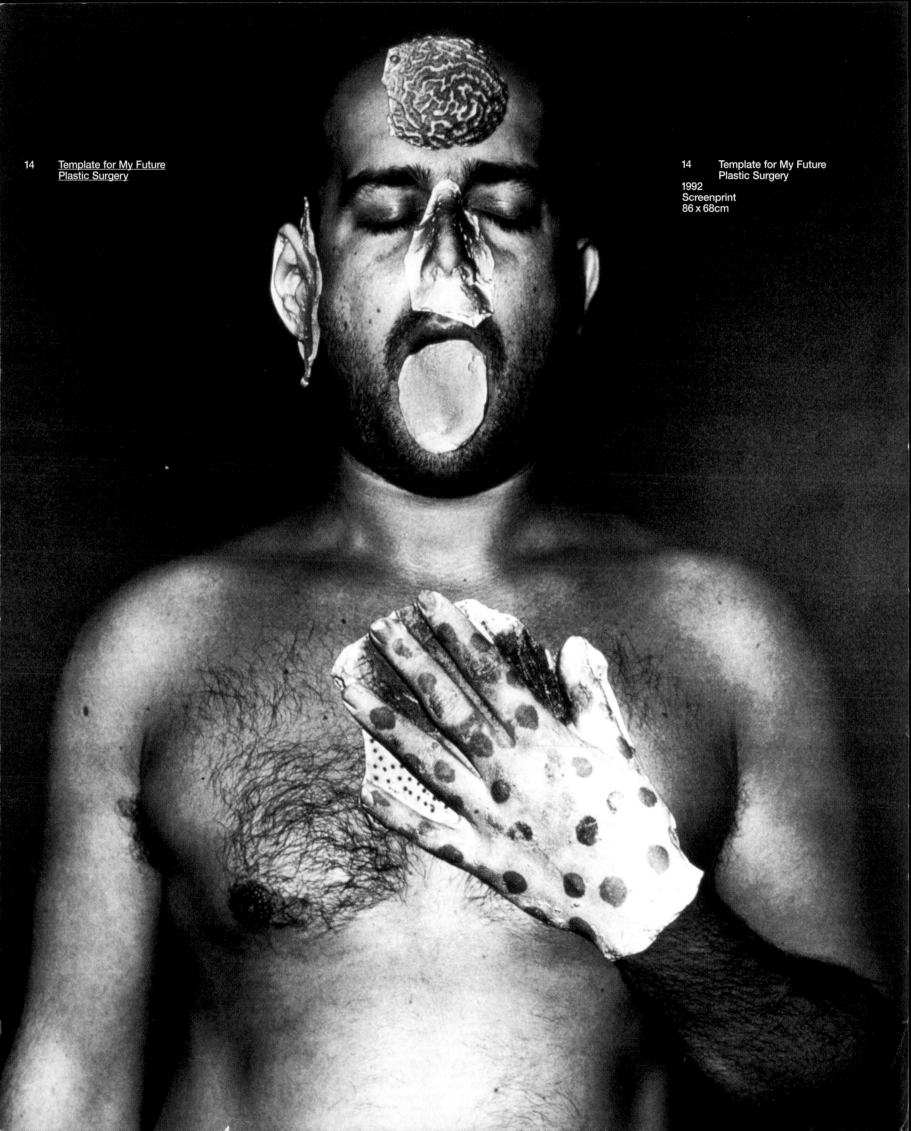

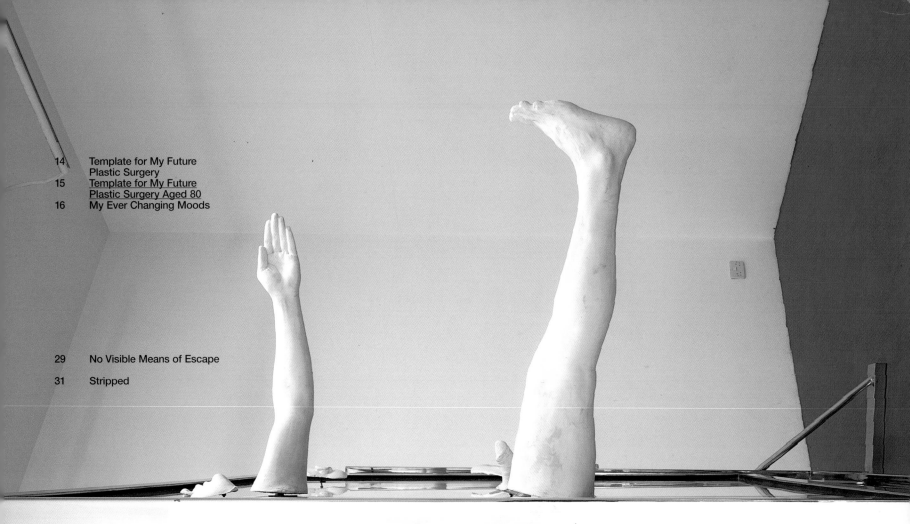

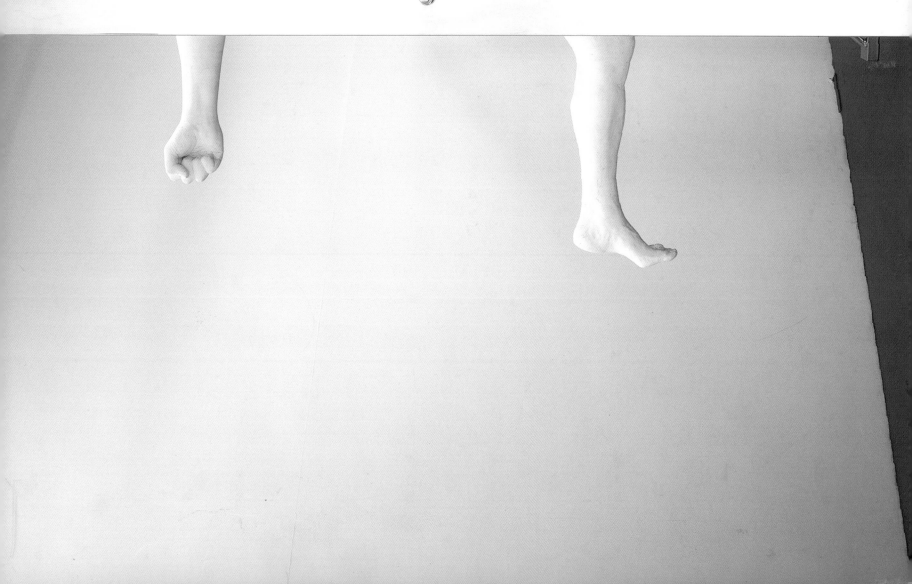

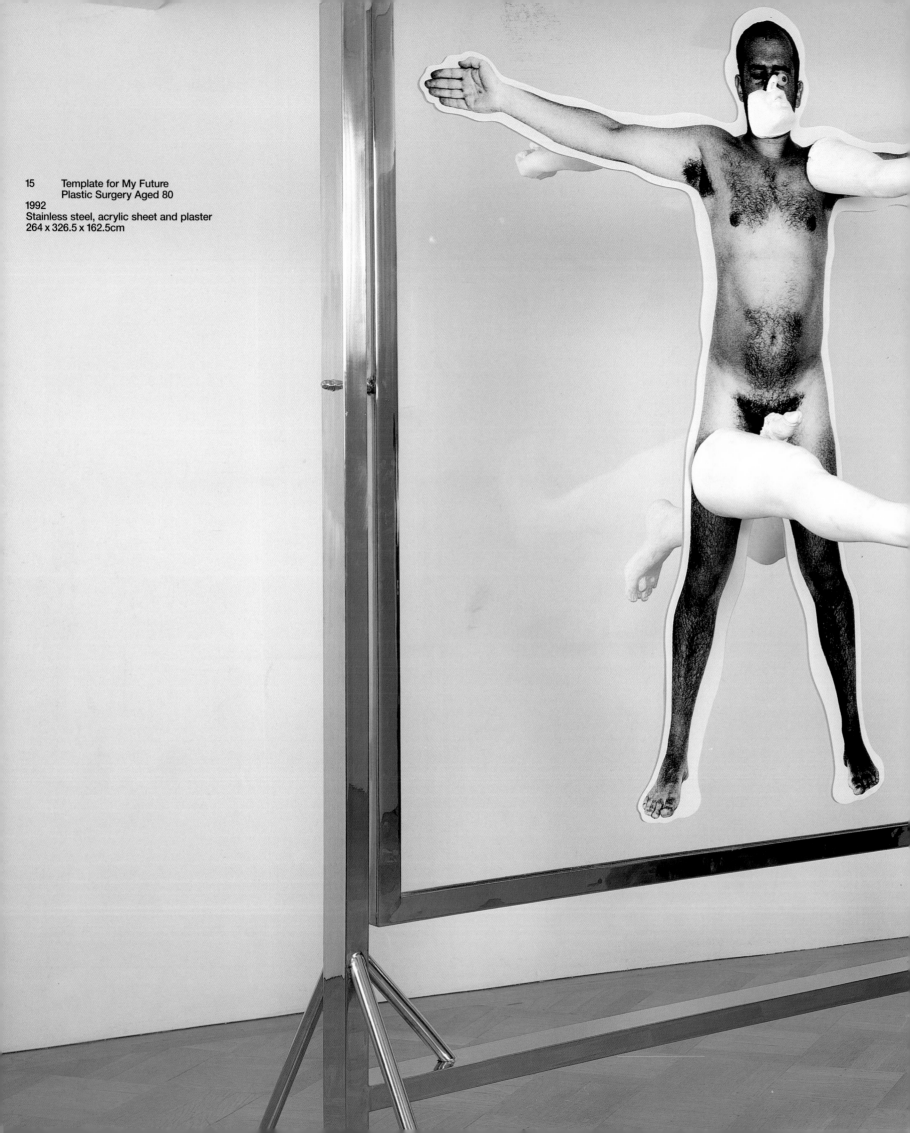

15 Template for My Future
 Plastic Surgery Aged 80
1992
Stainless steel, acrylic sheet and plaster
264 x 326.5 x 162.5cm

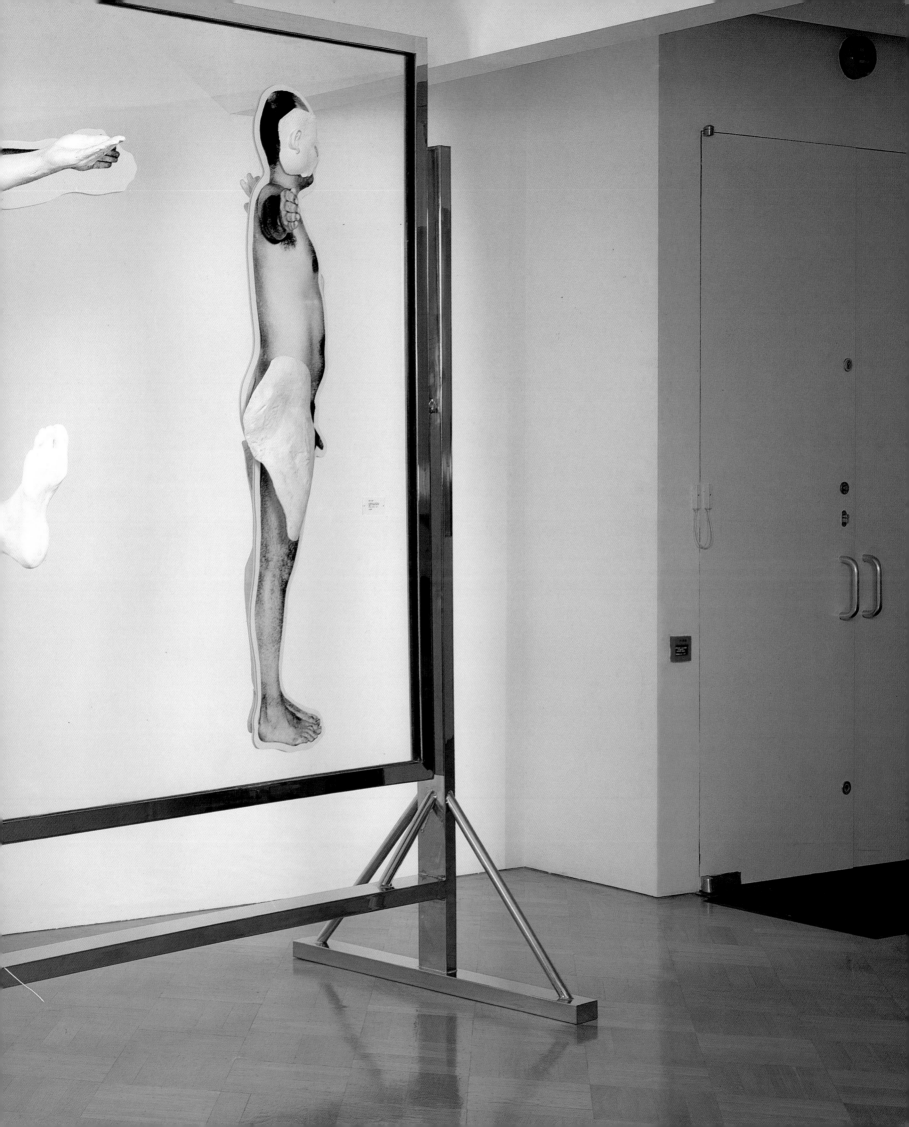

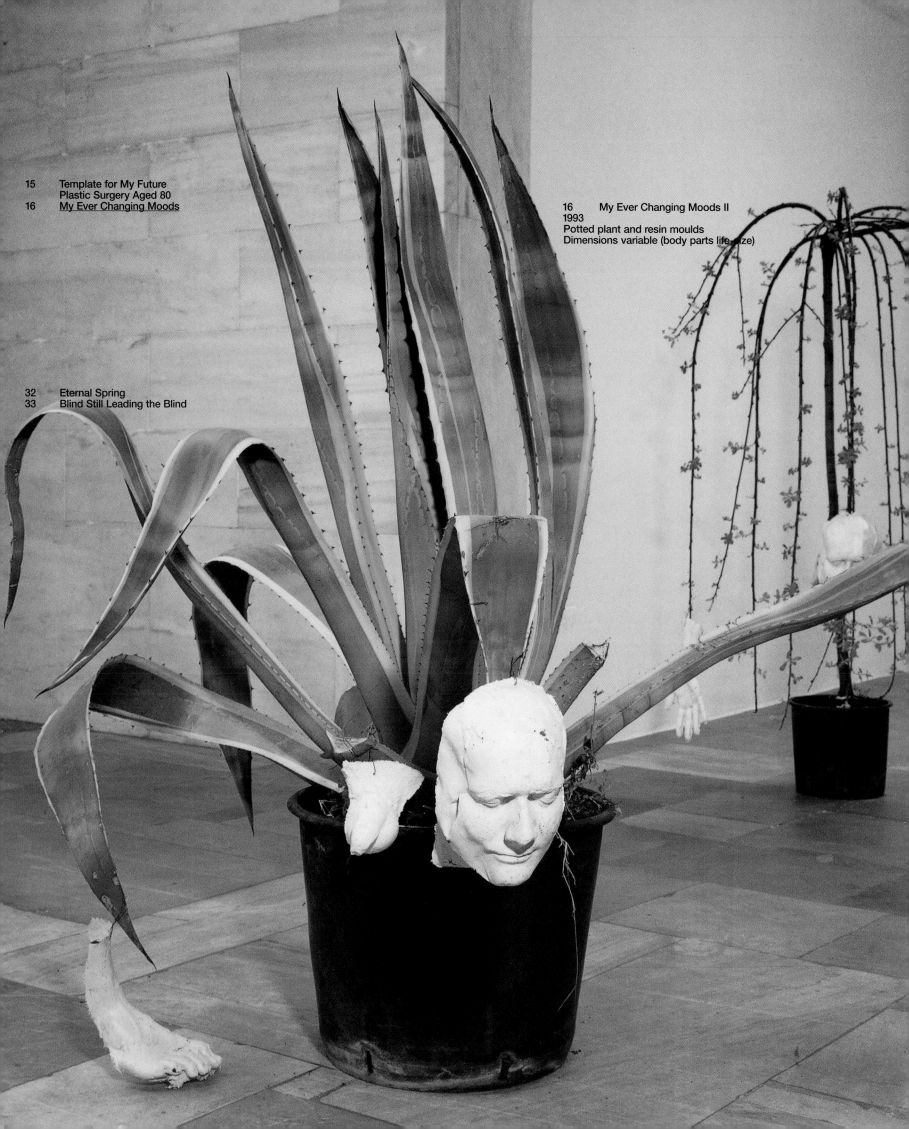

16 My Ever Changing Moods II
1993
Potted plant and resin moulds
Dimensions variable (body parts life-size)

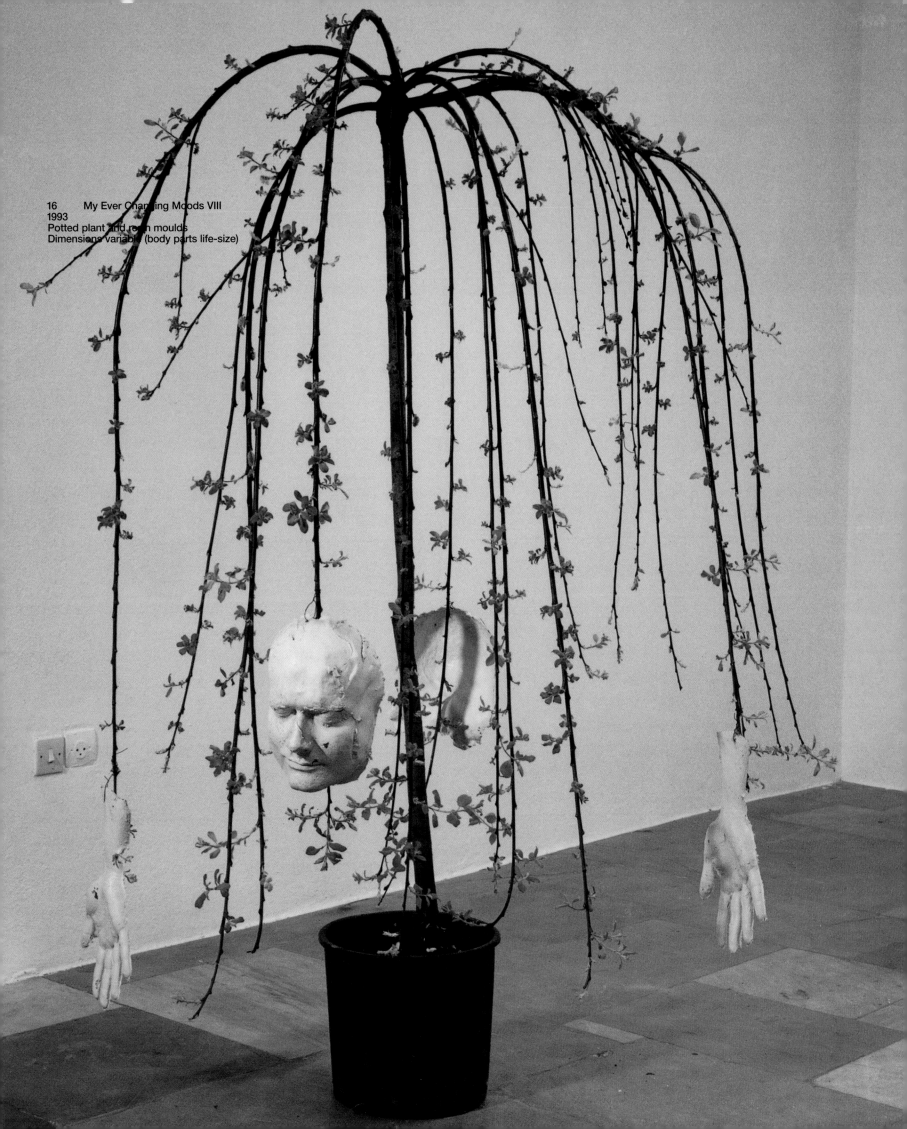

16 My Ever Changing Moods VIII
1993
Potted plant and resin moulds
Dimensions variable (body parts life-size)

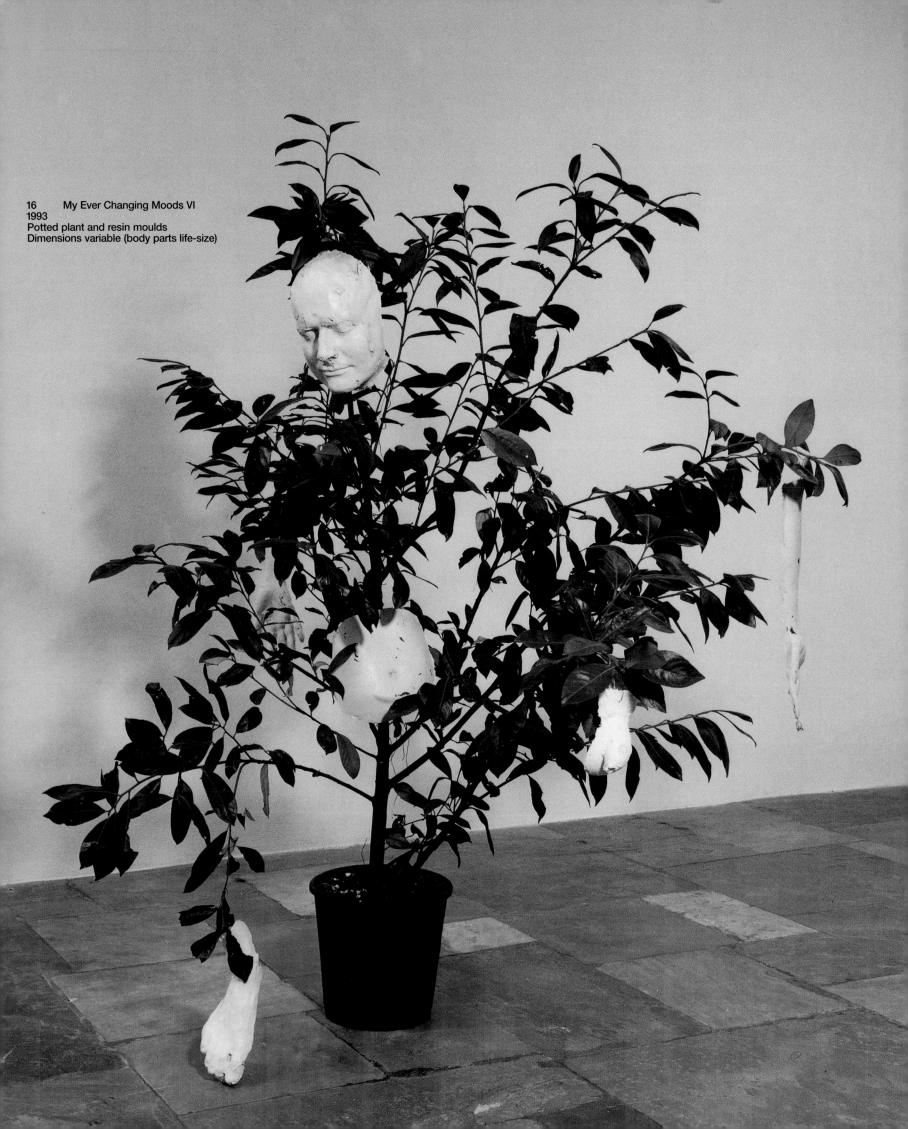

16 My Ever Changing Moods VI
1993
Potted plant and resin moulds
Dimensions variable (body parts life-size)

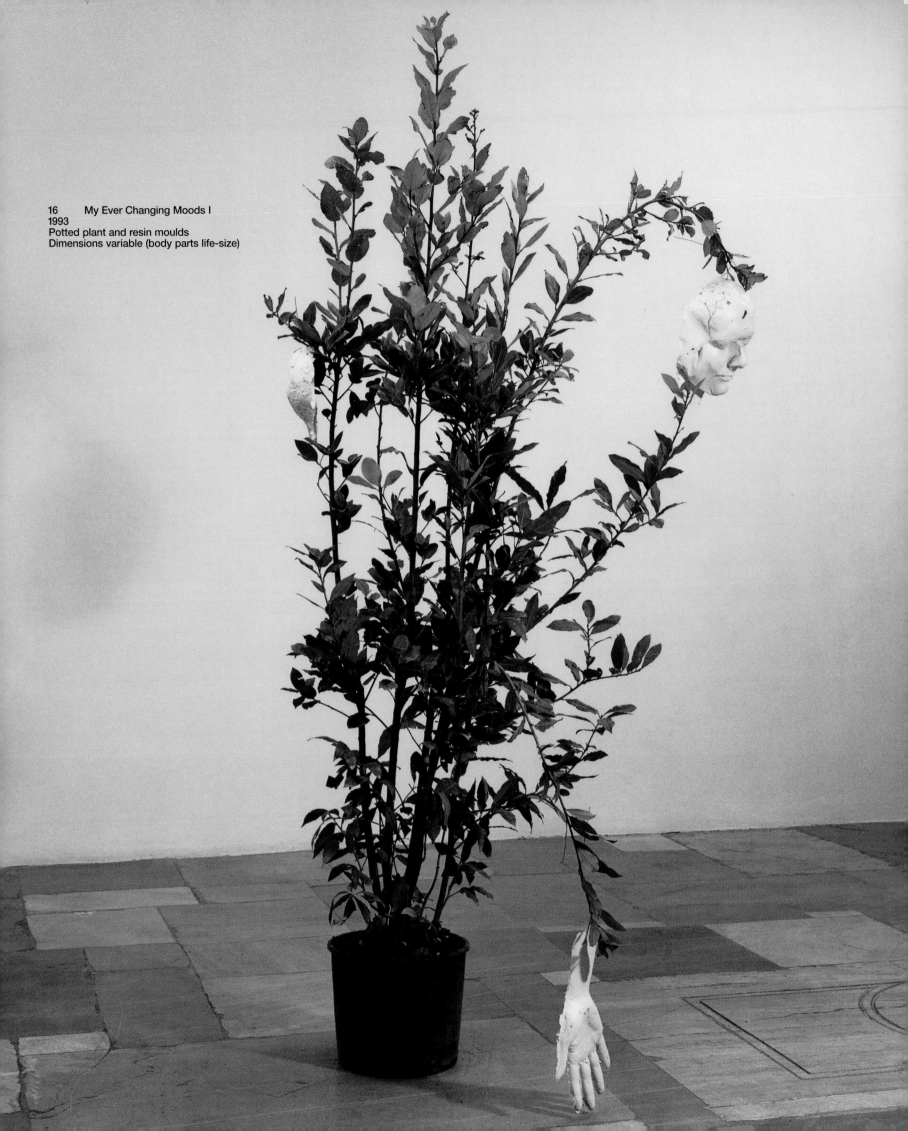

16 My Ever Changing Moods I
1993
Potted plant and resin moulds
Dimensions variable (body parts life-size)

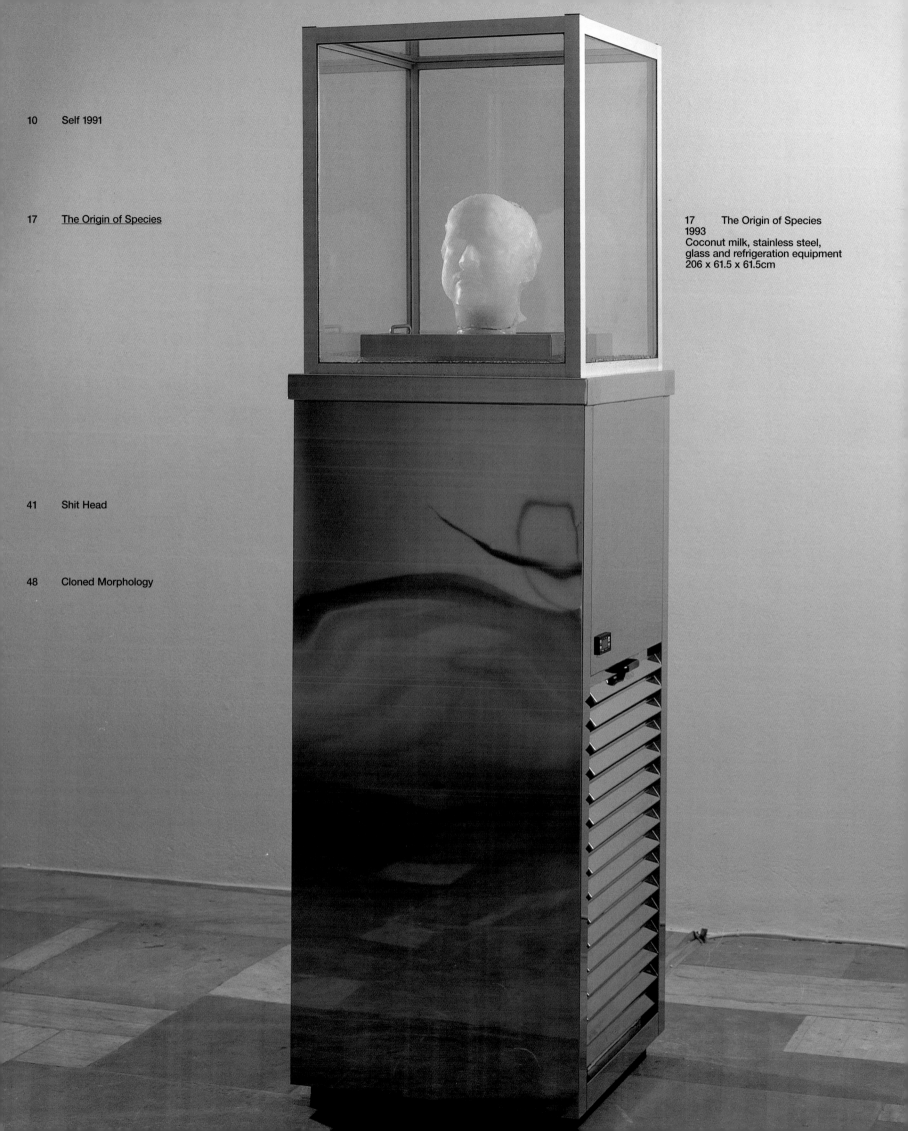

17 The Origin of Species
1993
Coconut milk, stainless steel,
glass and refrigeration equipment
206 x 61.5 x 61.5cm

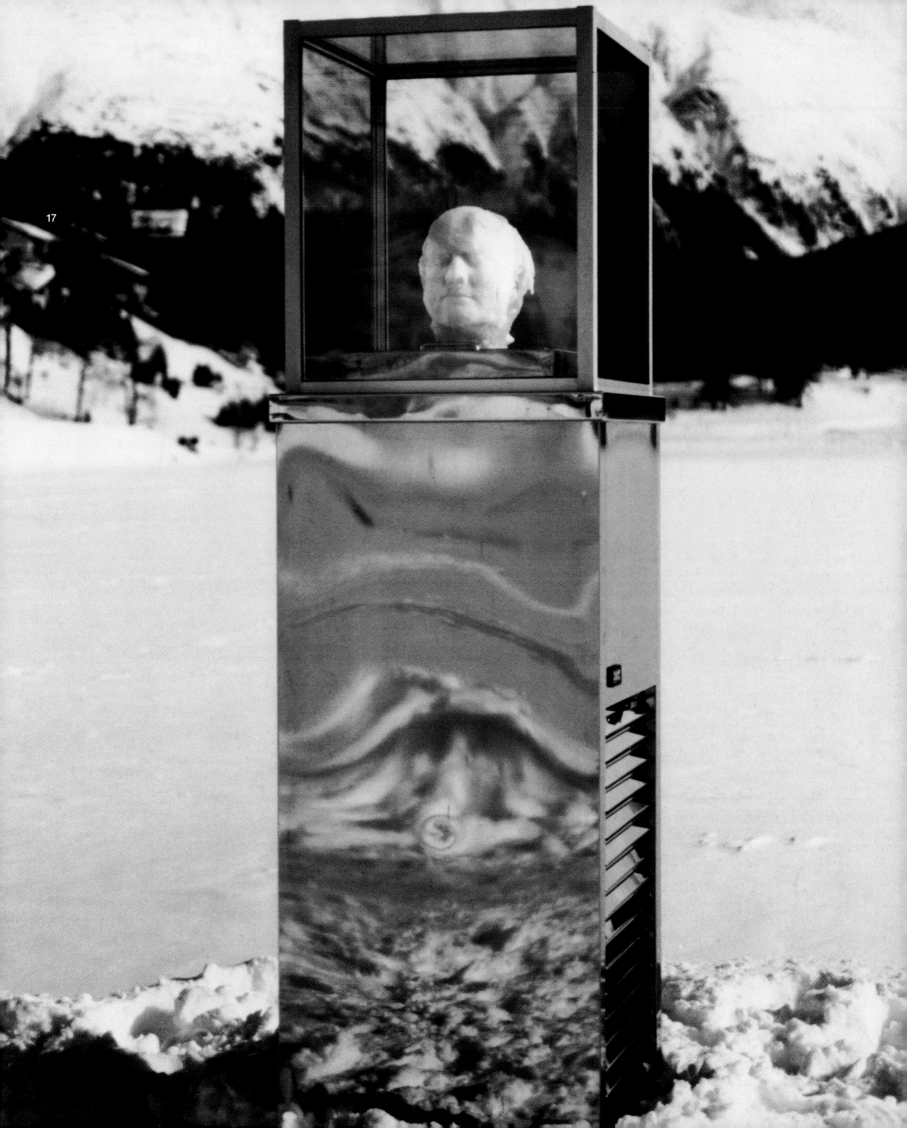

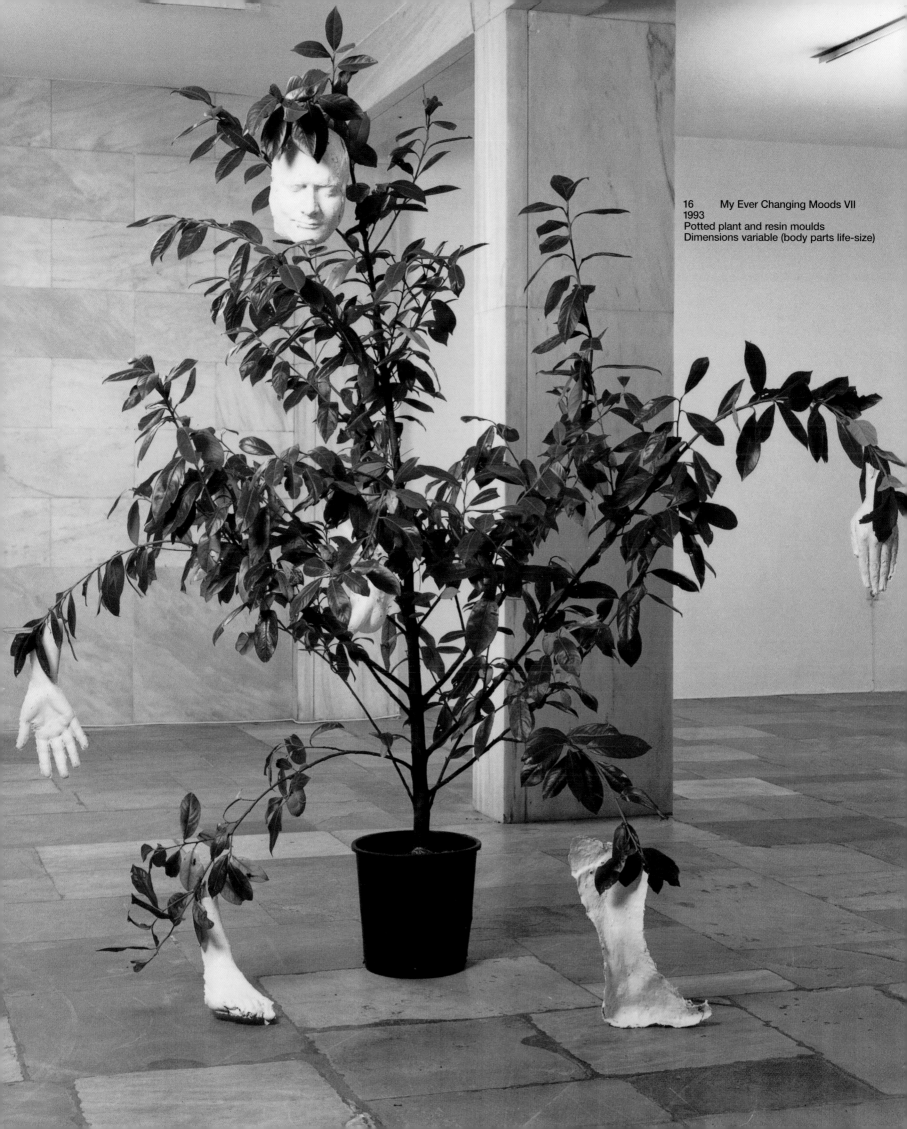

16 My Ever Changing Moods VII
1993
Potted plant and resin moulds
Dimensions variable (body parts life-size)

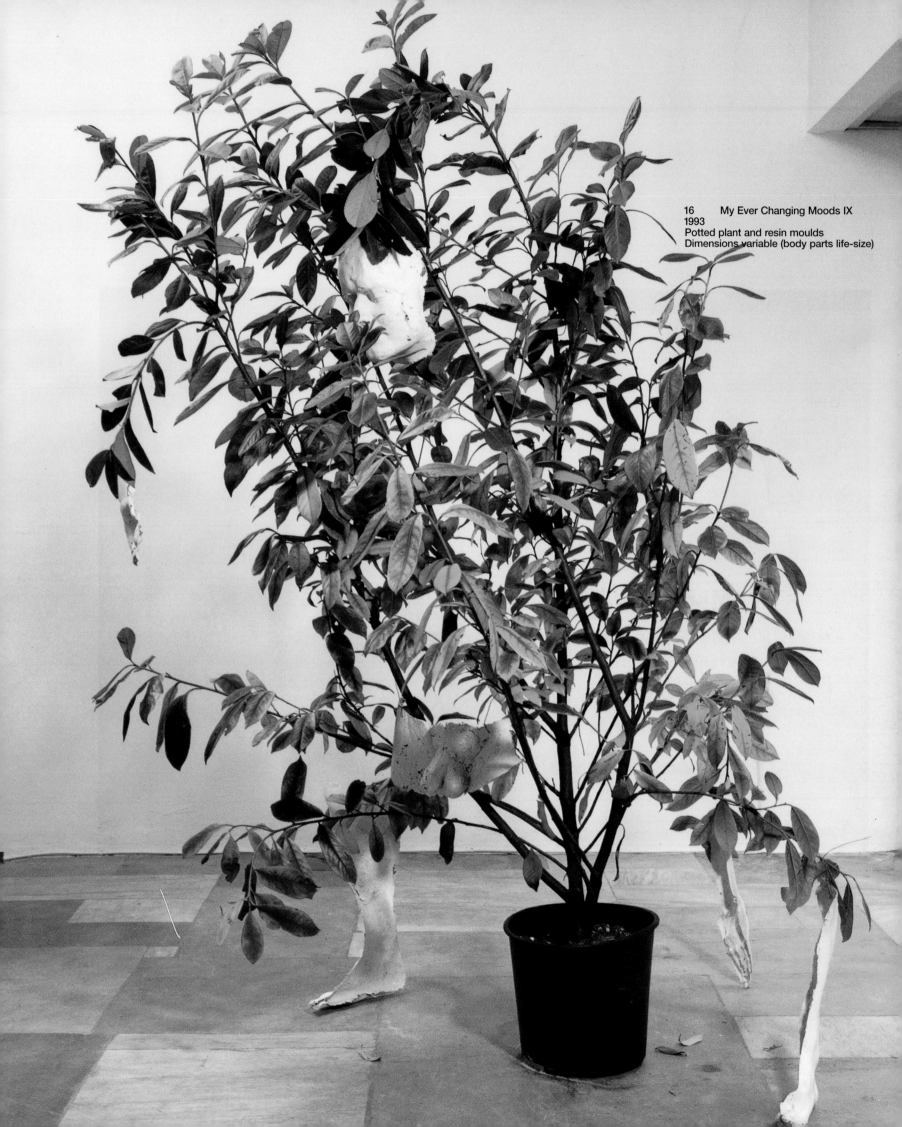

16 My Ever Changing Moods IX
1993
Potted plant and resin moulds
Dimensions variable (body parts life-size)

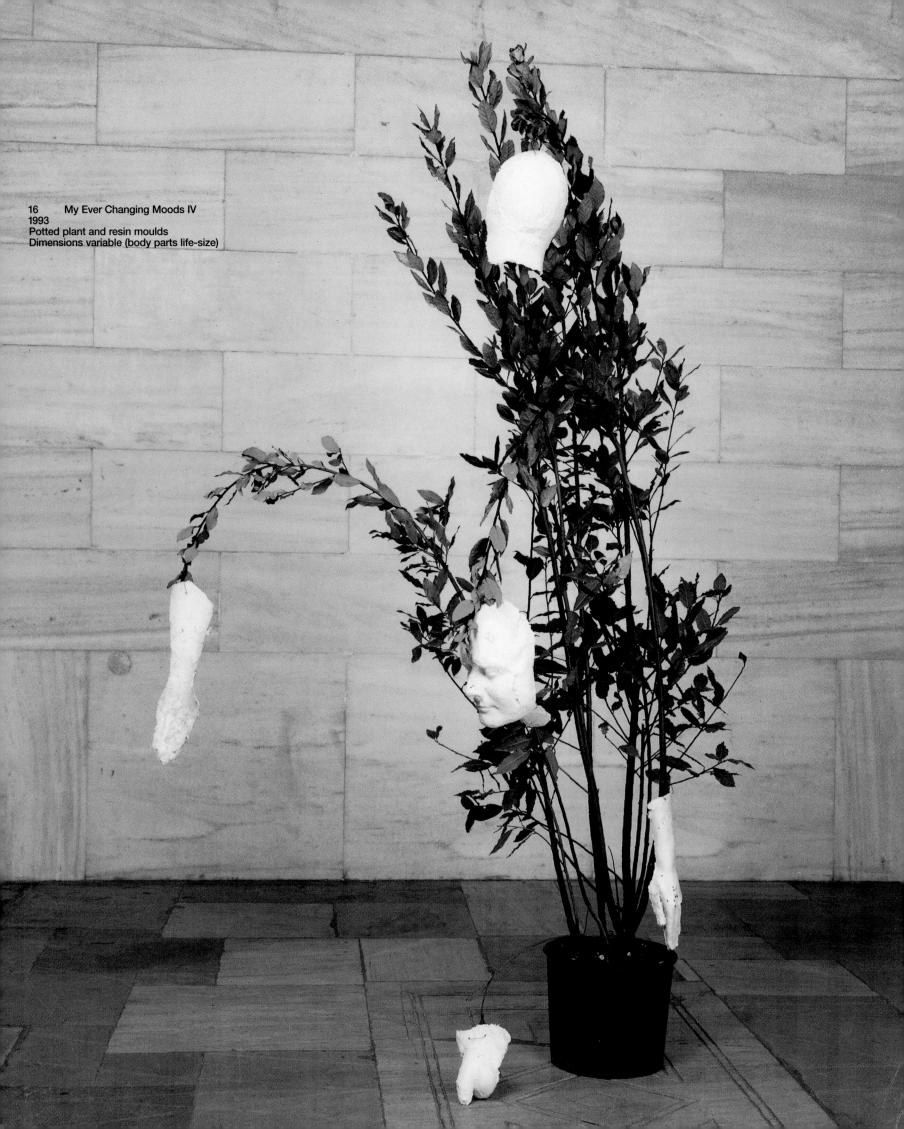

16 My Ever Changing Moods IV
1993
Potted plant and resin moulds
Dimensions variable (body parts life-size)

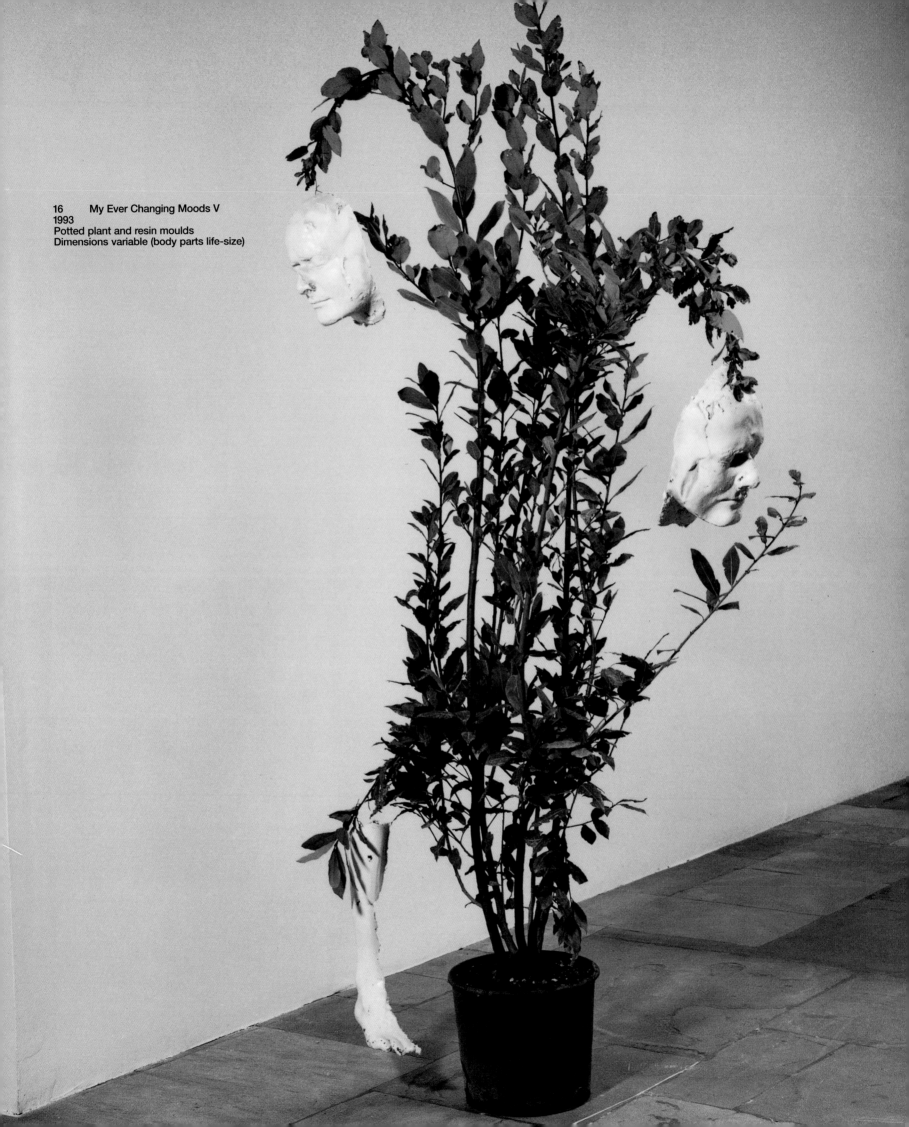

16 My Ever Changing Moods V
1993
Potted plant and resin moulds
Dimensions variable (body parts life-size)

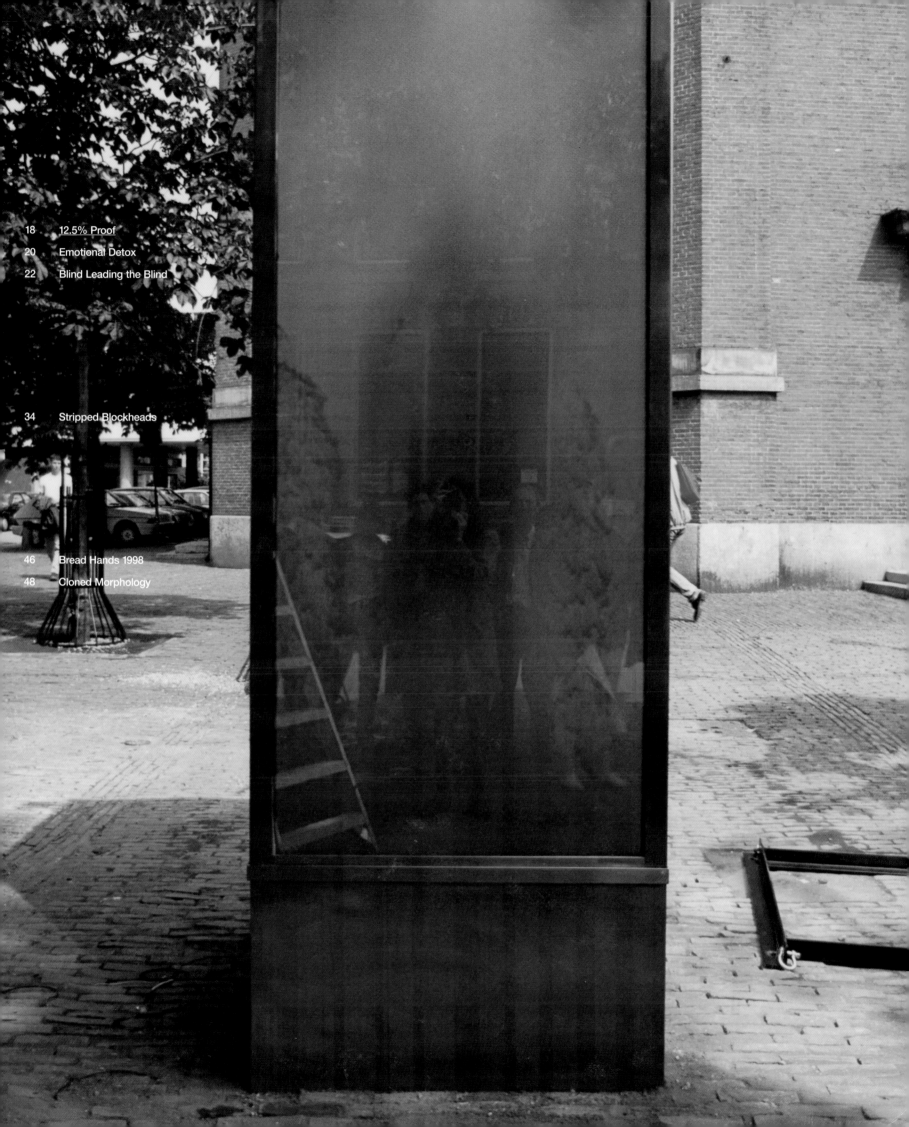

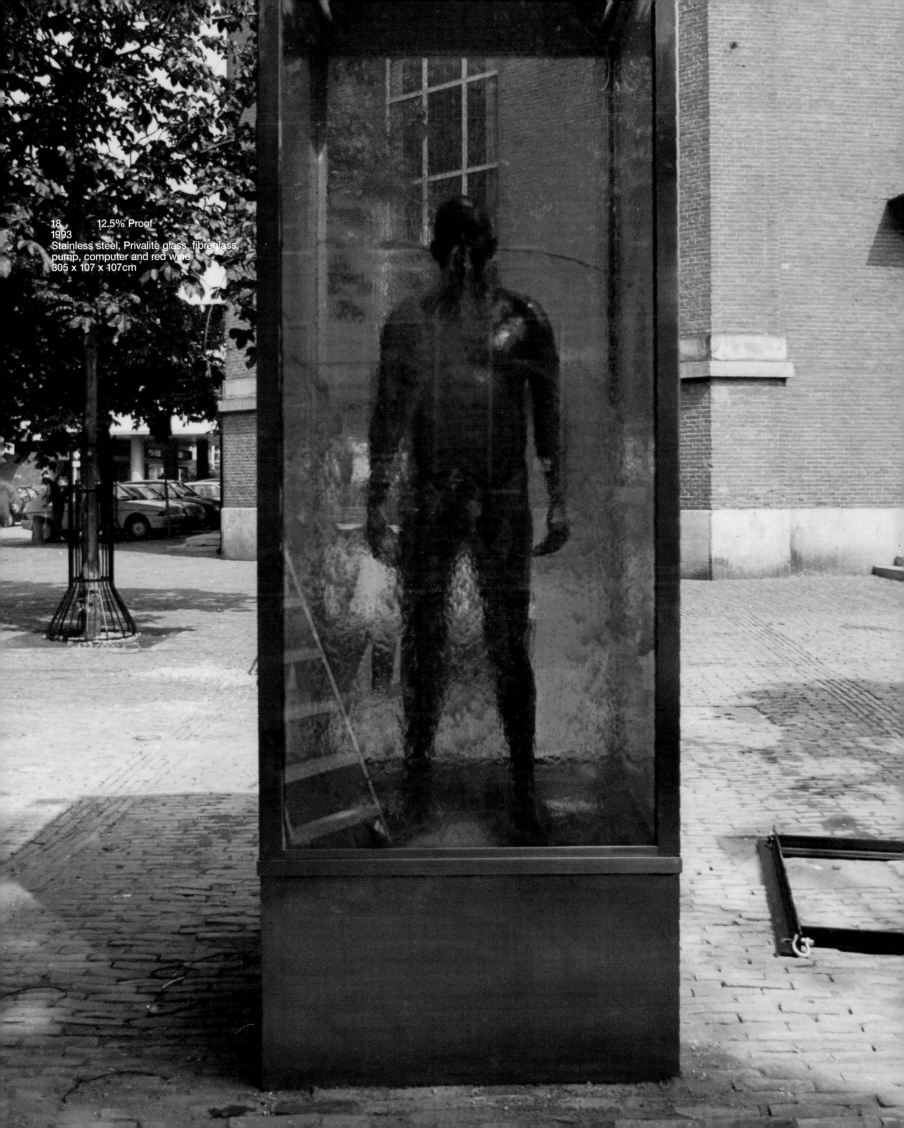

18 12.5% Proof
1993
Stainless steel, Privalite glass, fibreglass,
pump, computer and red wine
305 x 107 x 107cm

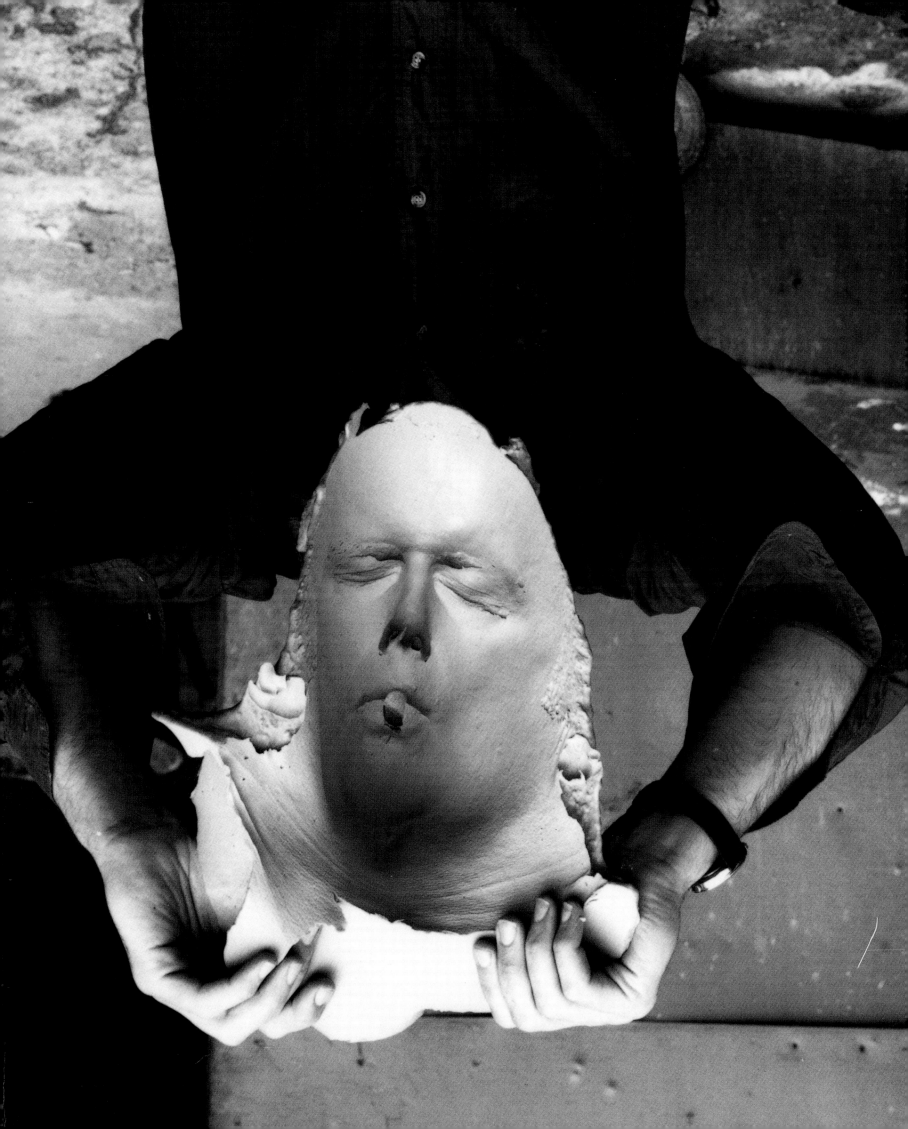

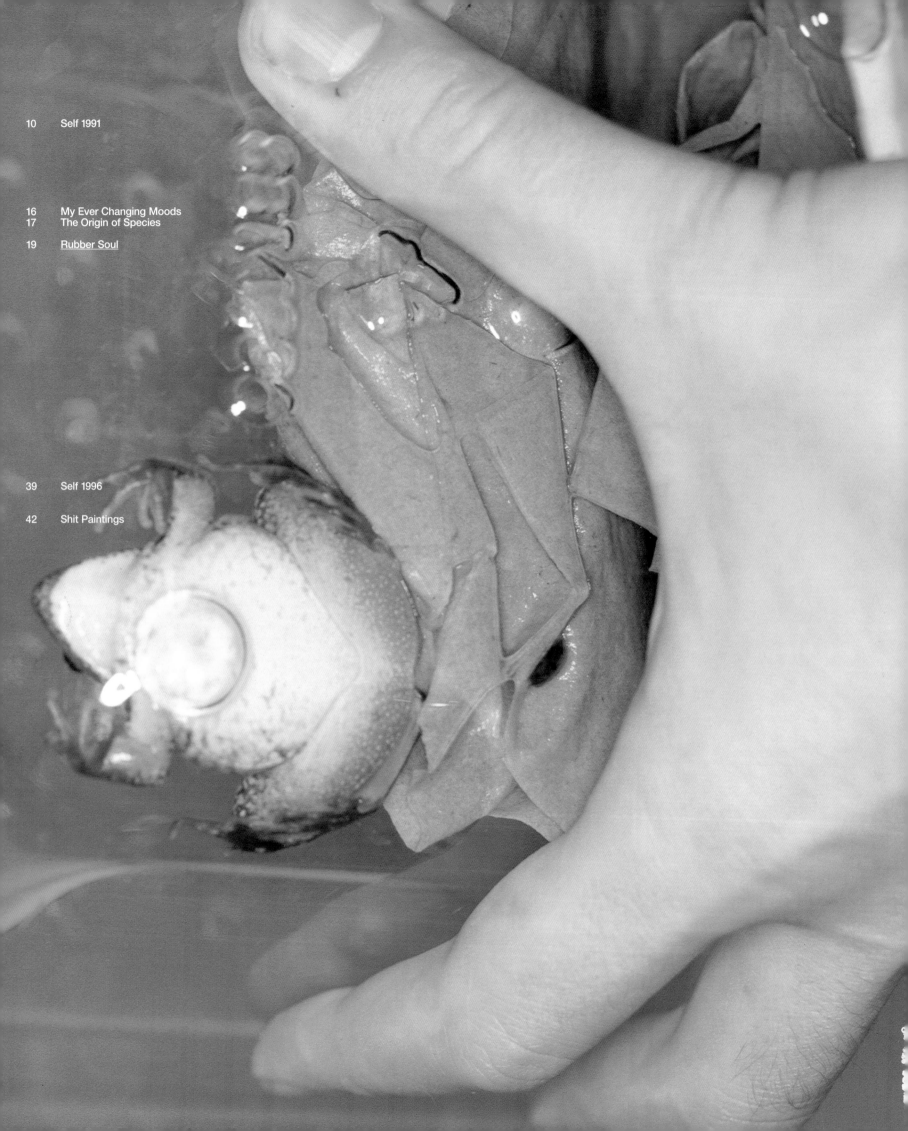

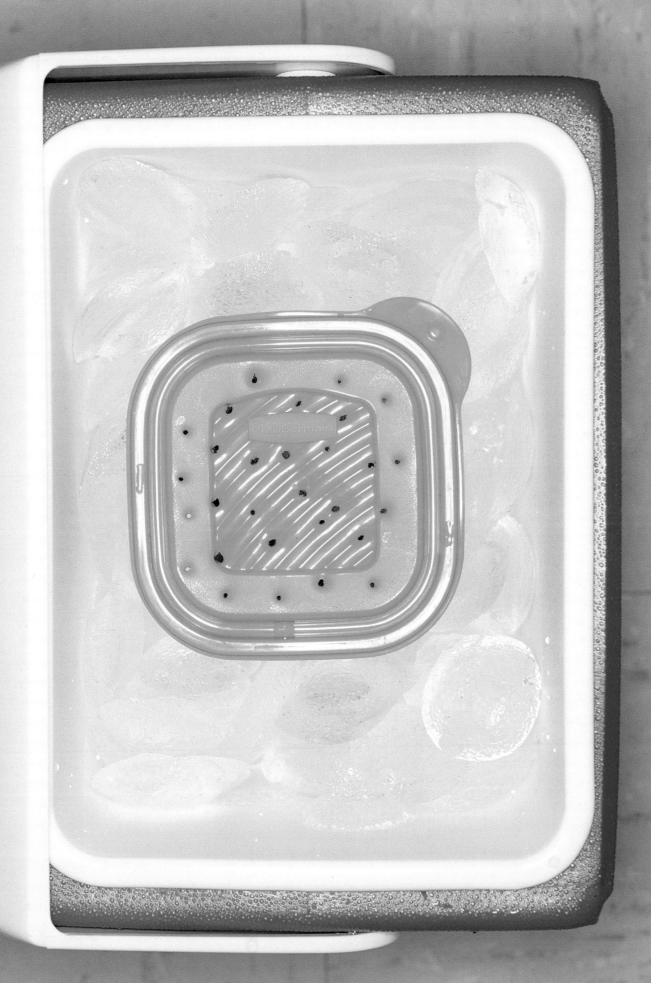

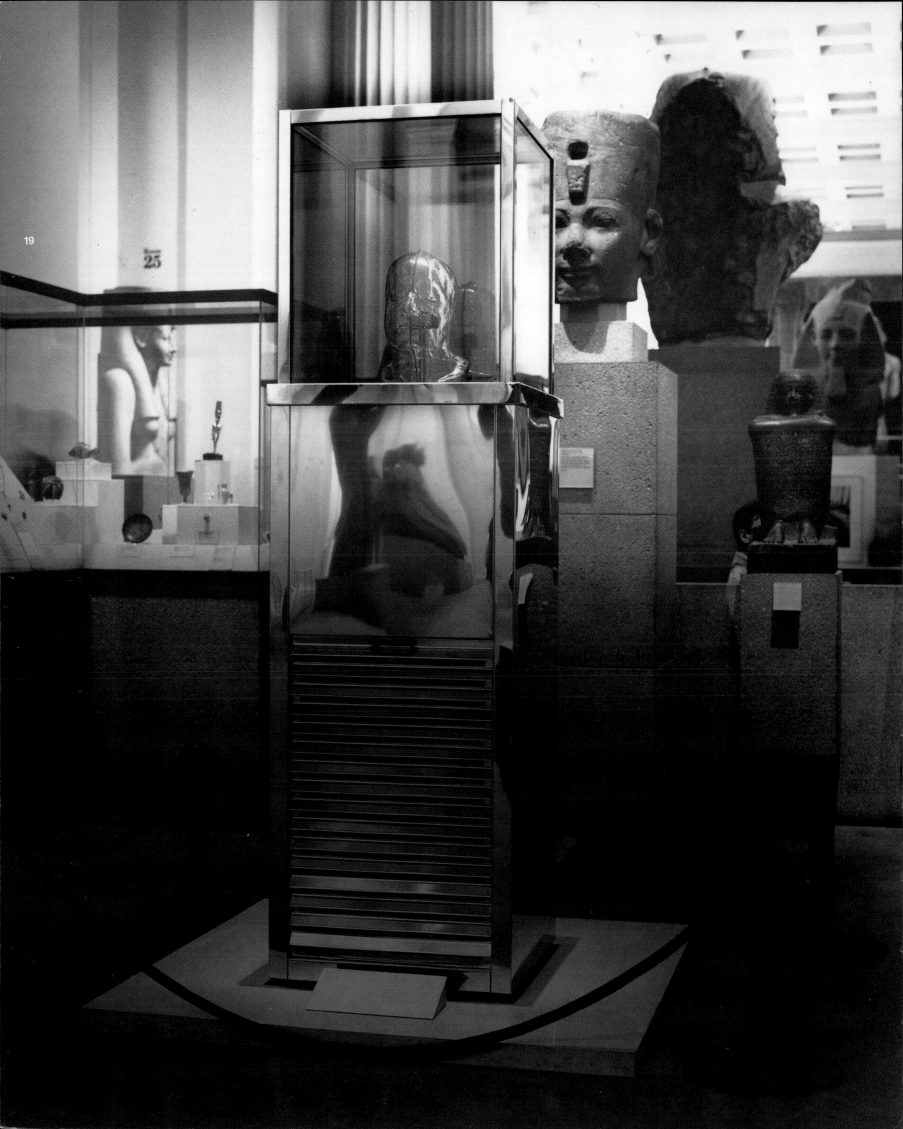

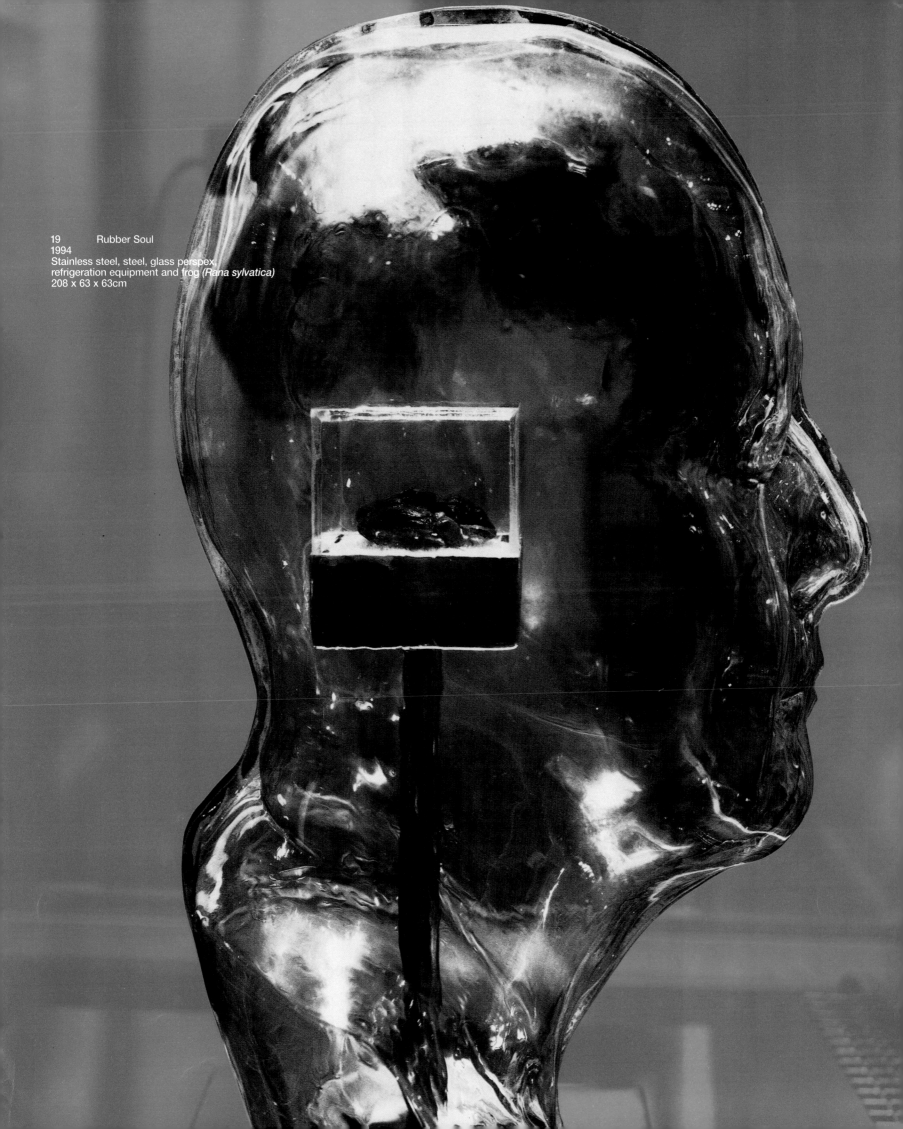

19 Rubber Soul
1994
Stainless steel, steel, glass perspex,
refrigeration equipment and frog *(Rana sylvatica)*
208 x 63 x 63cm

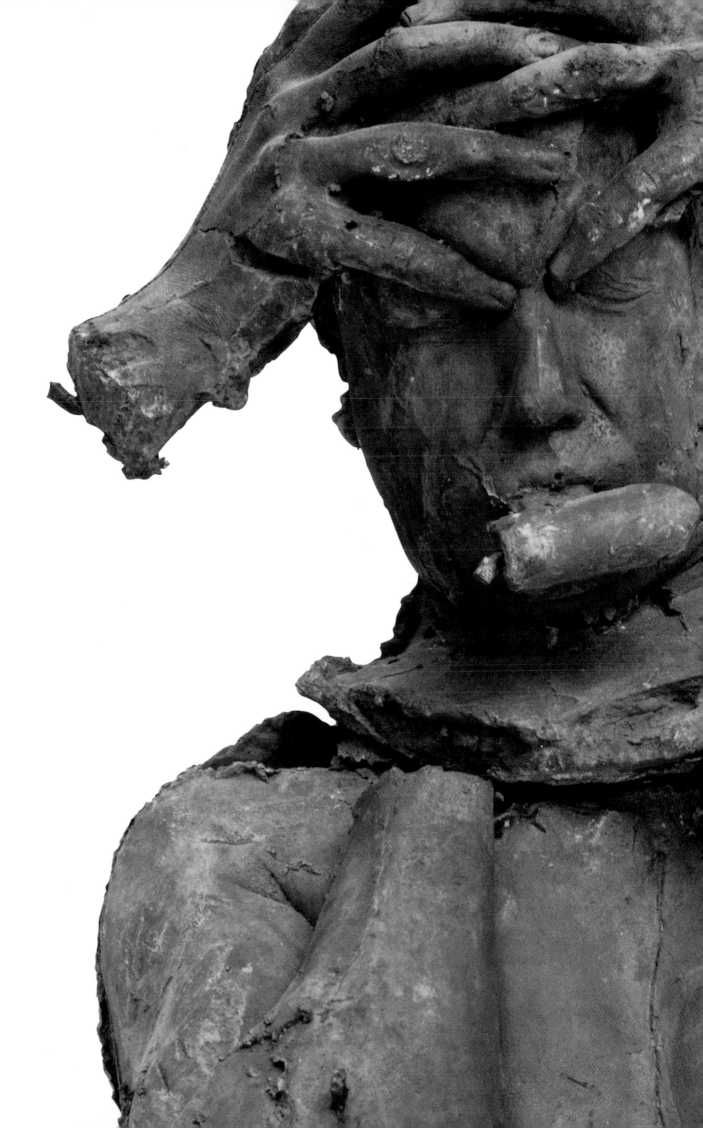

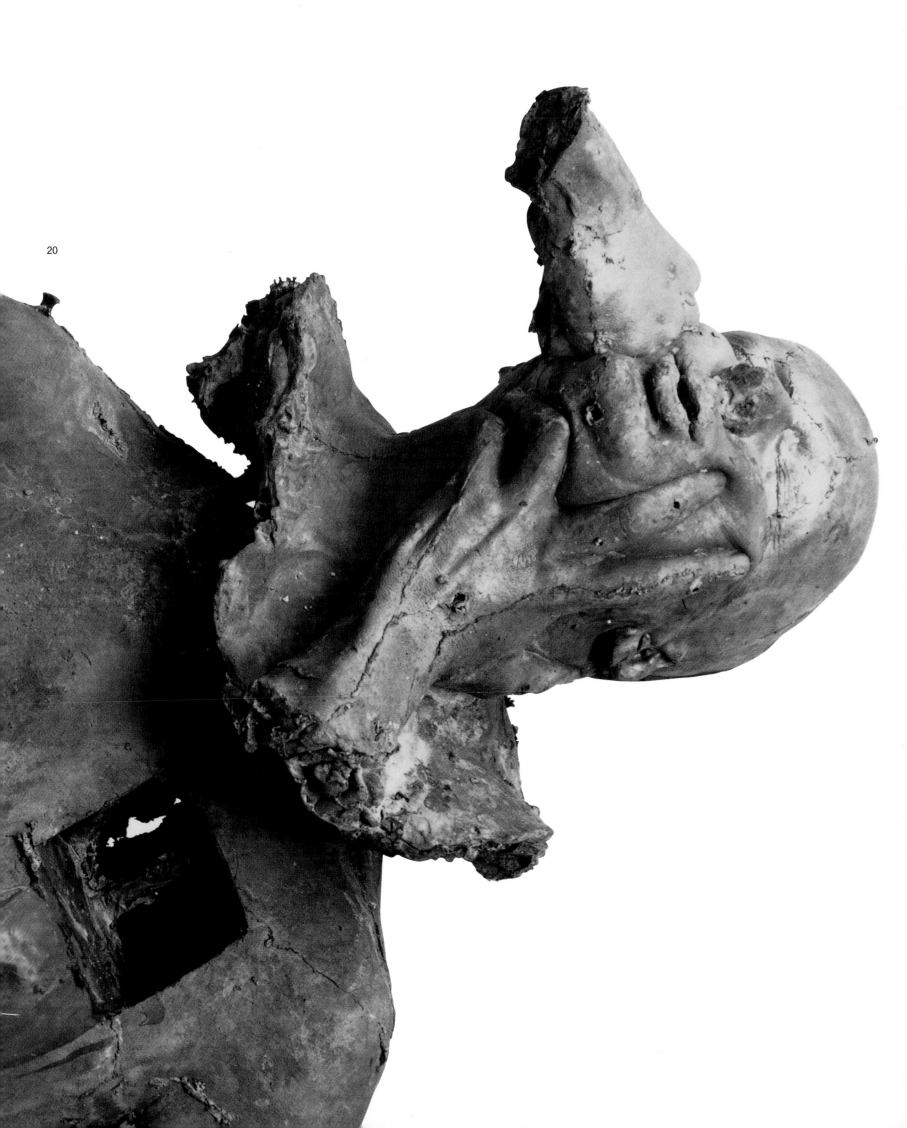

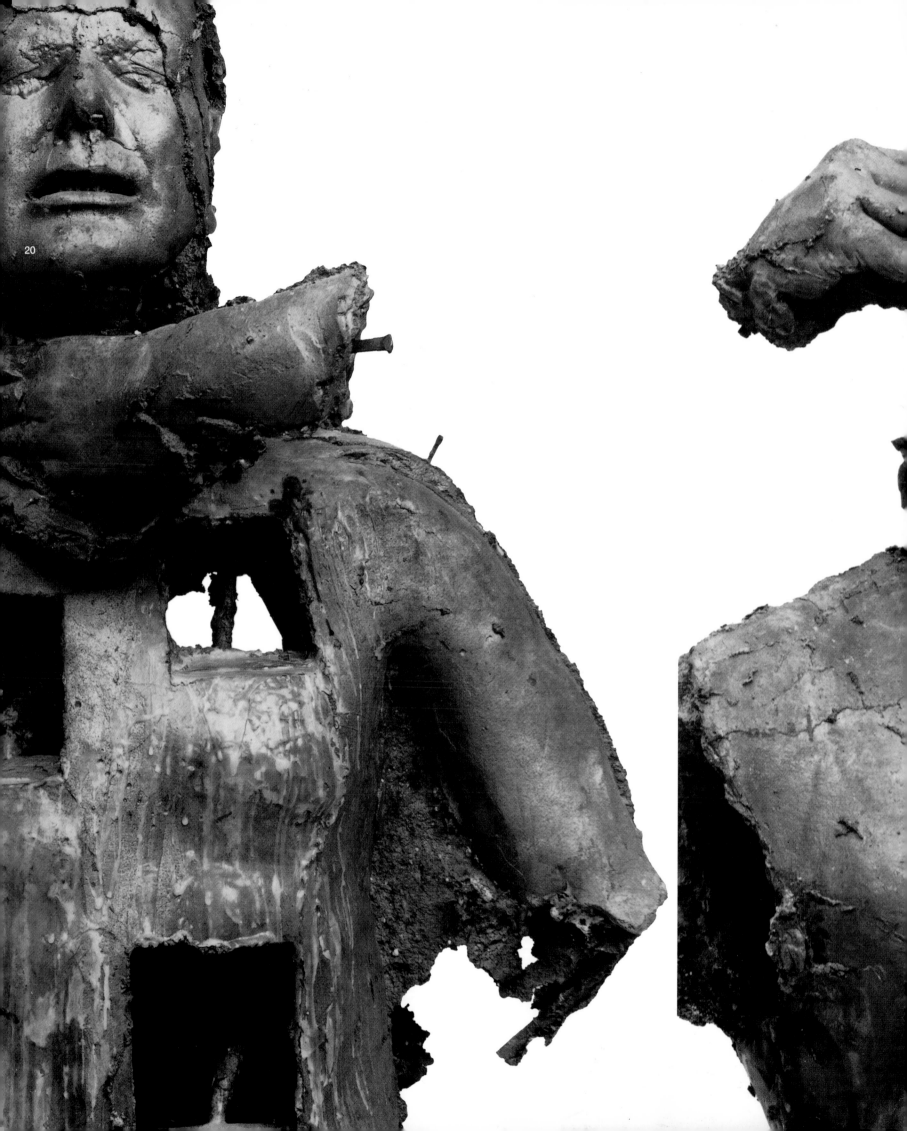

20

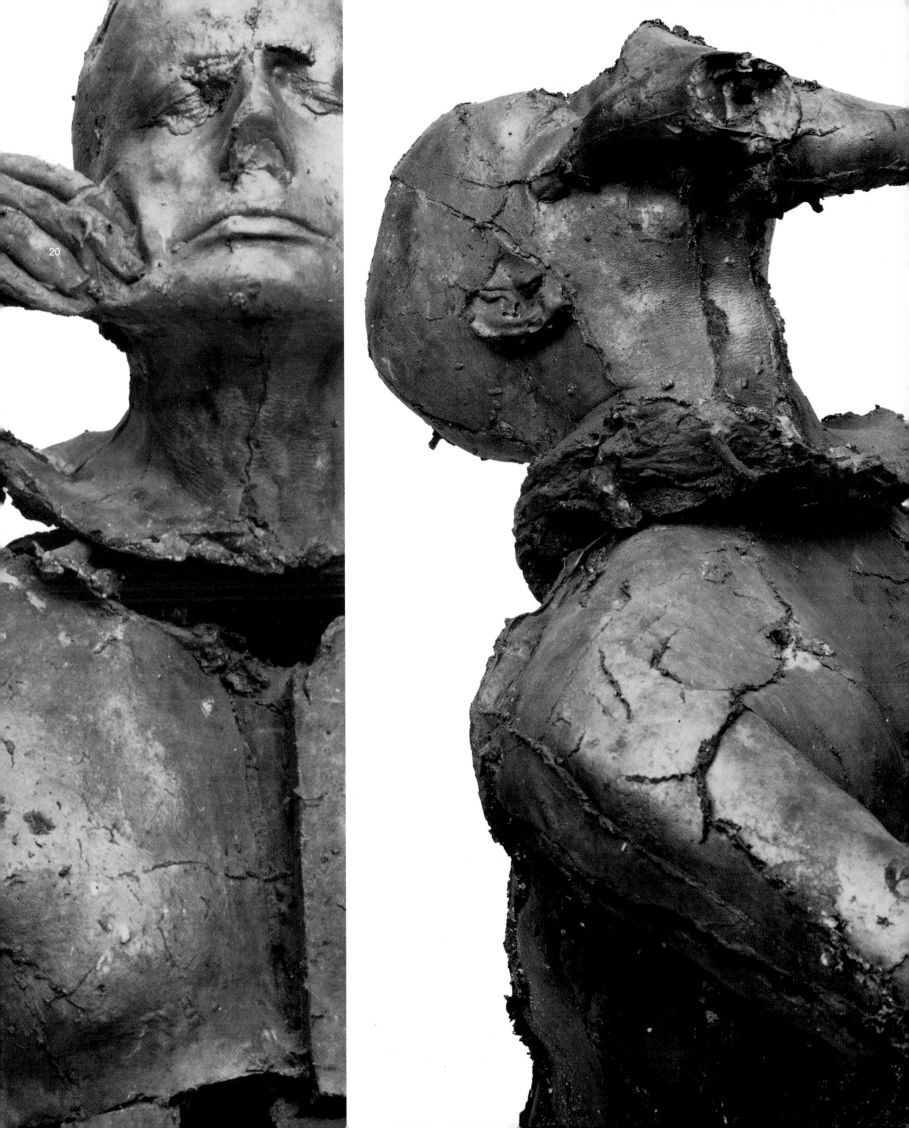

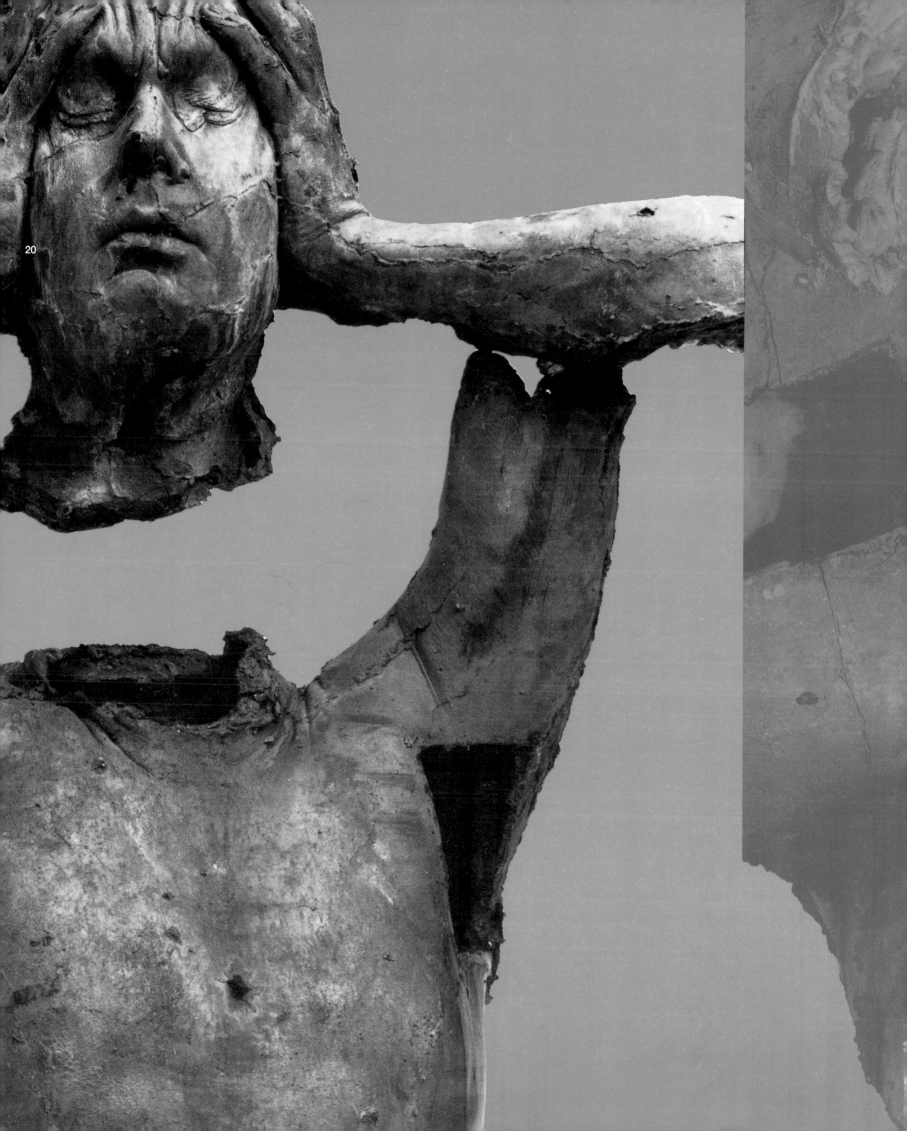

20

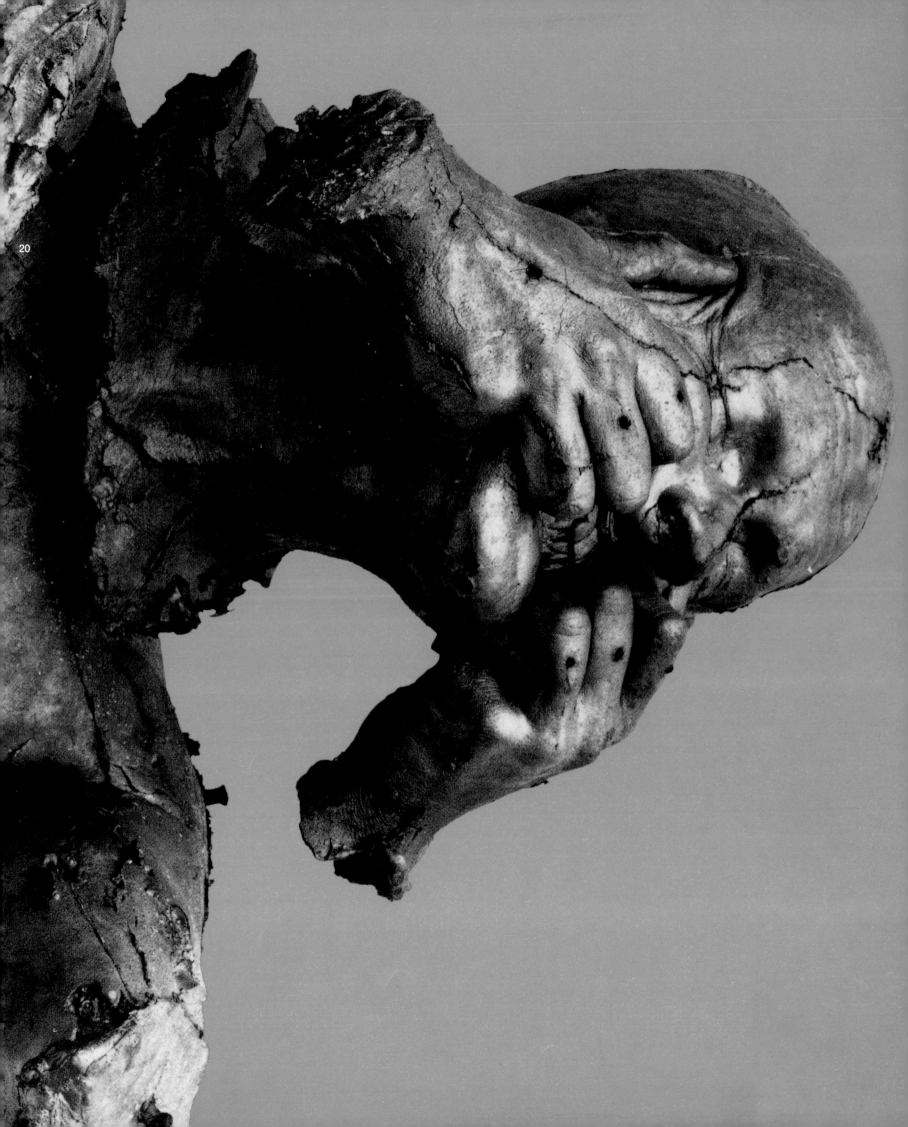

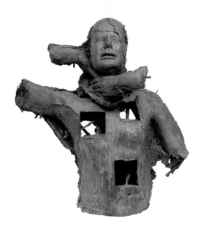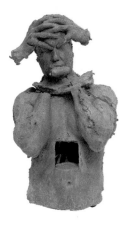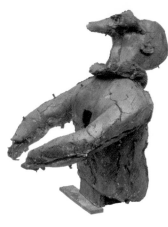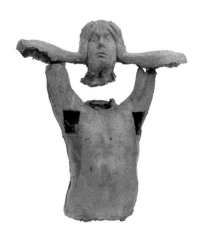

20 Emotional Detox:
The Seven Deadly Sins I
1994–5
Cast lead and wax
80 x 65 x 35cm

20 Emotional Detox:
The Seven Deadly Sins II
1994–5
Cast lead and wax
86 x 47 x 37cm

20 Emotional Detox:
The Seven Deadly Sins III
1994–5
Cast lead and wax
83 x 75 x 55cm

20 Emotional Detox:
The Seven Deadly Sins IV
1994–5
Cast lead and wax
90 x 80 x 30cm

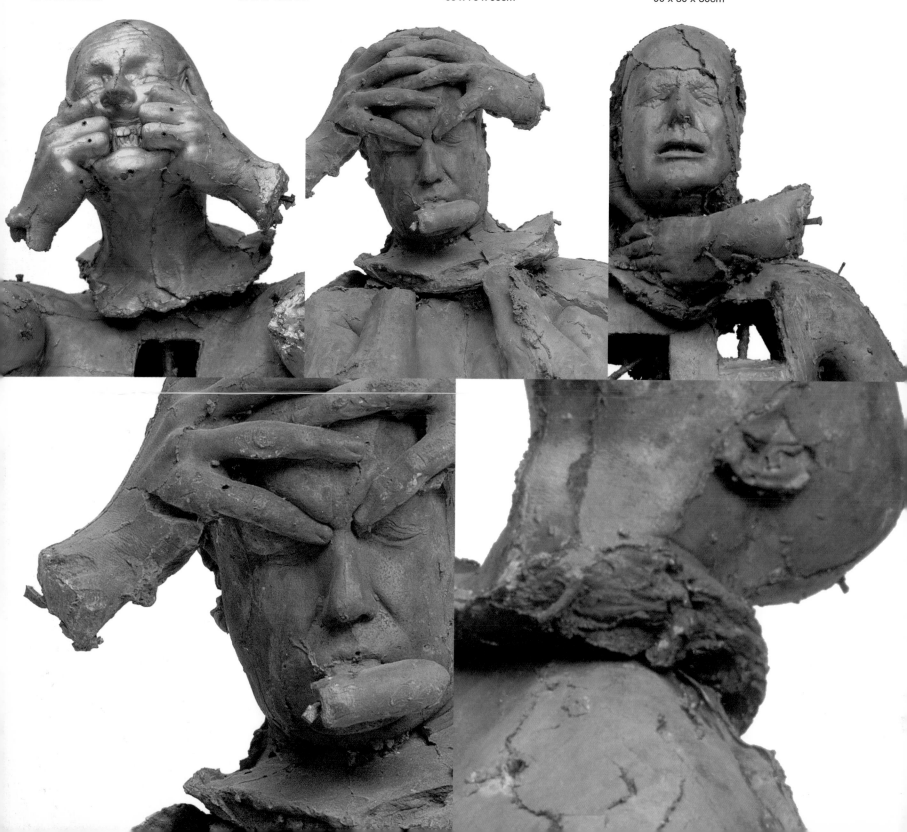

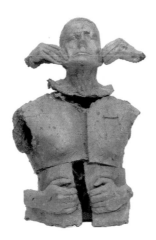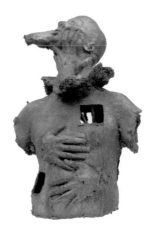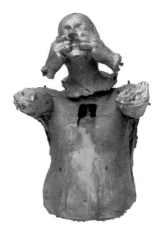

20 Emotional Detox:
 The Seven Deadly Sins V
1994–5
Cast lead and wax
86 x 52 x 36cm

20 Emotional Detox:
 The Seven Deadly Sins VI
1994–5
Cast lead and wax
86 x 55 x 40cm

20 Emotional Detox:
 The Seven Deadly Sins VII
1994–5
Cast lead and wax
75 x 49 x 45cm

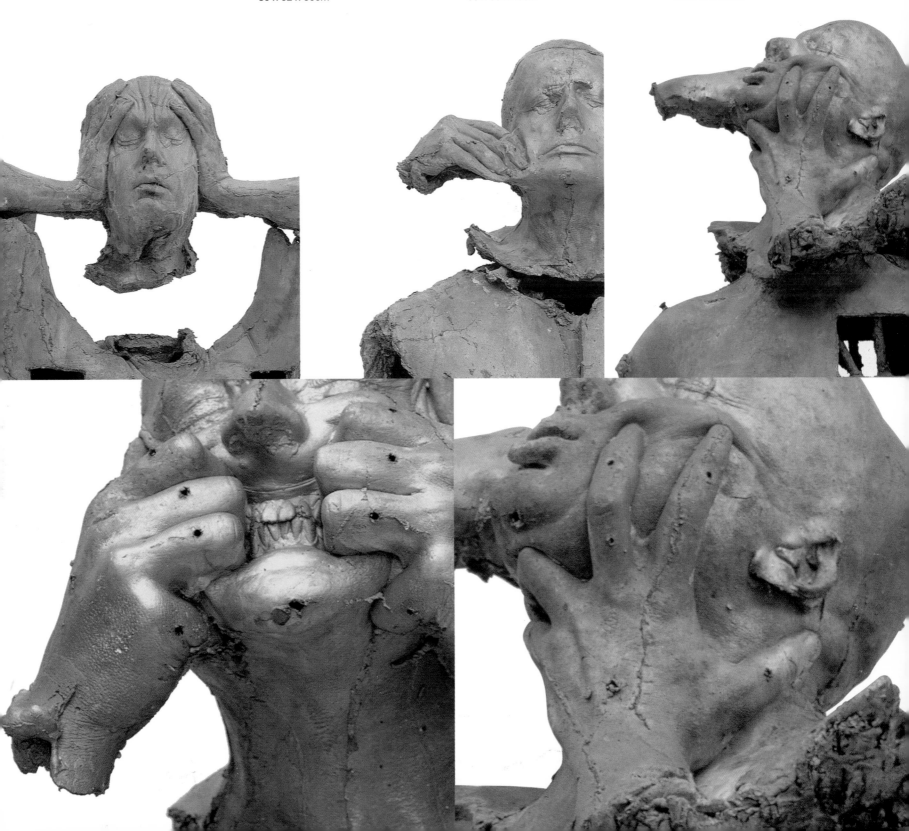

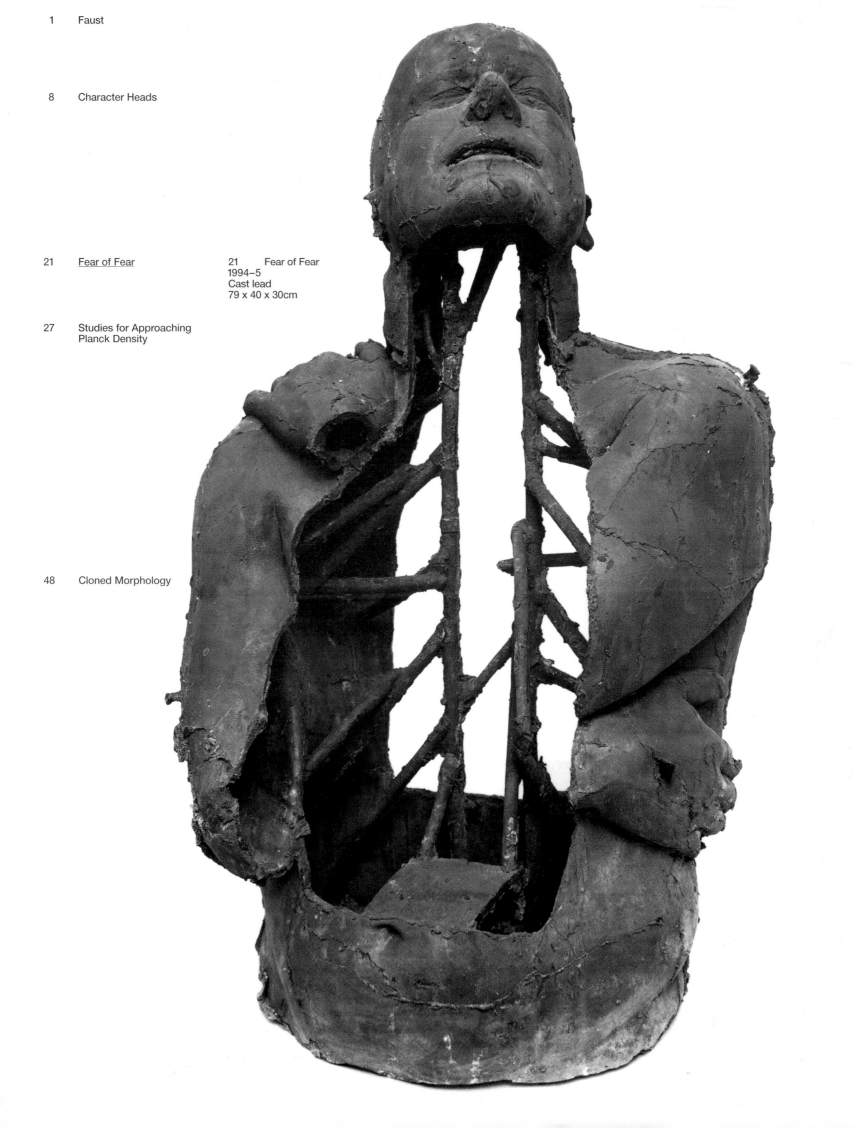

21 Fear of Fear
1994–5
Cast lead
79 x 40 x 30cm

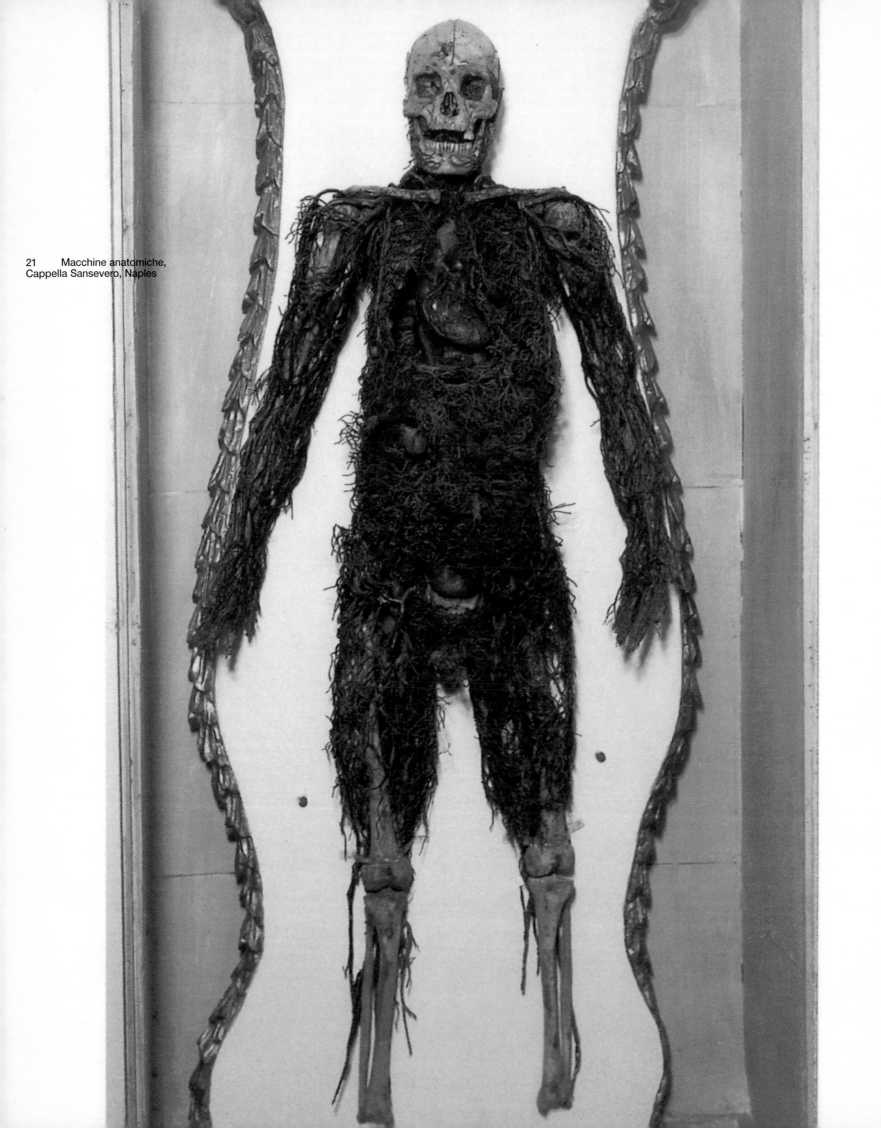

21 Macchine anatomiche,
Cappella Sansevero, Naples

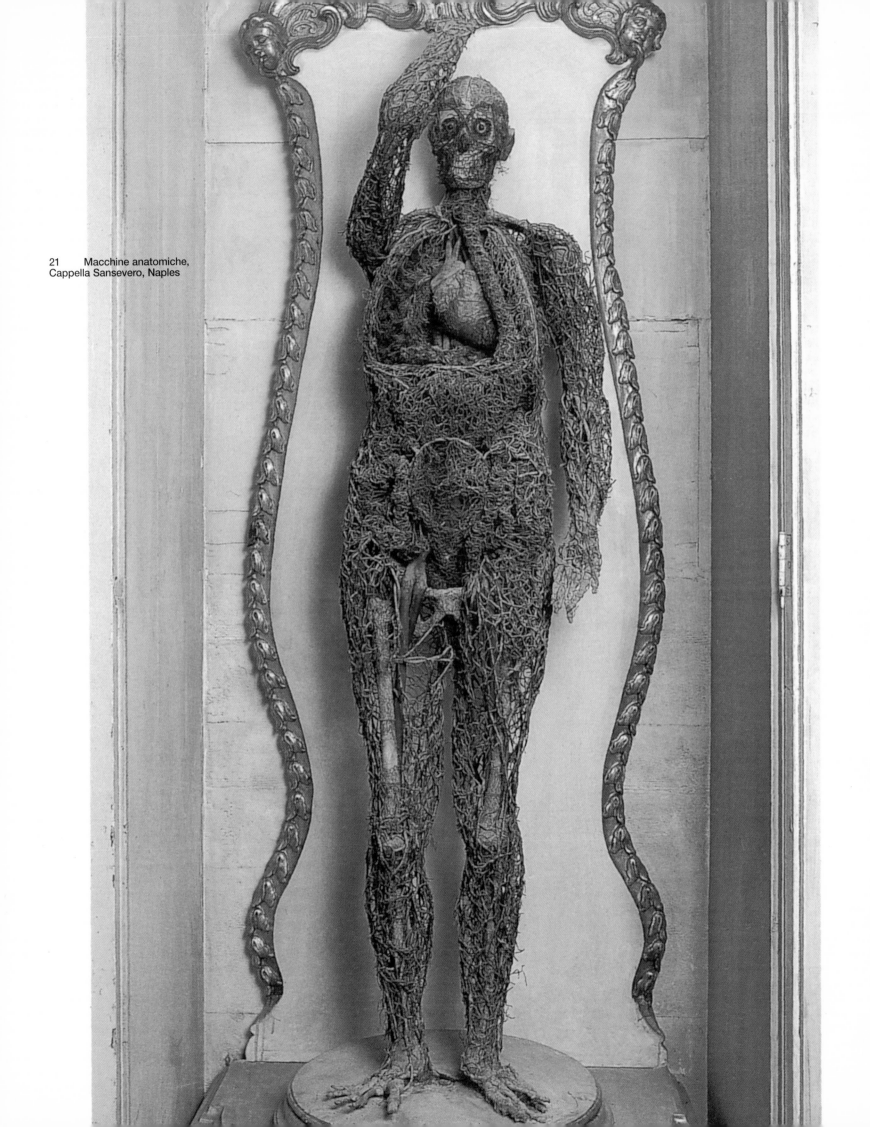

21　Macchine anatomiche,
Cappella Sansevero, Naples

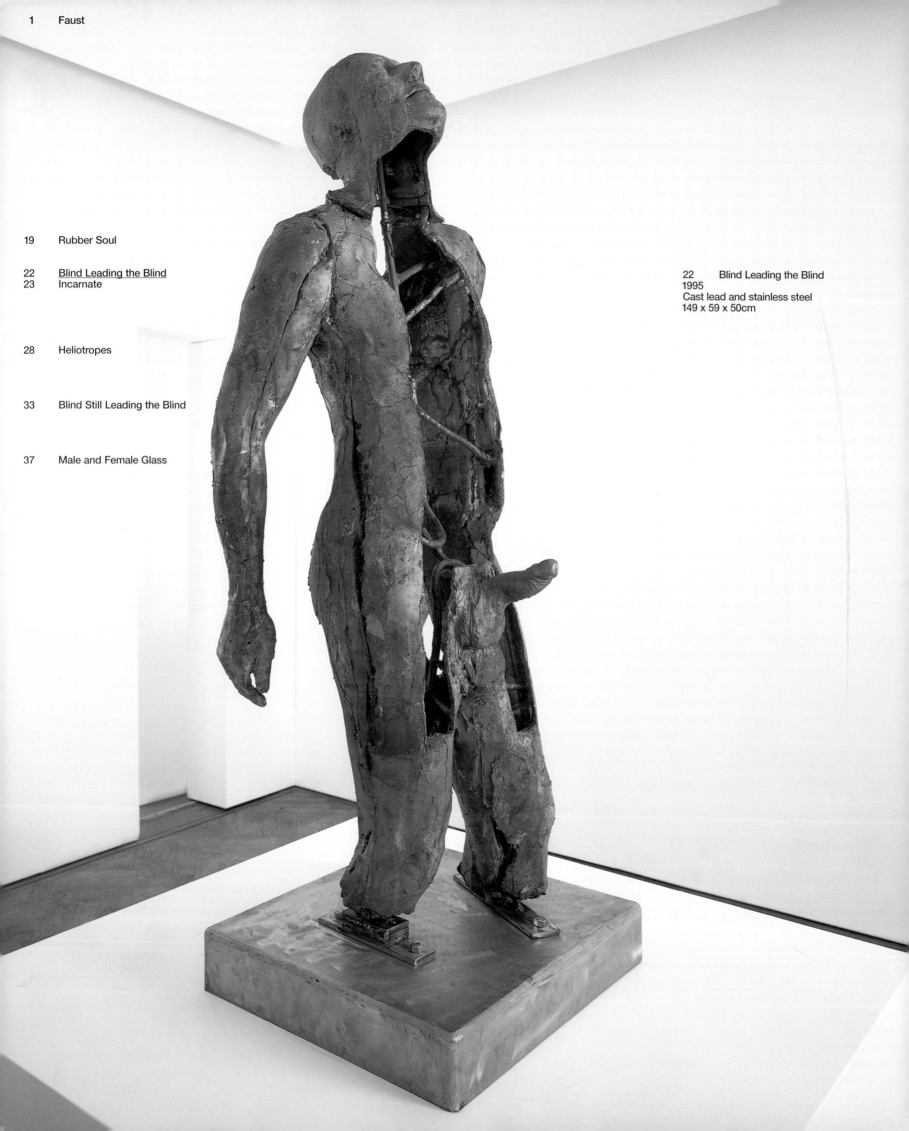

22 Blind Leading the Blind
1995
Cast lead and stainless steel
149 x 59 x 50cm

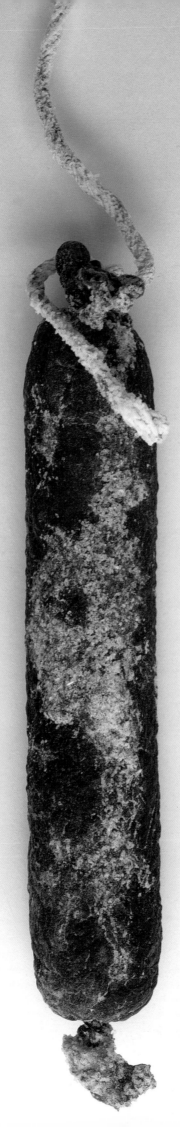

23

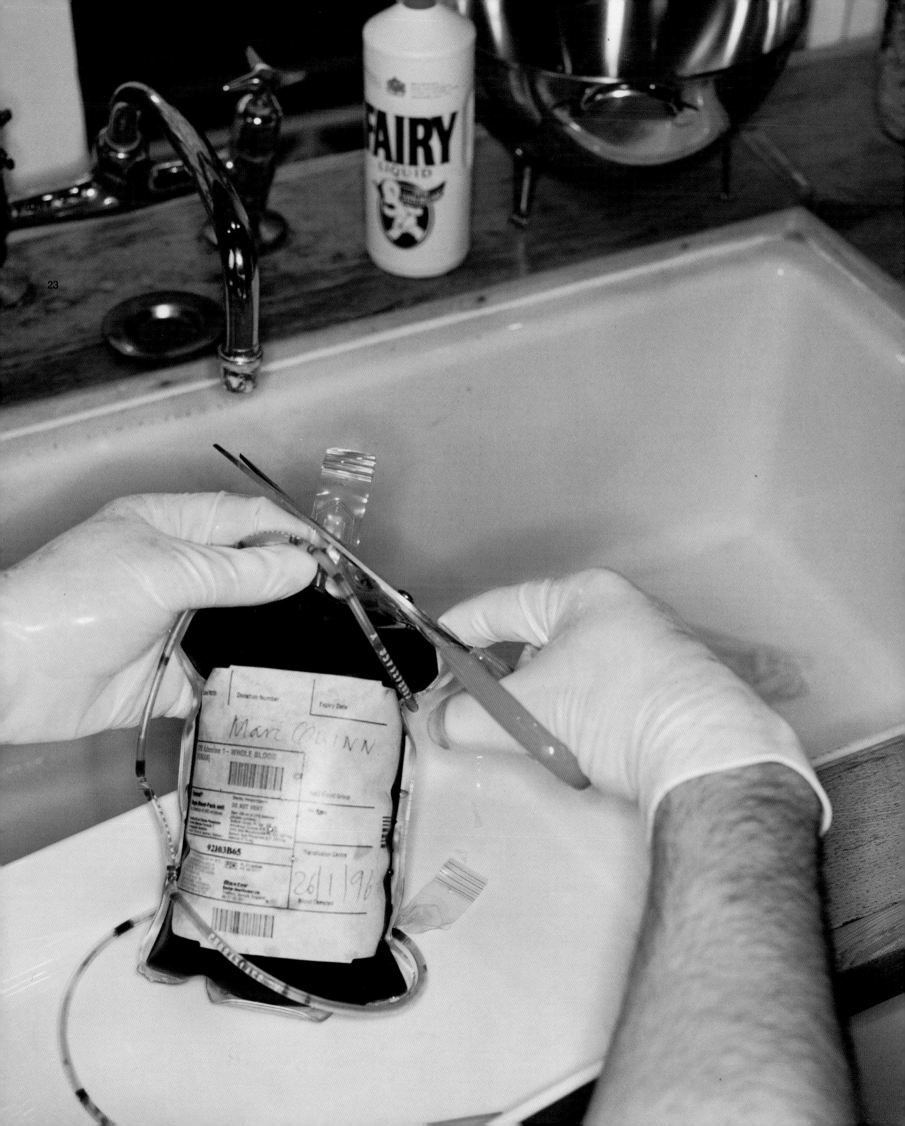

23

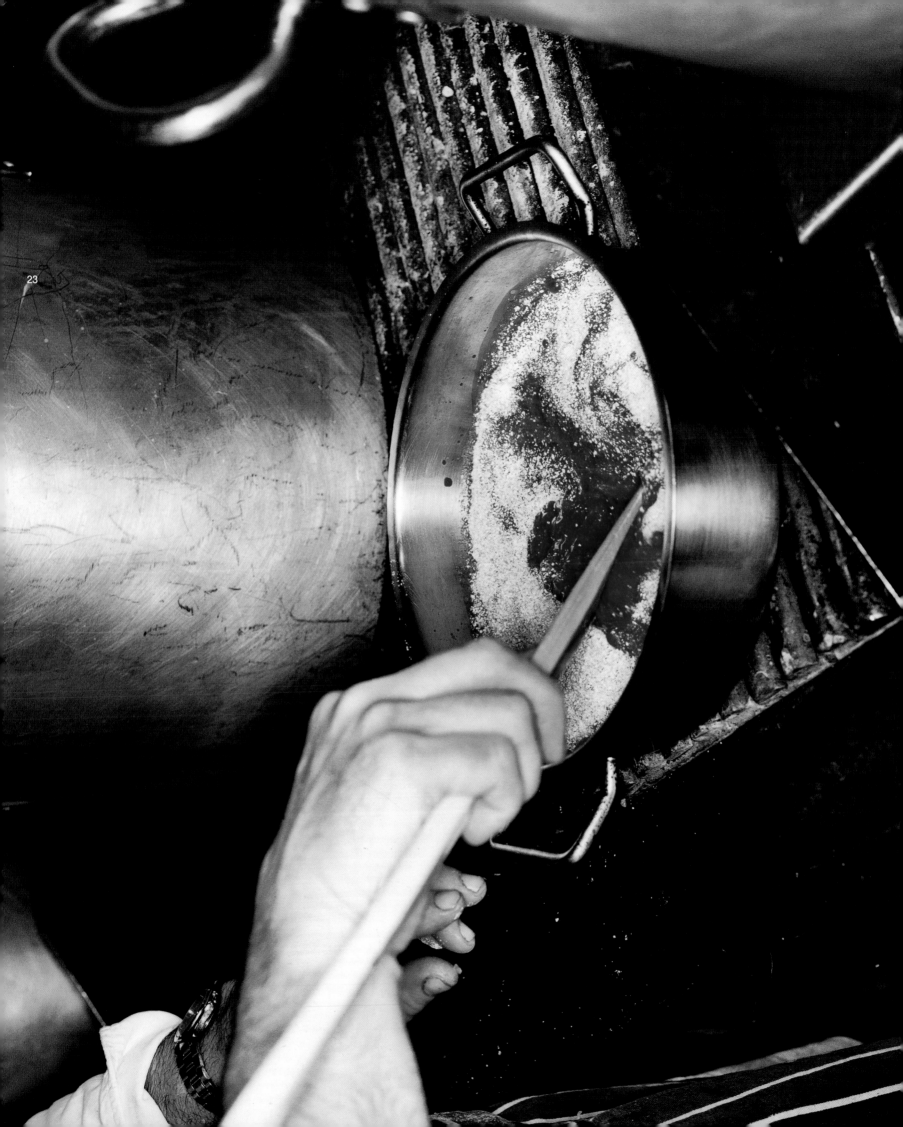

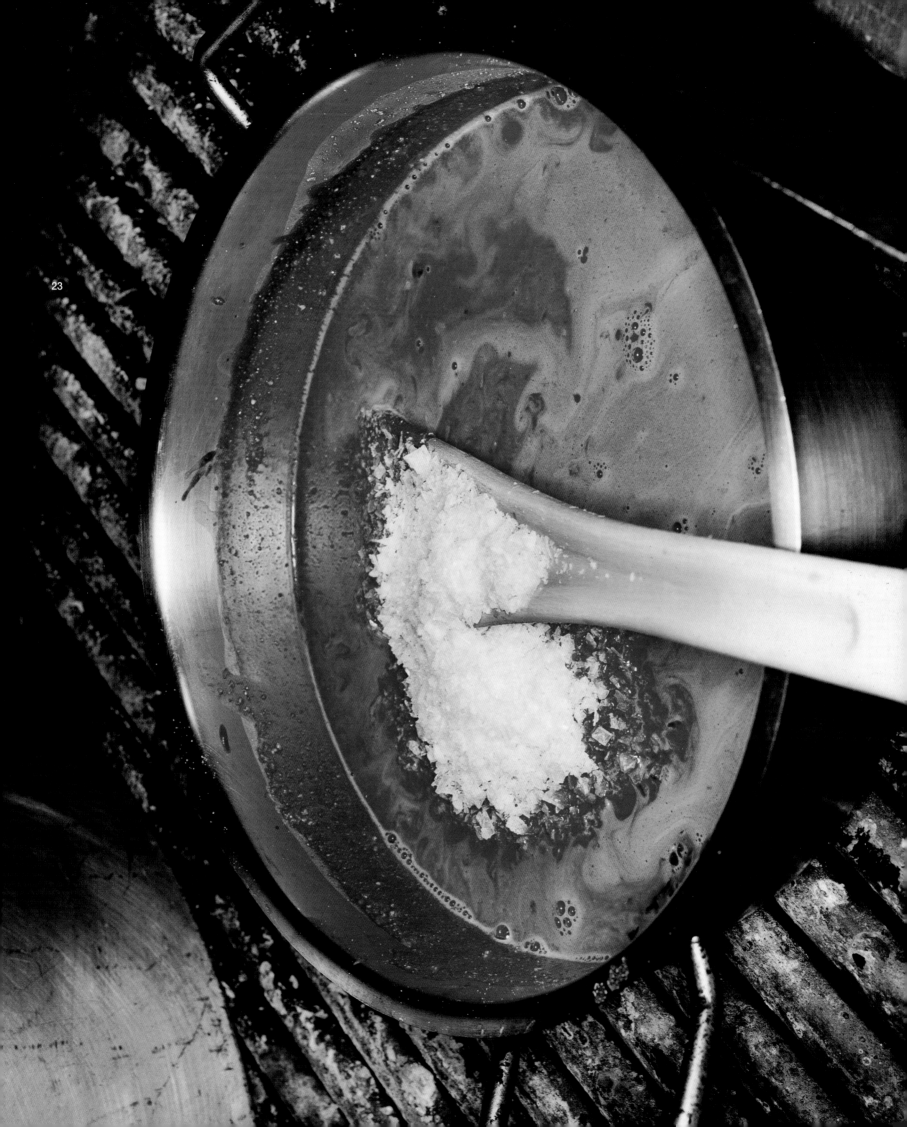

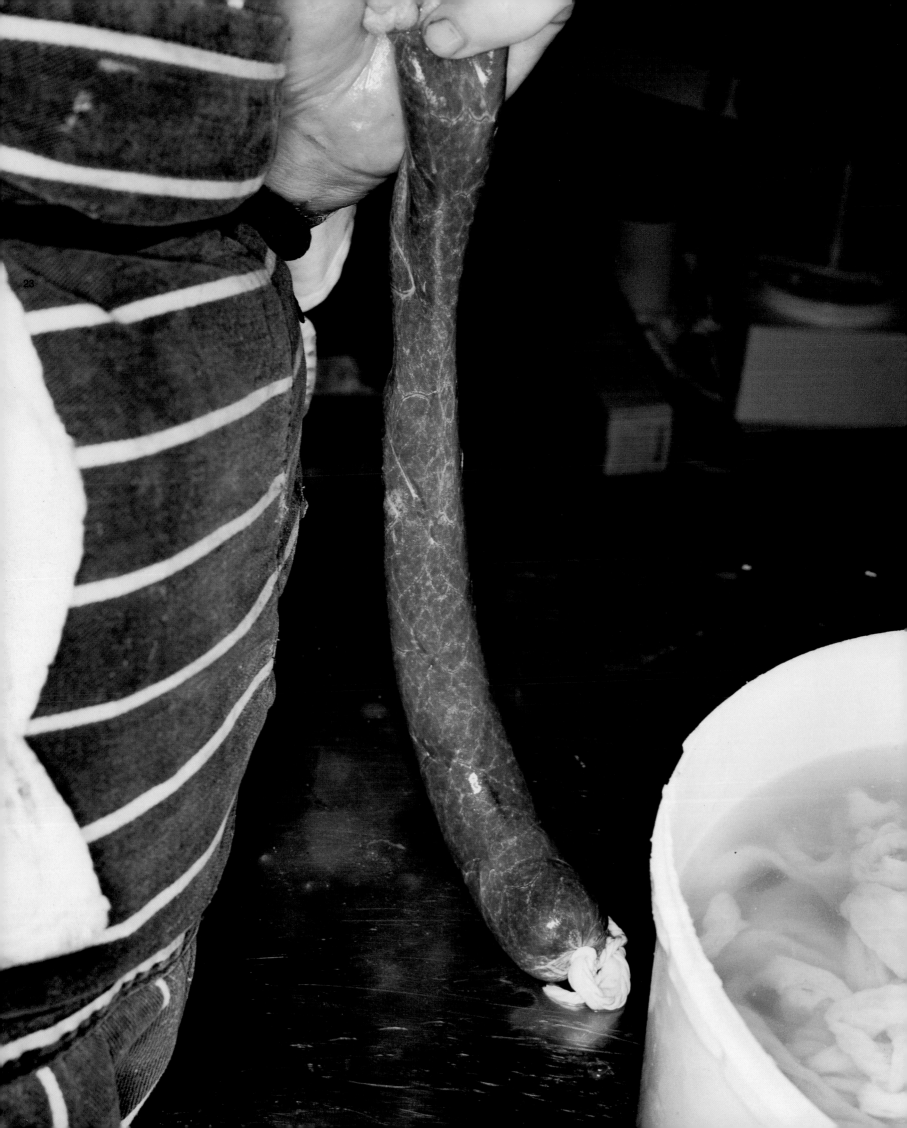

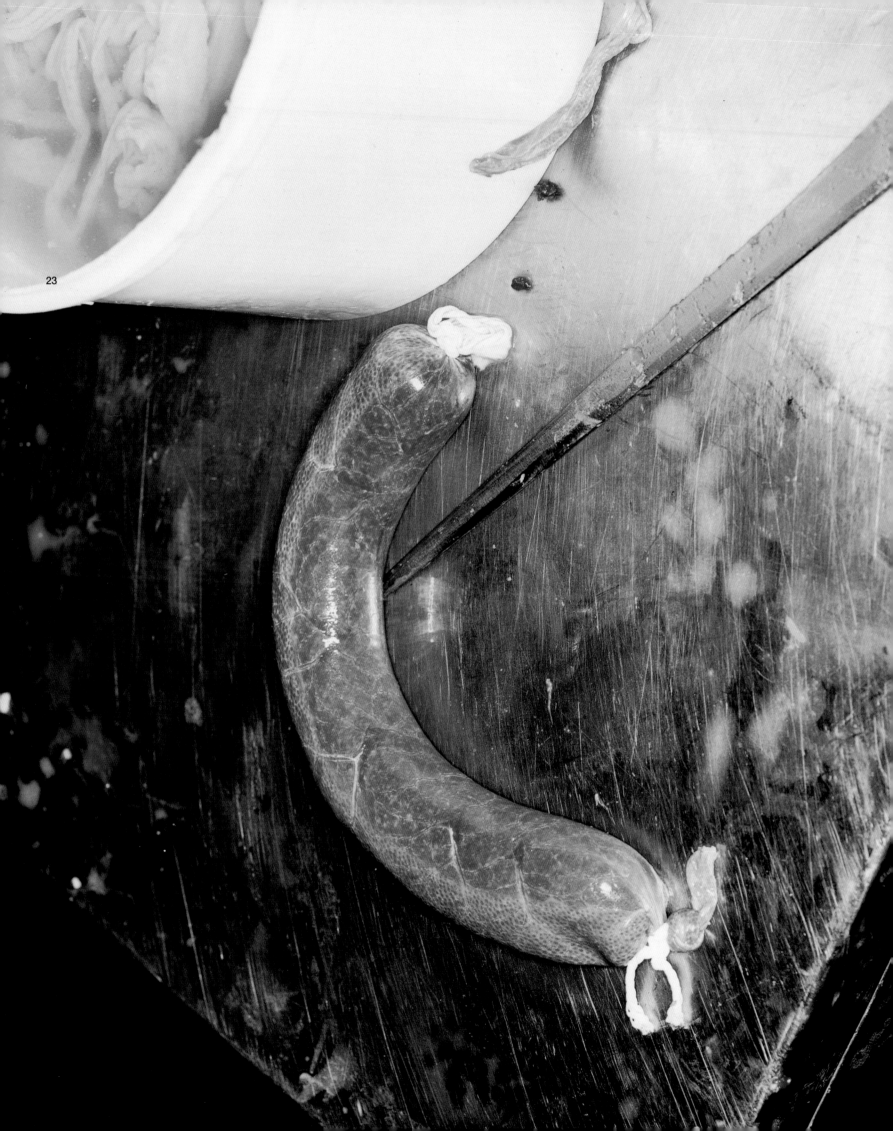

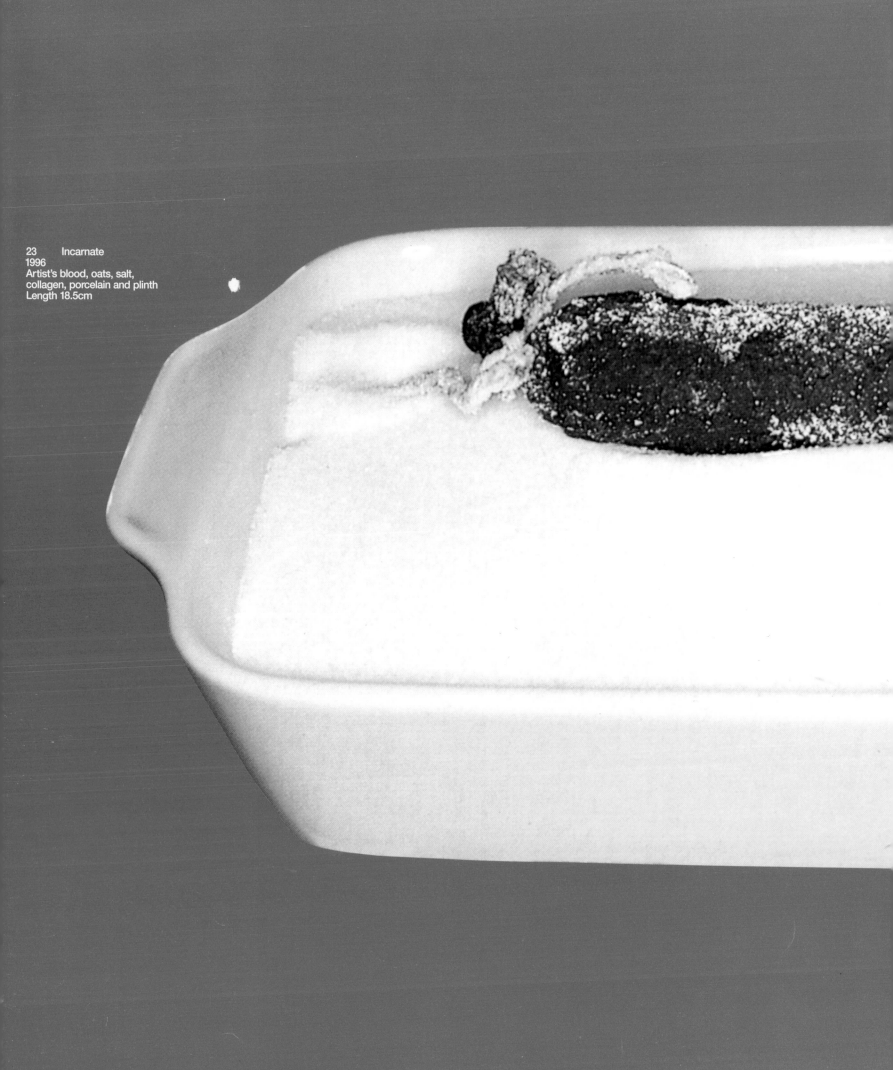

23 Incarnate
1996
Artist's blood, oats, salt,
collagen, porcelain and plinth
Length 18.5cm

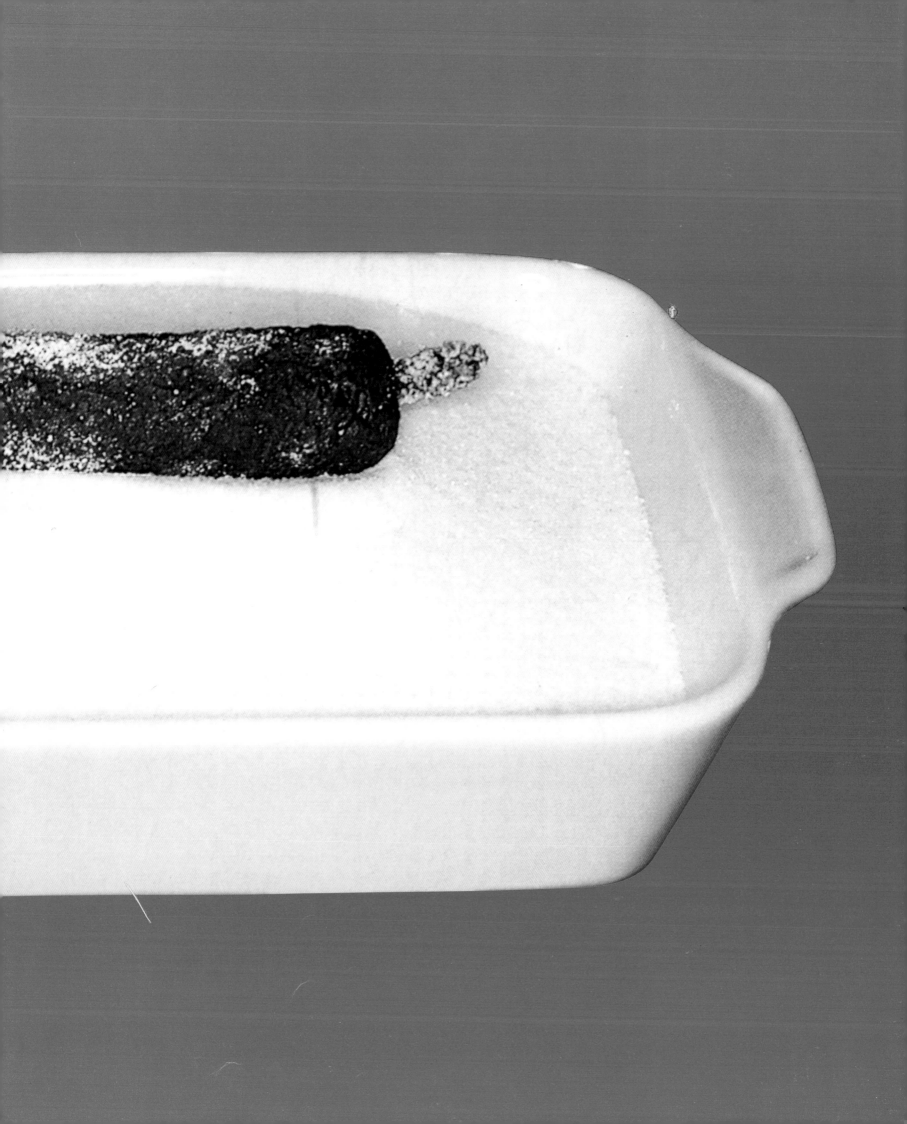

A Report to the Symposium
Will Self
Writing as 'Bill Self'

A poet is the most unpoetical of anything in existence, because he has no identity; he is continually informing (?) and filling some other body.

Keats

The venue chosen for this, the second symposium to be held on the discovery, had been prepared to accommodate the maximum possible number of delegates. At the earlier convocation only the most formed, the most incarnate were admitted.

The building was drum-like in shape, and enormous – some five hundred metres in diameter, a hundred metres high, and featuring a floor which sloped at an angle of twenty degrees towards the centre. The overall impression the venue gave was that it was a drainage tank, as yet unlinked to a waste system of incredible proportions.

Many of the delegates at the previous symposium had been critical of the building, finding in its smooth white surfaces and its imperceptibly curving walls the faintest traceries, the merest lineaments, of the identity of its builder. But the President had countered these objections, pointing out that as the venue had been purpose-built, there could be no worries about the corruption of Soul.

The funnel floor of the building was divided into five sections of equal size, and each of these sections was customised so as to allow for the convenient housing of the delegates. Thus, the first section featured an involved basketry of cushioned bafflers – many many thousands of them – into which the delicate extrudomorphs could fit. The second section, by contrast, was comprised of cubicular glass pods, into which the filaforms could tuck their latex lengths.

The third, fourth and fifth sections were of a piece with the allotropy they exhibited: four two-hundred-and-fifty-metre-long tracks – two sets of equal gauge – supported the wheels of the cabinets. These, on arriving at the outside wall of the building, were winched up, then insinuated through unloading bays. Deposited on the end of the tracks, they rolled down until housed by the accumulation of their fellows – like so many beads on a string.

Simultaneous translation facilities were arranged so that glass, latex, shit, blood, wine and water might communicate. For a while – until the President generated silence through the radiation of their congruence – the delegates burbled, pinged, snapped and slurped, the acoustic of this great barrel reverberating with their noise. But then there was nothing, save for the tintinnabulation of the extrudomorphs.

They had headed south – as the ancient texts dictated they should – into the empty zone. At first, progress was relatively easy, although the dried-out river beds were flagged with rubble, their gradients were level and their direction resolute. Where once water had coursed now the extrudomorphs flowed. Their silvered bodies broke up into individual plashes where the going was rough, then conjoined when the way was smooth. At night they gathered themselves together into a single, pulsing globe about ten metres in diameter and rolled beneath a rocky overhang. When the sun rose the following morning its rays would discover this mundane disc, reflecting its red glory back in thrown scintilla which smashed against the abandoned landscape.

The extrudomorphs headed south, switching from one river bed to another. Gradually the gaps of bled in between the desiccated troughs became broader and broader, and the river beds became shorter and shorter, until they were no more than scratches on the desert floor. Then, still further to the south, where vapid empyrean was bisected by irrelevant horizon, they saw the beginning of the dunes.

Even though the trip had been arduous – the extrudomorphs by their very nature having to formulate, then reformulate, then formulate again in order to advance – there had nonetheless been more than incidental pleasures. Phalloid found the continual surging forward answered a deep-lain need within him; and torsoid concurred. The smaller bloboids, blipoids, spermoids and dripoids were – unless combined – barely anoetic; while the head remained aloof.

Then there was the fact of abrasion against sand and mica, stone and gravel. Just as the sun bounced and shattered off their quicksilver progress, so the bled and then the dunes were pictured in their undulant undersides. The extrudomorphs were not unappreciative that what they were traversing here was a colossal reservoir of themselves as yet unformed, unrealised, unimagined; and they saw in themselves – themselves.

This was before the dunes had surrounded them, bit down on them with their carious peaks and extruded them through their unfilled troughs; and this was before the many metres had become thousands, then tens of thousands, then hundreds of thousands; and this was before they had reached the pseudomorphs.

The first ones would not have been noticed were it not for the starkness of the dunescape; its unrelenting smoothness. They were bloboid, or rather diplobloboid, in form. Atop one blob blobbed

could be into the corners, but the *pseudomorphs*,' and his gibe and gyre increase, 'are figures rotated around a mean so as to leave psychic impressions within the Polydimethylsiloxane. And this was done seriatim. The harbinger pseudomorphs came first – then the garden, this is the method. The intentionality is all of it and so sad, so unutterably sad. My biopsy samples, the twists of shit head on the hard silica of the desert floor, the wind amongst the carious canyons, all parts of a definite pattern definitely disrupted. Get this right: the garden is no exercise, but is *is*, standing into being, basic *esse*, and the espaliered filiform is correct in this much: darkness does spread itself on the plain air of our world more in strips than sorrow.' Moisture gathered in the cratered bash uppermost near to shit head's brow place. The President whistled Tlon Uqbar.

The blood heads clacked into one another on their tracks, never been Newtonian cradle expressing inHumean conception: identity transmitted from billiard ball to billiard ball like inertia, a five year plan interpreted by the President thus: 'First came mould like me, then mould like you, shape that was not shape within shape that might yet define shape, you follow me?' Too static for this. 'These in one dimension, or if two only poorly raised, a crust of pseudomorphic stuff, no fun, not ever. These shapes, bifurcated then rotated about the mean, immensely popular, symetriad, asymetriad, for many aeons – no need to differentiate. No need to consider isomorphism – why would we, we who are wholly negative? And then someone adds cabinet, adds container, supplies framed referent within and of itself and so isomorphism crowds round us, shoots through us. Shit head parhelion. I yearn for you all in your five years, in your cracked jowls bleeding Polydimethylsiloxane. Your cracks like pin holes suck through uninterpretable view that is unseen and unknown. Poor blood heads – doomed five year plan, you may never run for president. Where in this dielectric desert can you find relief from viscosity, from eternal slipperiness? Where might you find friability? Where might you effect cohobation? No grip on the grip within; no sight of seeing. For you, my dear, dear blood heads, there can be no proprioception of less save than proprioception and no shavings nor neither – I laud your dirty protest against incarnation. Carry on!'

Smacking back one on one the blood heads withdraw up the tracking and plop one on one out through the loading bay and wheel south once more, sent on a lovelorn mission by the President to discover the lost heart of their own lack of now; the pumping pistil that might yet flower. When they are gone the drum reverberates with the threat of their passage and all is silent save for that unceasing whicker and whistle of rubber on paint, the shit heads' nervousness, the bowels' fear of the colon: the writer's fear of the copula – and – the President's fear of a move to continuance, which came, sure enough, from the forms of blood and wine.

'Inverted transubstantiation,' pedantic to the end they sluiced and slooshed, 'can only be seen as the evidential basis of the garden. To turn life – a novel concept for you we know, animated sentience does not cover it not now, nor never – into death and imprison it thus: subject to instantaneous decay once the transparent tegument is ruptured, Polydimethylsiloxane flowing out of cracks, running rivulets on banks of pulverised shit head. Like us. Made not born, reinvigorated by Burgundy and given pseudo-morphic status – it is with the garden, we abjure you. We stand here, orreries for non-eternal, non-cosmological, internal investigation of a journey to the end of the colon. We fear it just as shit head does—' They were gone into thin plasma. Into misty substantiality. Into themselves.

And all is silent save for that unceasing whicker and whistle of rubber on paint, the shit heads' nervousness, the bowels' fear of the colon: The President generated silence through the radiation of their congruence – the delegates burbled, pinged, snapped and slurped, the acoustic of this great barrel reverberating with their noise dying away into a negative feedback loop of feedback, the President said: 'My status is the President, mould of moulds, impression of impressions, look into my vacuities and disintegrate. In the desert and all about nothing else remains save for the pseudomorphs you may not read – not now, nor ever. You have not isomorphism, you have not now, nor never. You have blood and wine and water and shit and filoform and extrudomorph, you have that now, and forever. Nothing else remains save for the pseudomorphs you may not read. You have failed what might have been yourselves and hence disappeared into pulverised shit head. So be it. Look upon your failed industry and despair.'

In the big vacuum left by the passage of the President's vacuity there was naught save for that whistle and whicker and a sinuous squeak as shit head did another biopsy, drilling for evidence of self.

London, February 1998

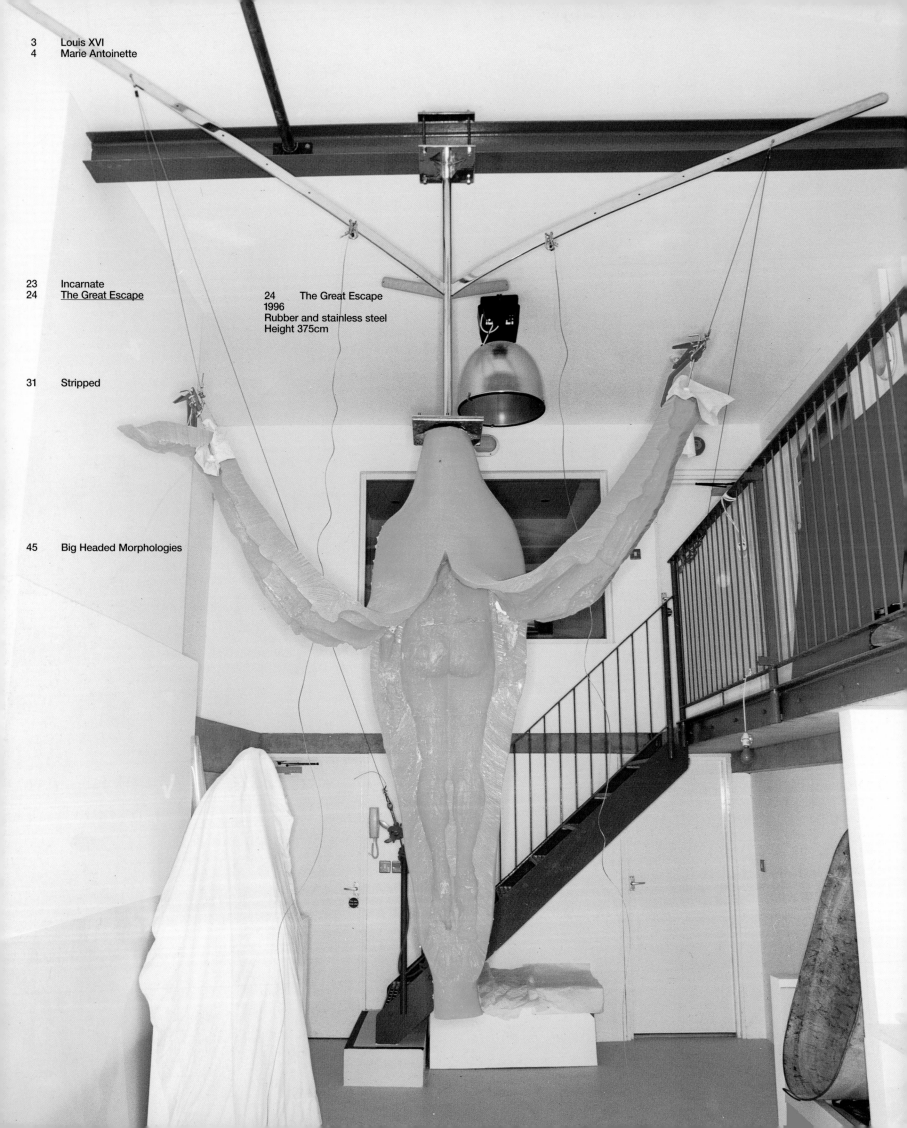

24 The Great Escape
1996
Rubber and stainless steel
Height 375cm

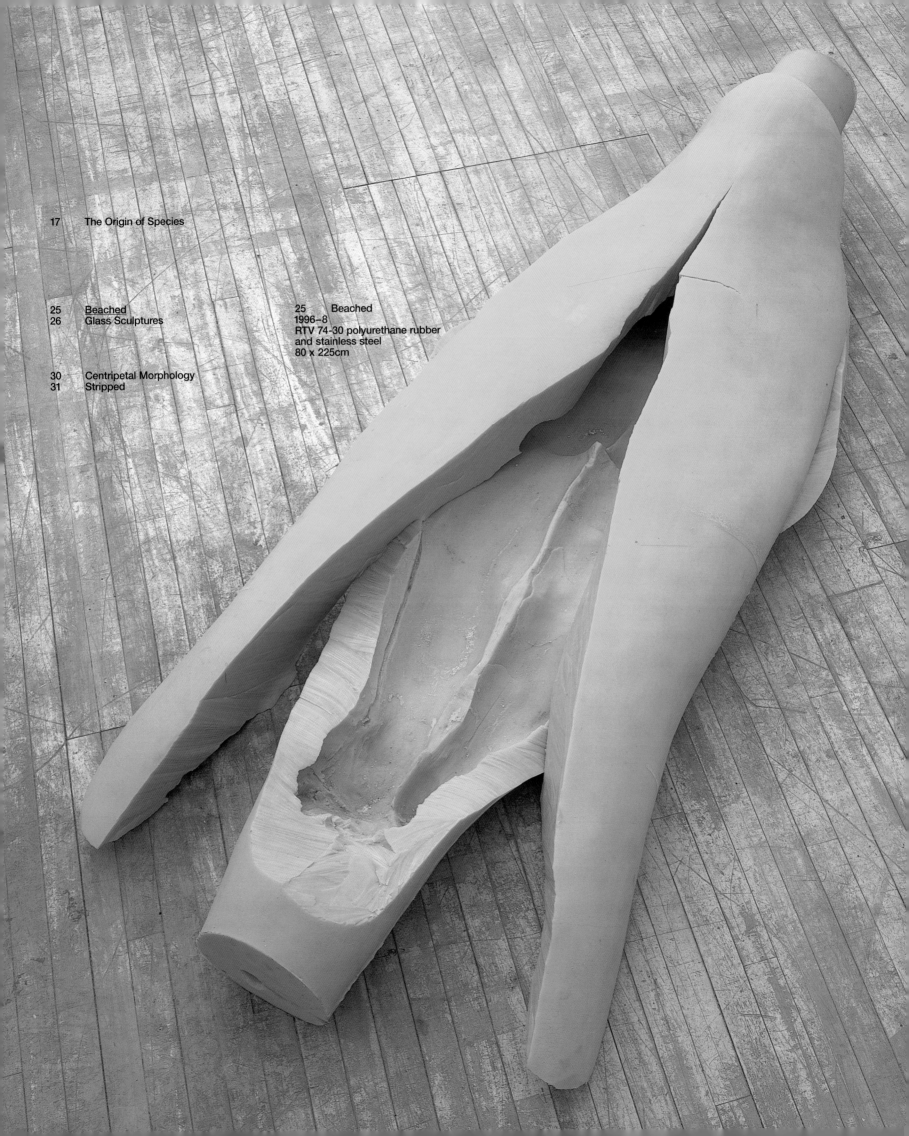

25 Beached
1996–8
RTV 74-30 polyurethane rubber
and stainless steel
80 x 225cm

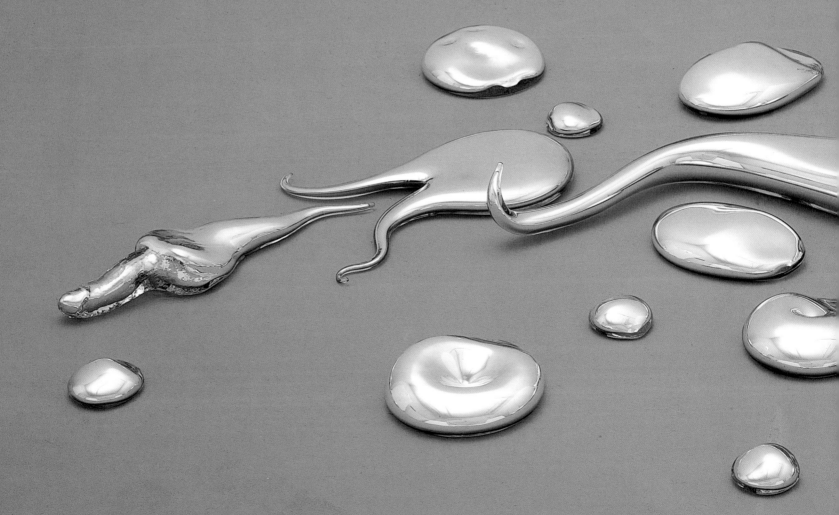

26 The Etymology of Morphology
1996
Glass and silver
Approx. 180 x 120 x 25cm

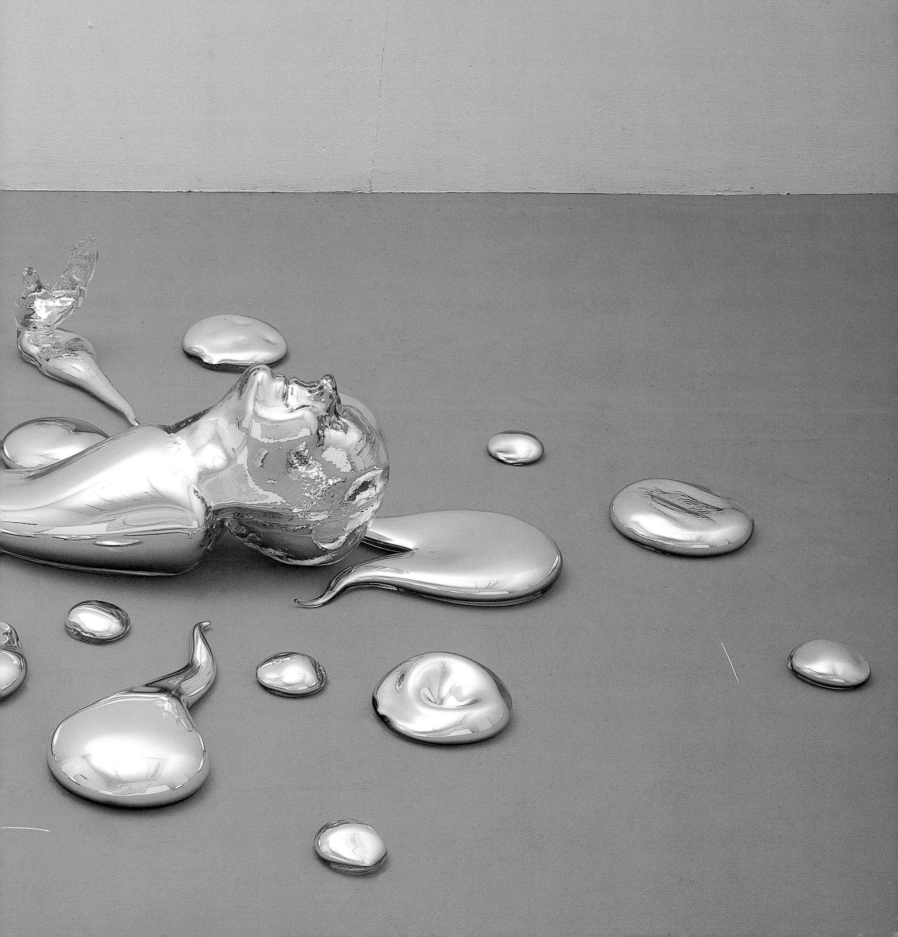

27 Lindow Man.
Remains of an ancient human
body found in a bog.

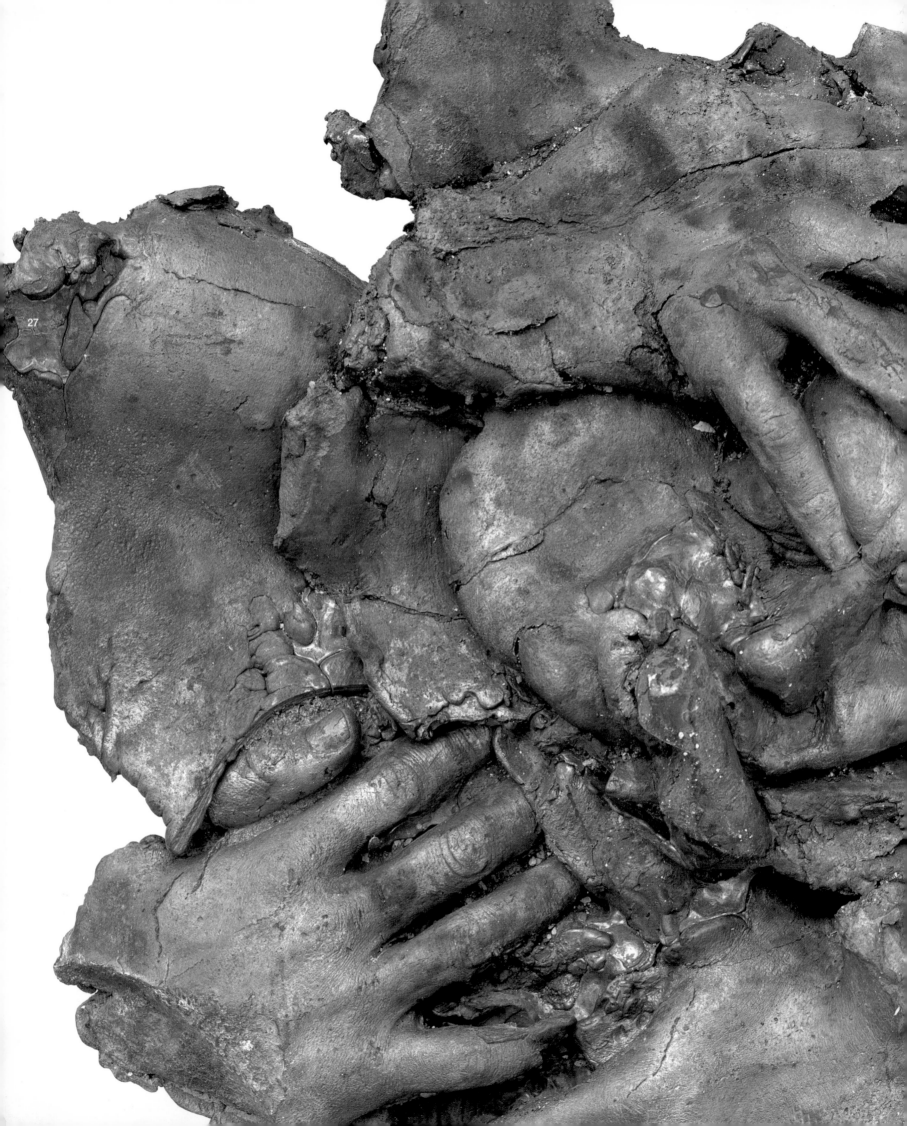

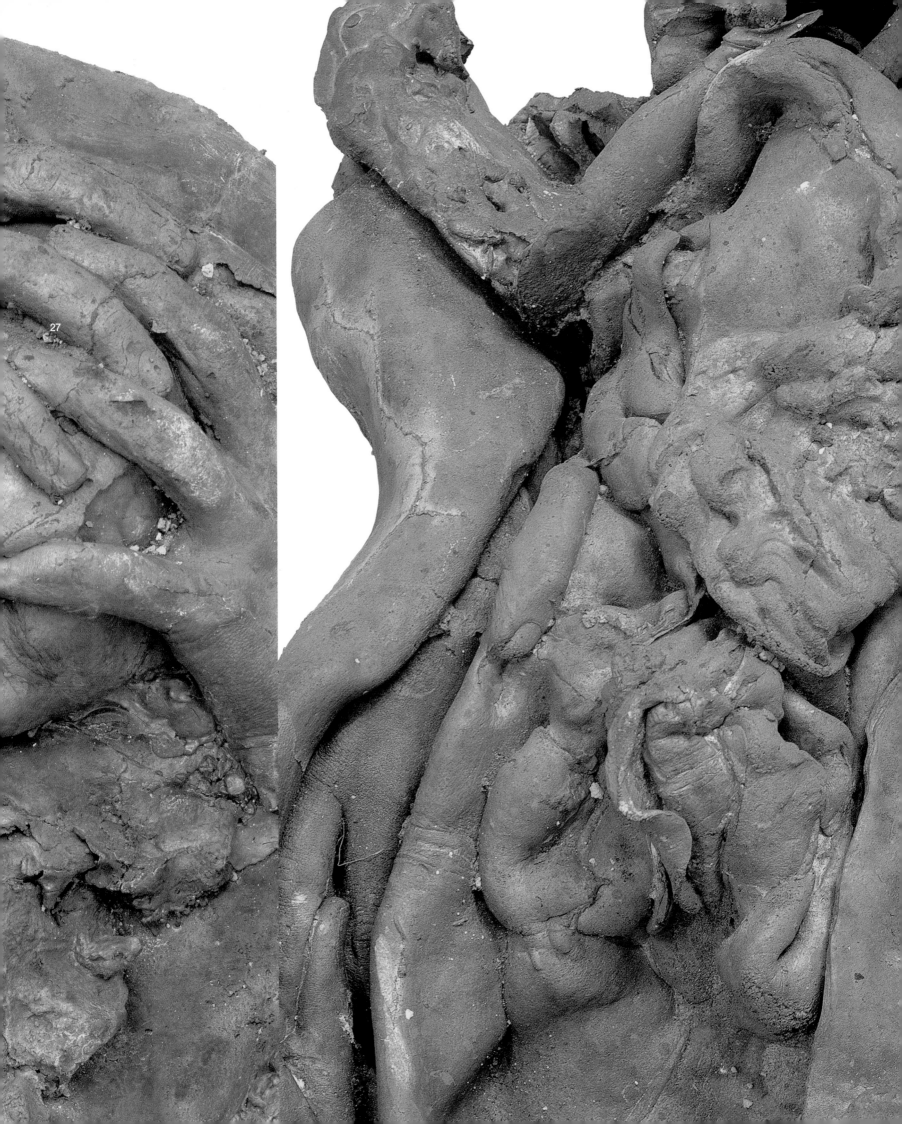

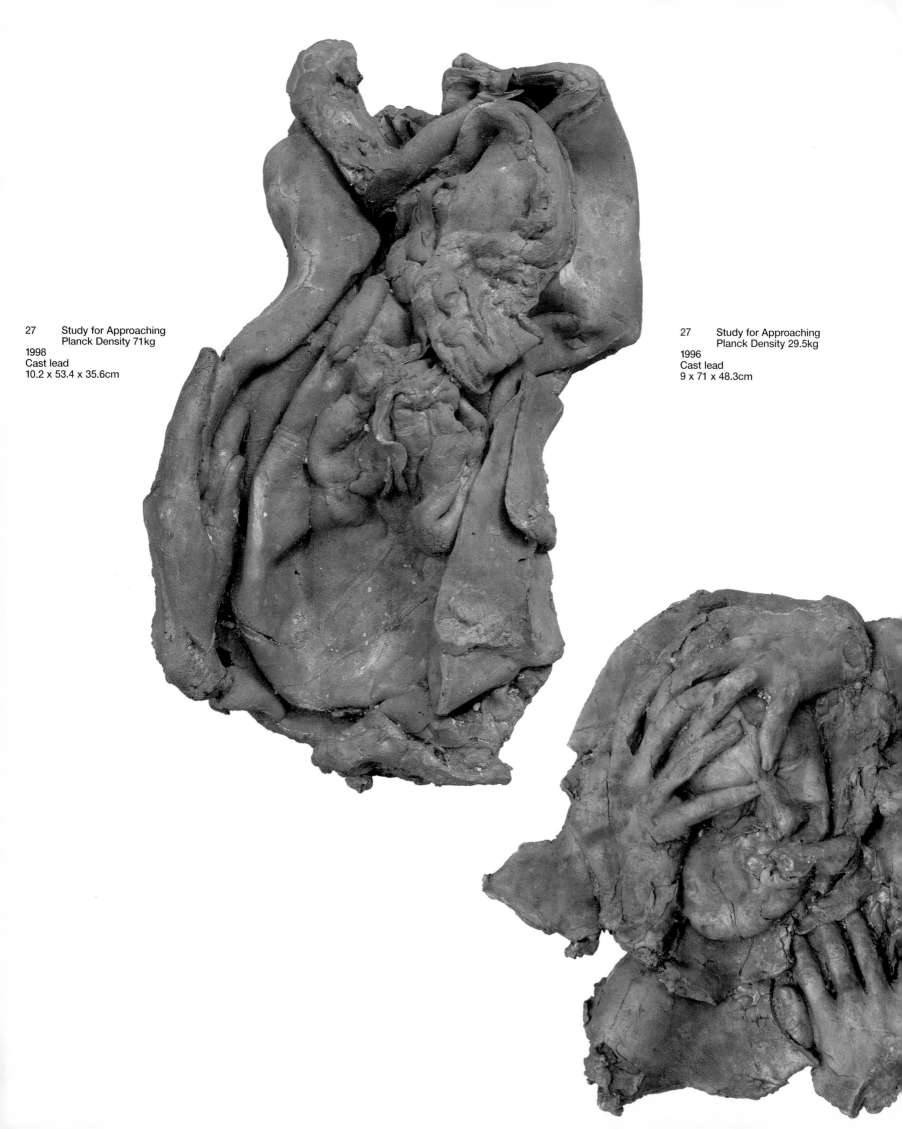

27 Study for Approaching
Planck Density 71kg
1998
Cast lead
10.2 x 53.4 x 35.6cm

27 Study for Approaching
Planck Density 29.5kg
1996
Cast lead
9 x 71 x 48.3cm

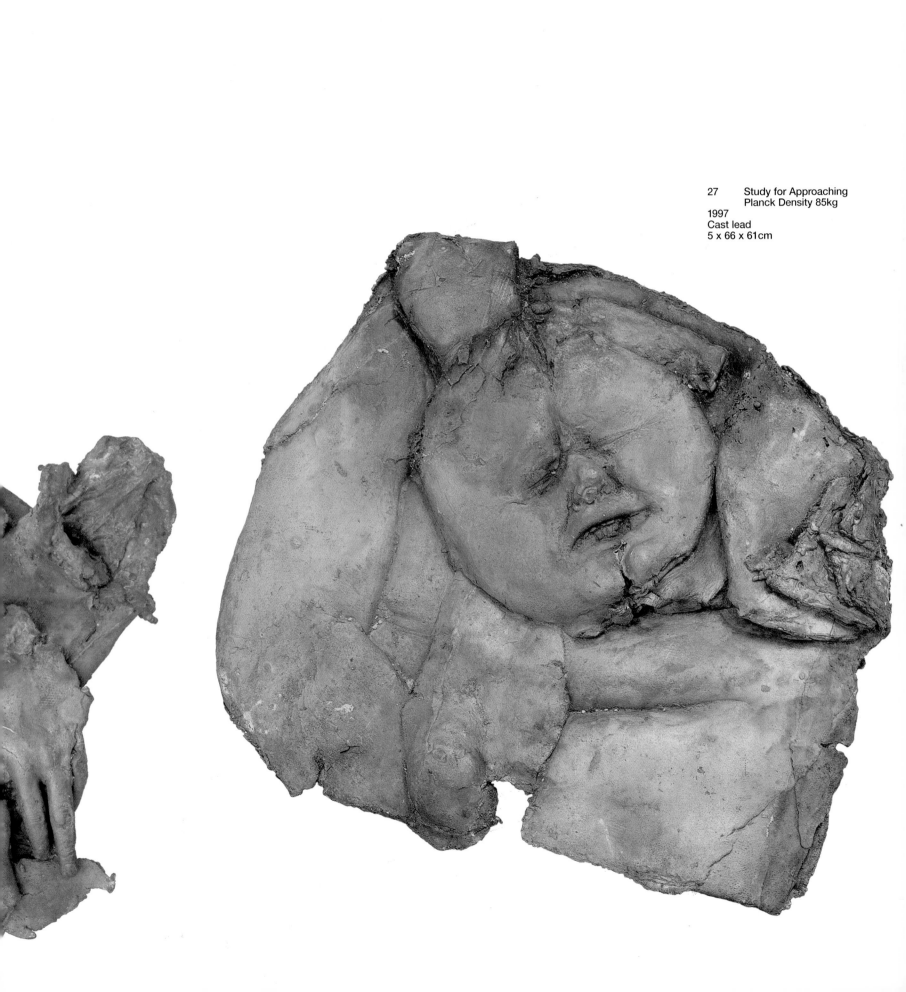

27 Study for Approaching
Planck Density 85kg
1997
Cast lead
5 x 66 x 61cm

27 Study for Approaching
 Planck Density 82.75kg
1998
Cast lead
57 x 50 x 15cm

27 Study for Approaching
 Planck Density 63.75kg
1998
Cast lead
66 x 39 x 16cm

27 Study for Approaching
 Planck Density 62kg
1996
Cast lead
71.2 x 48.3 x 9cm

27 Study for Approaching
 Planck Density 66kg
1998
Cast lead
50.8 x 48.3 x 10.2cm

27 Study for Approaching
 Planck Density 62.5kg
1998
Cast lead
54 x 40 x 16cm

27　　Study for Approaching
　　　Planck Density 64.5kg
1998
Cast lead
13 x 67 x 44cm

27　　Study for Approaching
　　　Planck Density 59kg
1996
Cast lead
8 x 84 x 47cm

27　　Study for Approaching
　　　Planck Density 78kg
1996
Cast lead
9 x 71.2 x 48.3cm

27　　Study for Approaching
　　　Planck Density 64kg
1996
Cast lead
9 x 71.2 x 48.3cm

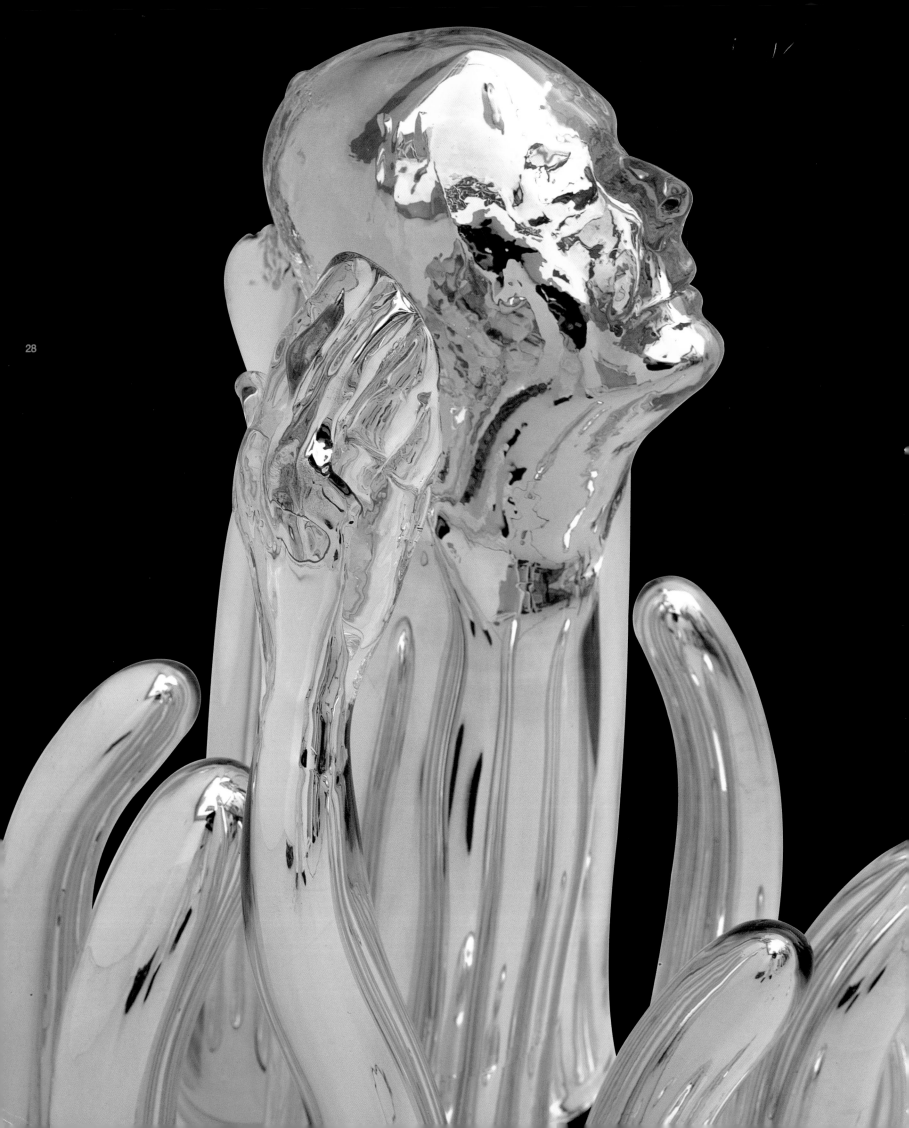

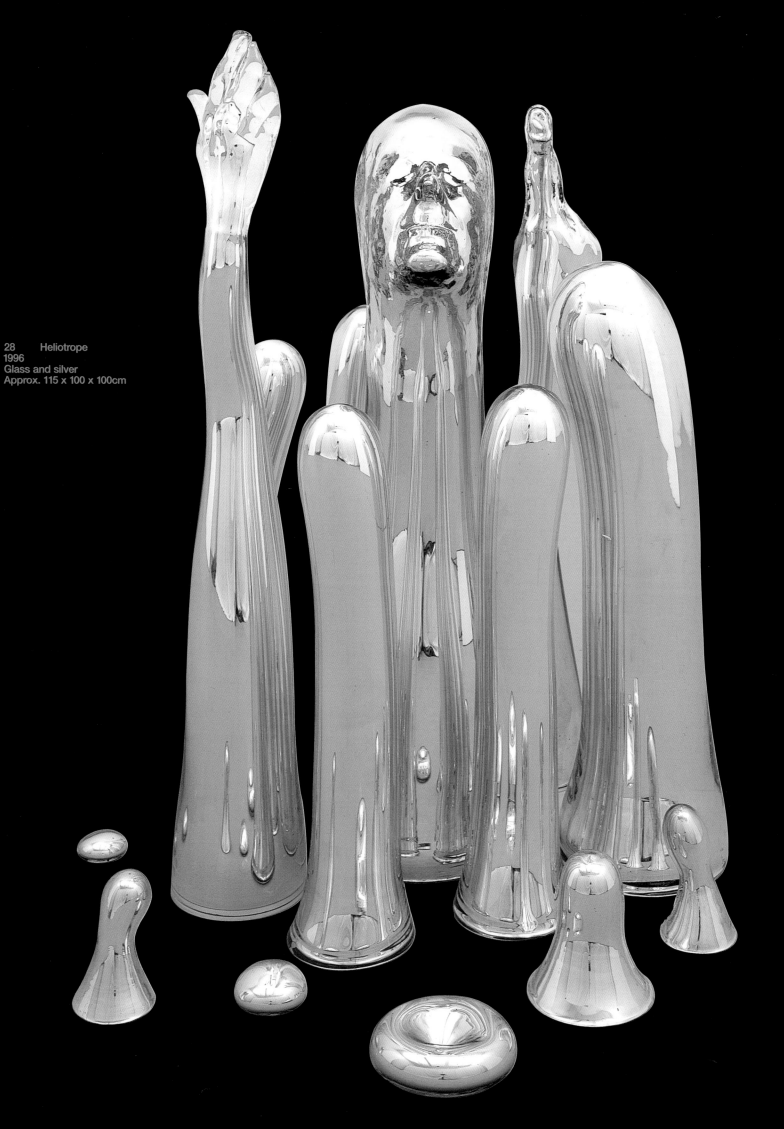

28 Heliotrope
1996
Glass and silver
Approx. 115 x 100 x 100cm

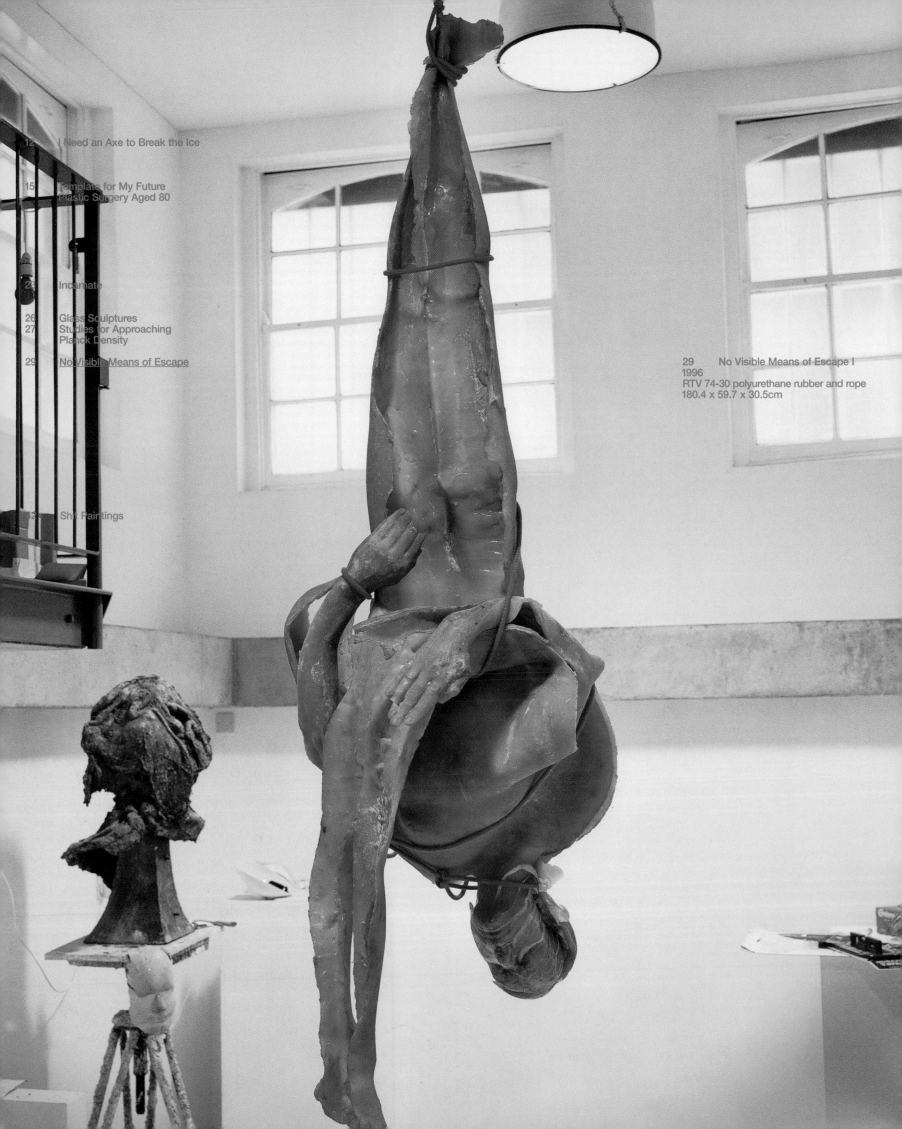

29 No Visible Means of Escape I
1996
RTV 74-30 polyurethane rubber and rope
180.4 x 59.7 x 30.5cm

29 No Visible Means of Escape II
1996
RTV 74-30 polyurethane rubber and rope
183.4 x 74 x 30cm

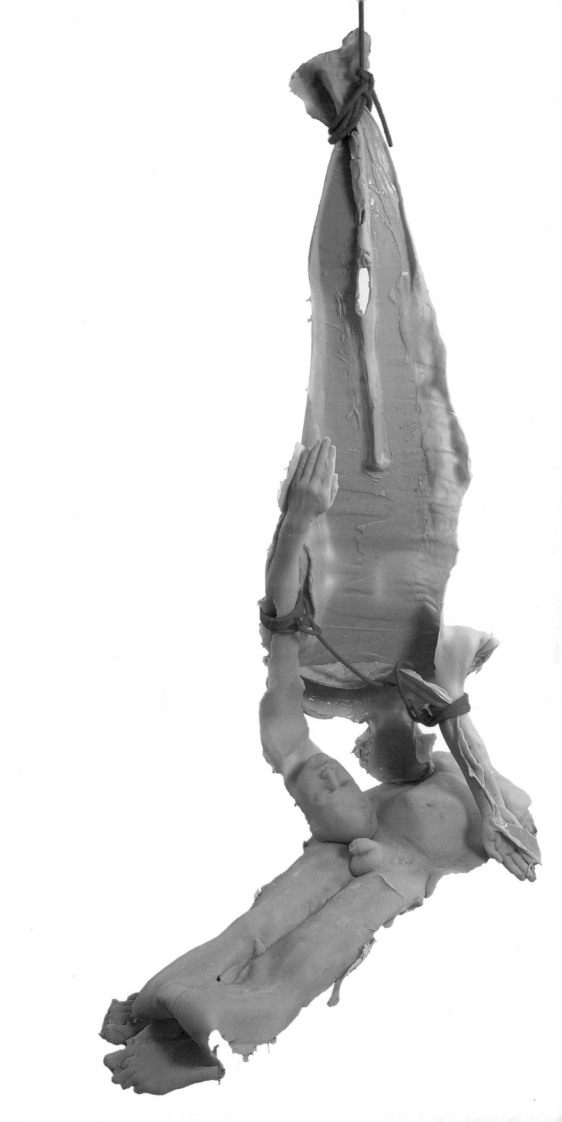

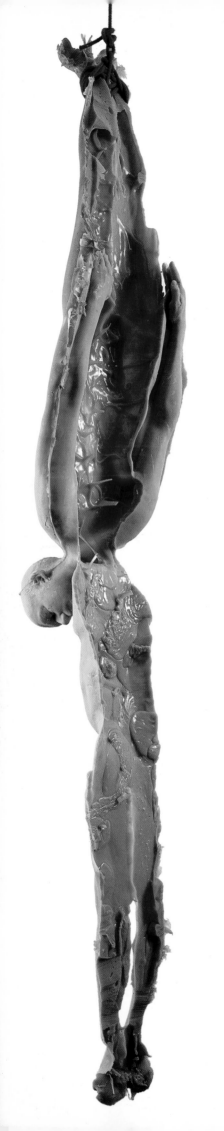

29 No Visible Means of Escape III
1996
RTV 75-60 polyurethane rubber and rope
348 x 80 x 23cm

29 No Visible Means of Escape V
1996
RTV 75-60 polyurethane rubber and rope
350 x 80 x 23cm

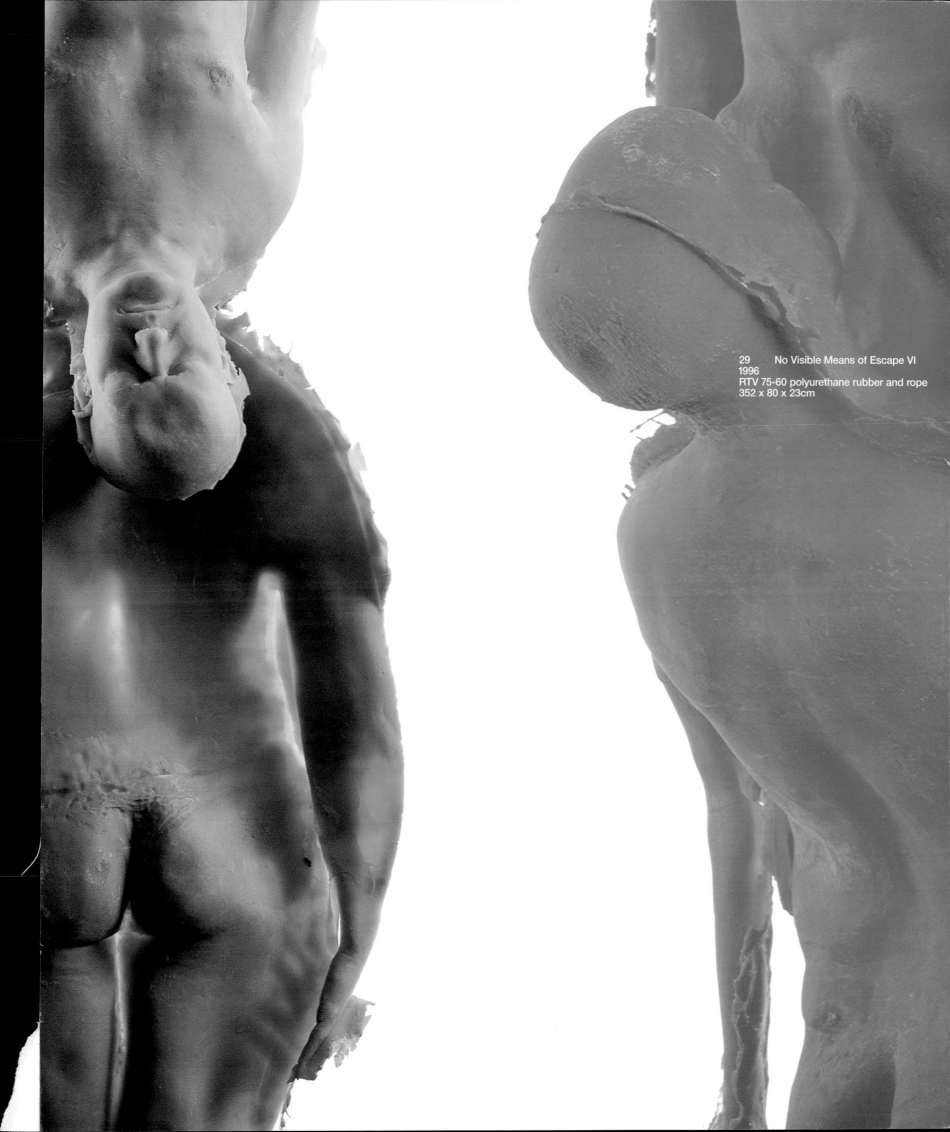

29 No Visible Means of Escape VI
1996
RTV 75-60 polyurethane rubber and rope
352 x 80 x 23cm

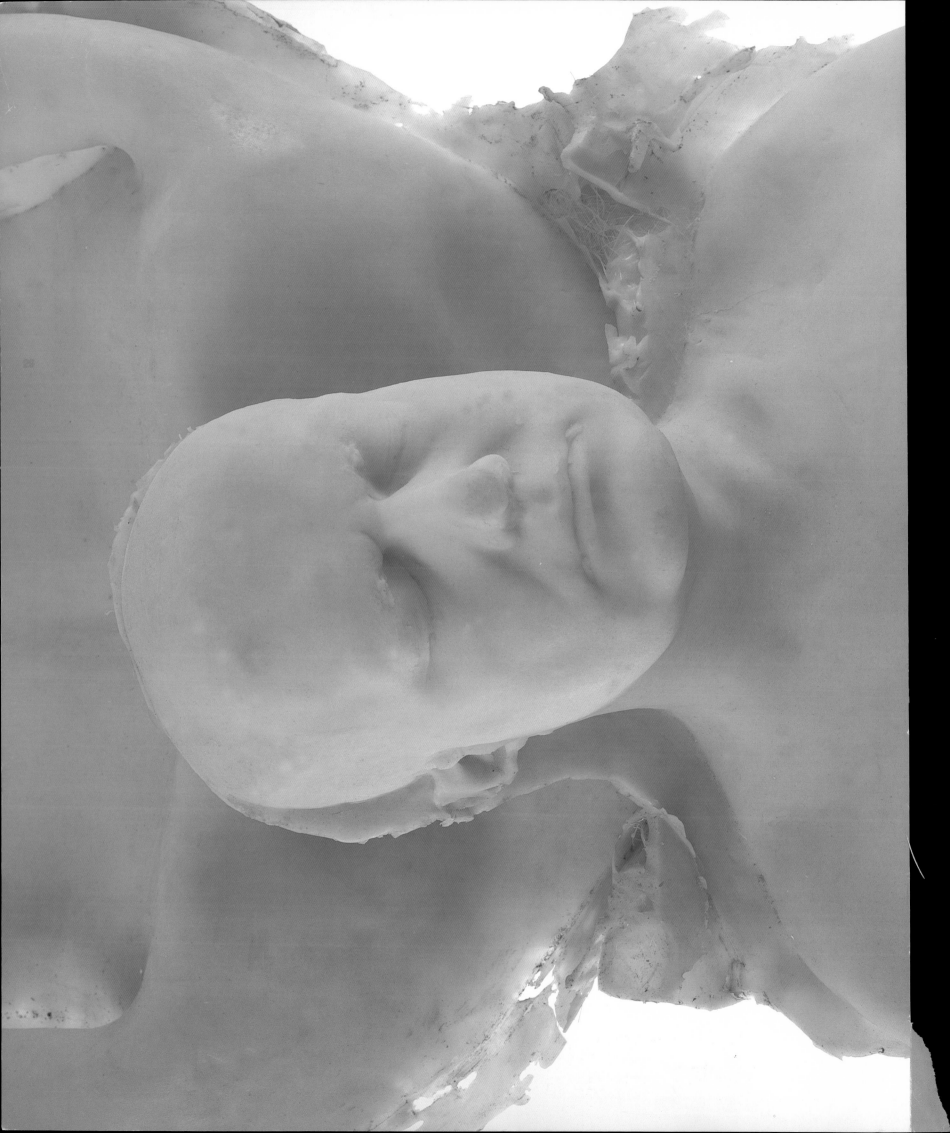

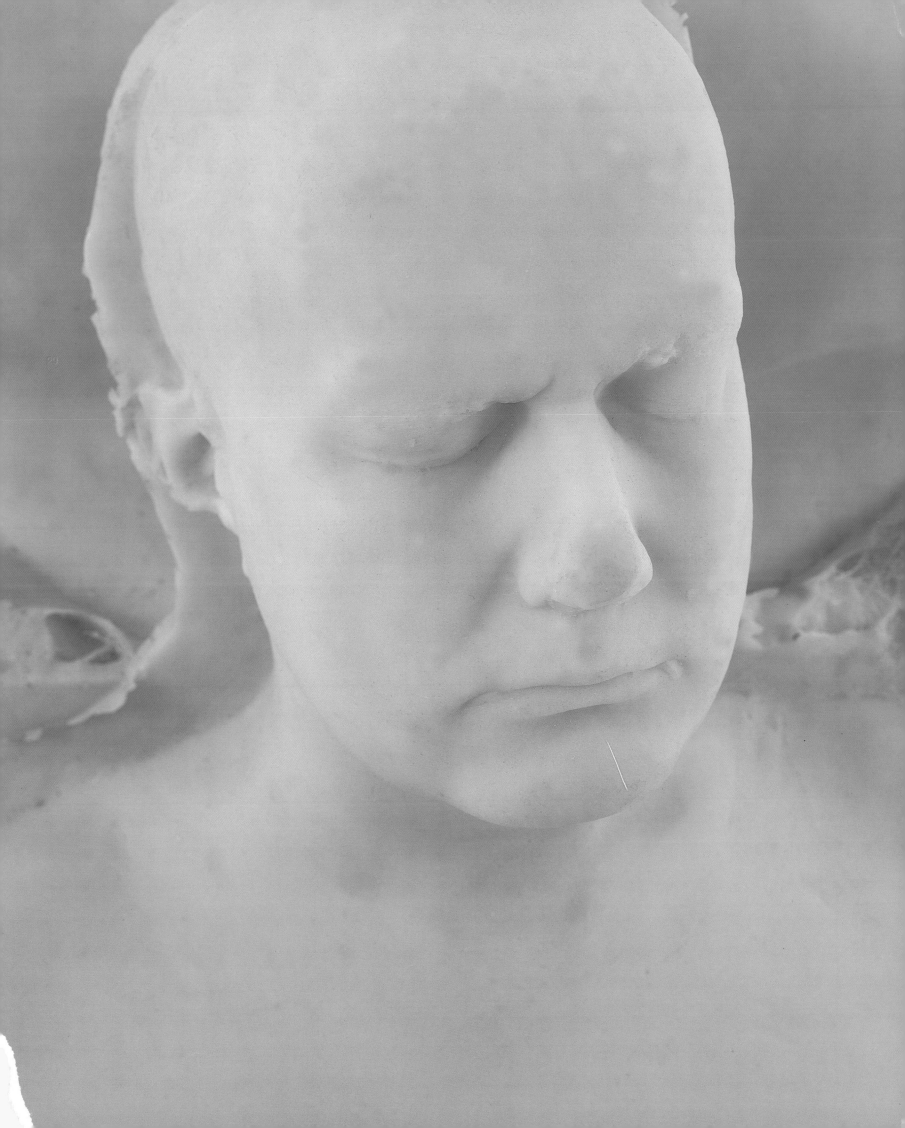

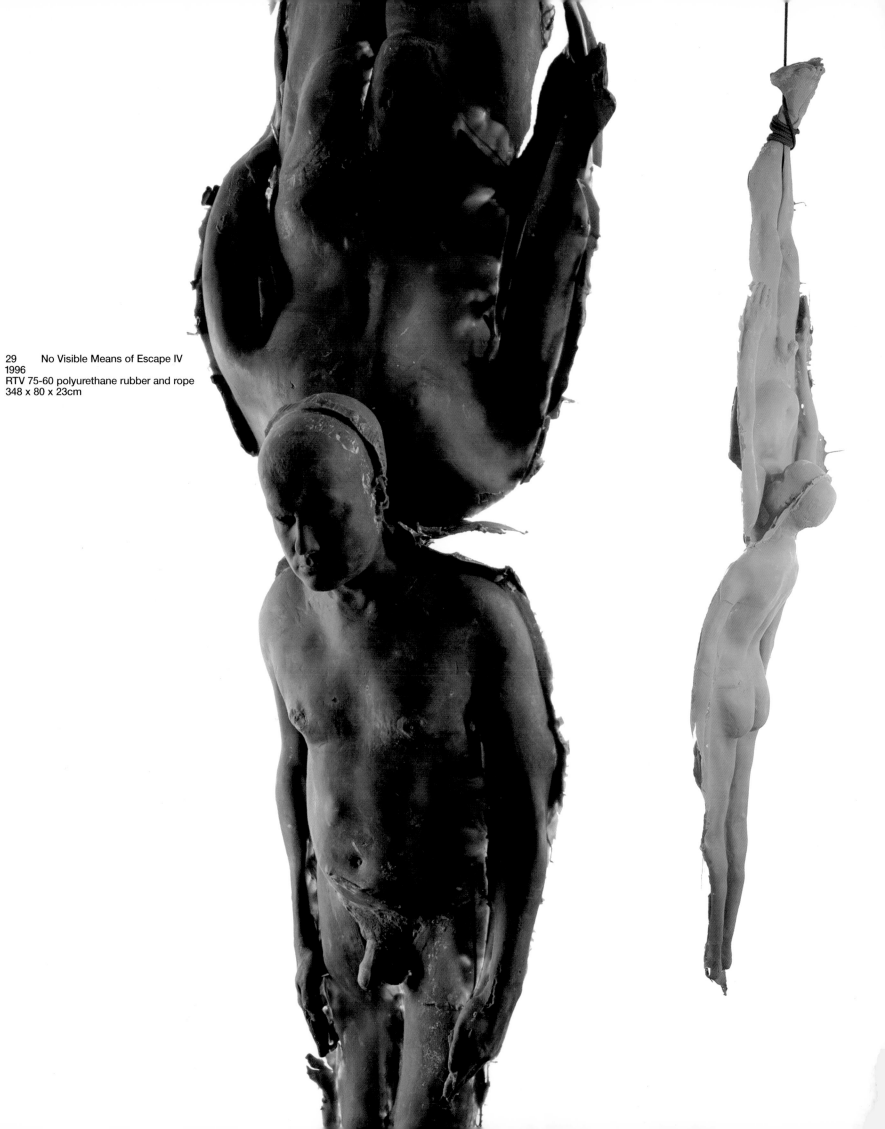

29 No Visible Means of Escape IV
1996
RTV 75-60 polyurethane rubber and rope
348 x 80 x 23cm

29 No Visible Means of Escape VIII
1997
RTV 75-60 polyurethane rubber and rope
350 x 80 x 23cm

29 No Visible Means of Escape XI
1998
RTV 75-60 polyurethane rubber and rope
352 x 80 x 23cm

30 Centripetal Morphology
1996
Glass and silver
240 x 150 x 43cm (19 parts)

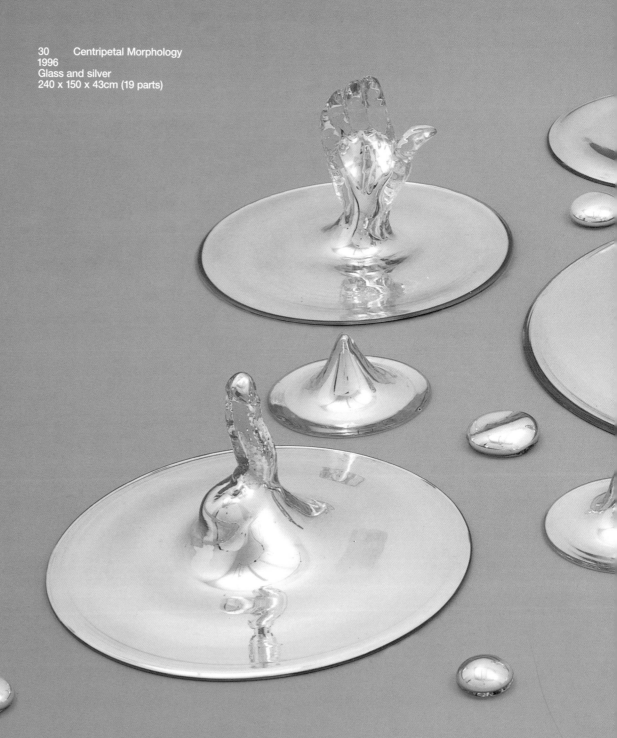

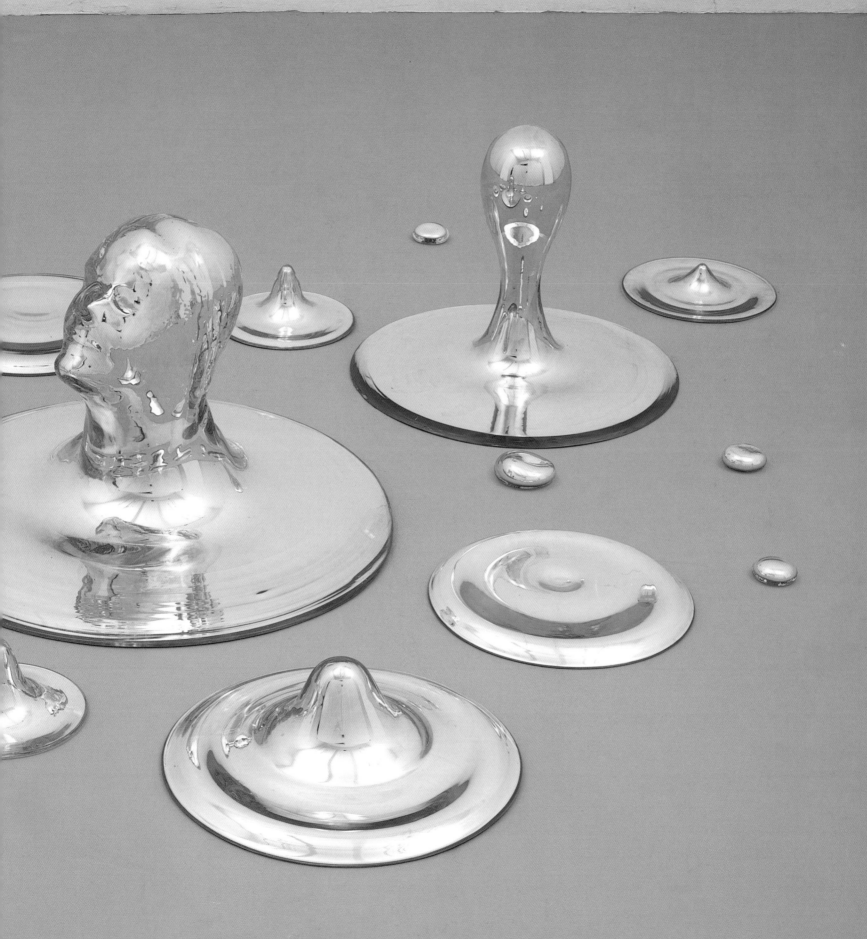

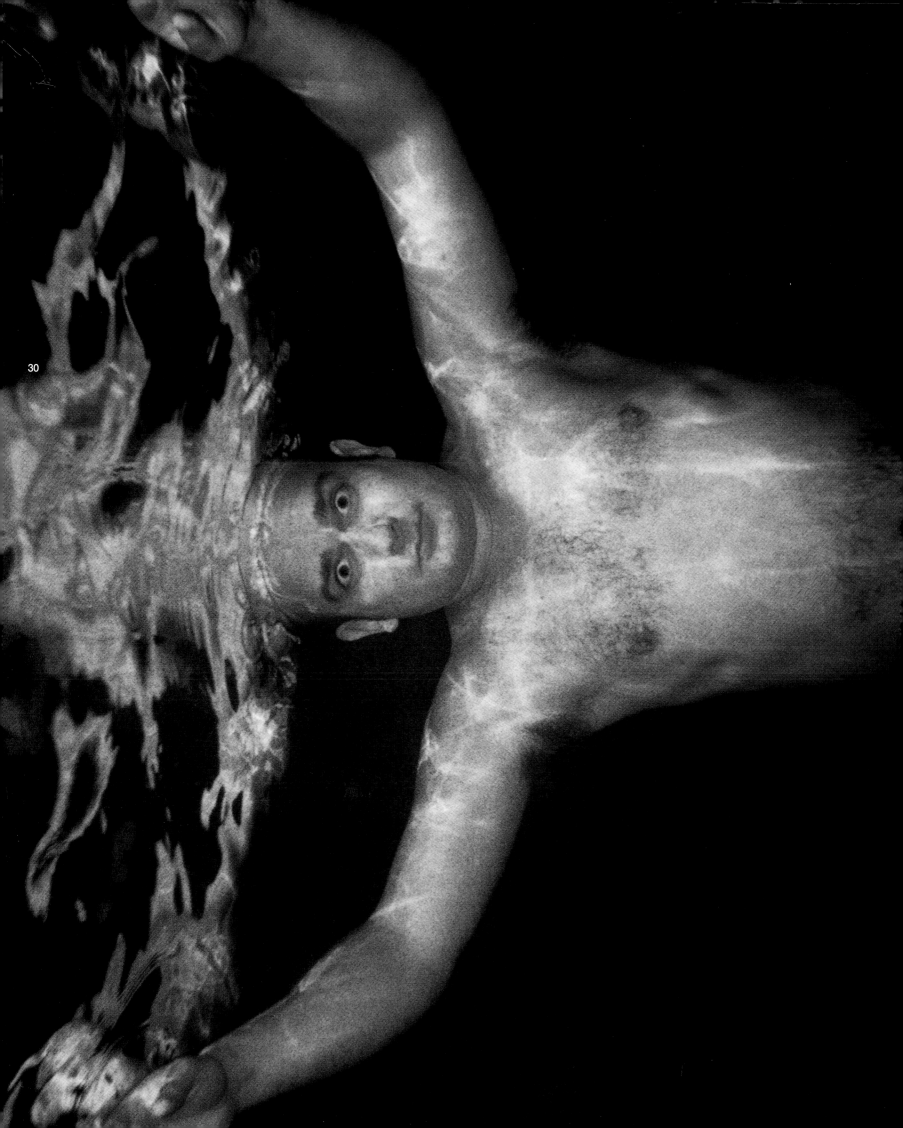

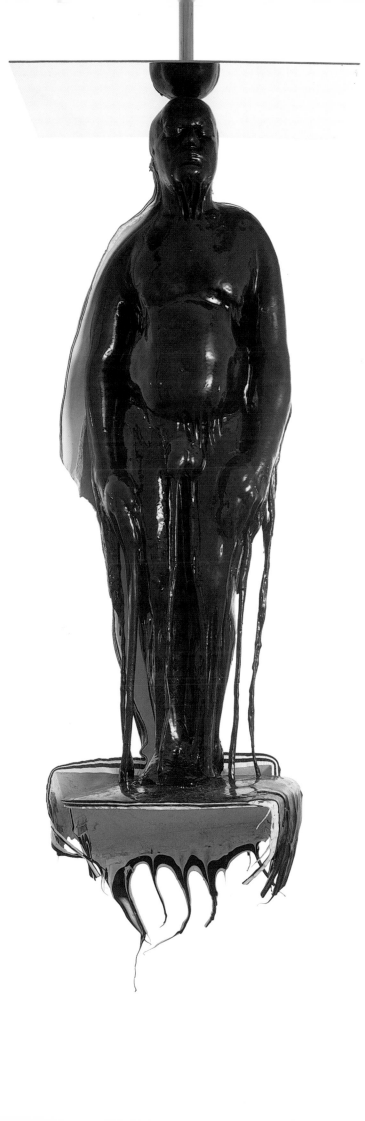
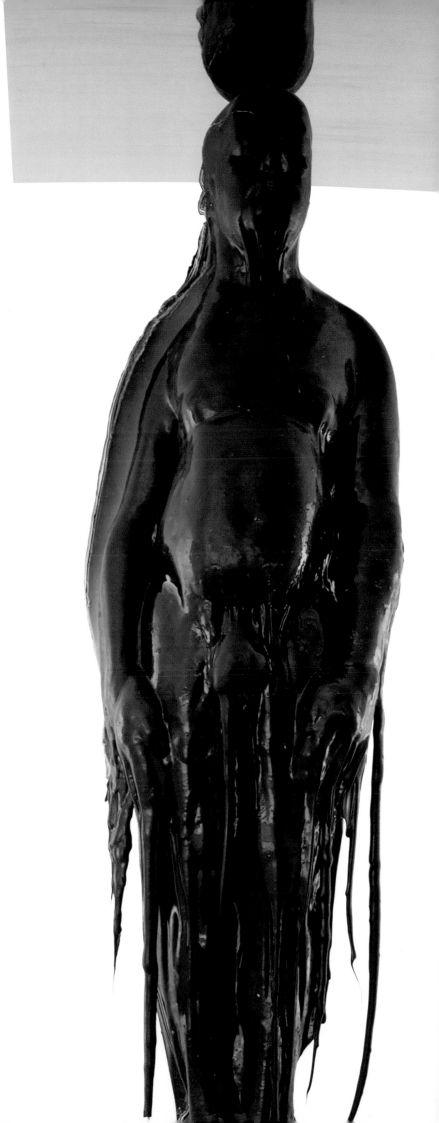

31 Stripped Monochrome (BW)
1997
RTV 75-60 polyurethane rubber
and stainless steel
Figure height 230cm

31 Stripped Monochrome
1996
RTV 75-60 polyurethane rubber
and stainless steel
Figure height 225cm

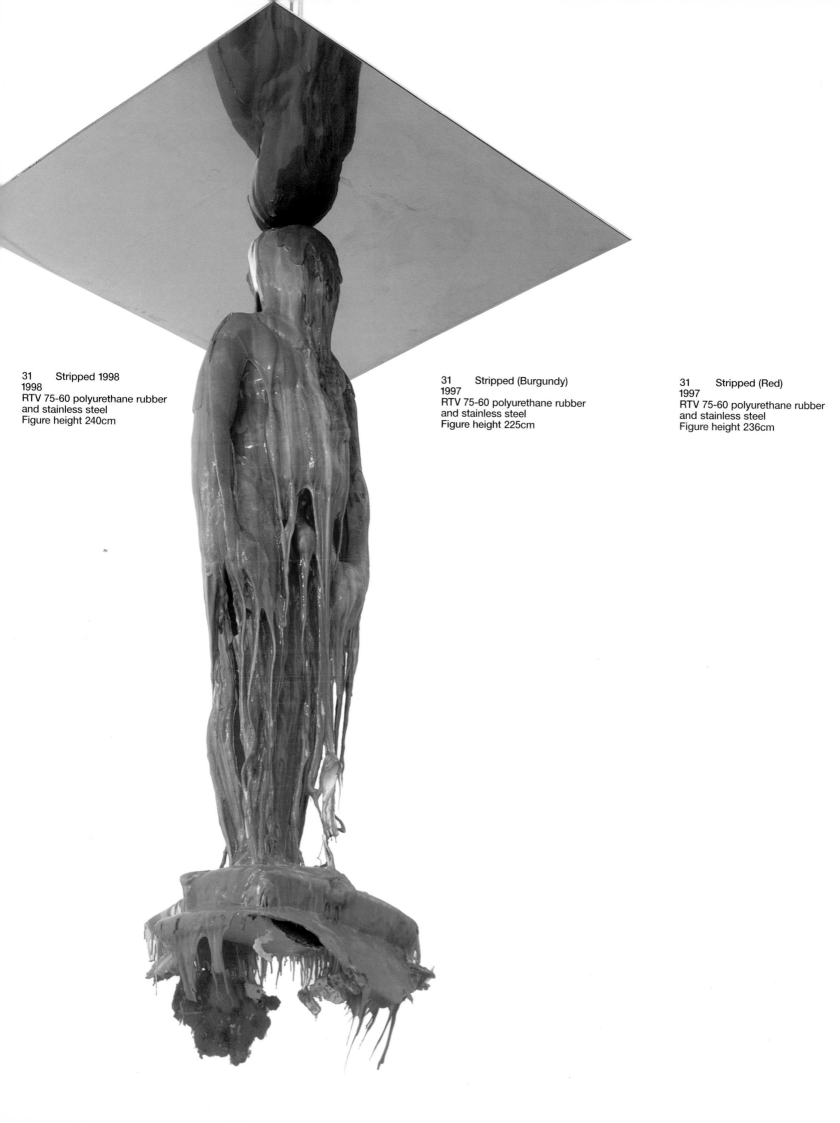

31 Stripped 1998
1998
RTV 75-60 polyurethane rubber
and stainless steel
Figure height 240cm

31 Stripped (Burgundy)
1997
RTV 75-60 polyurethane rubber
and stainless steel
Figure height 225cm

31 Stripped (Red)
1997
RTV 75-60 polyurethane rubber
and stainless steel
Figure height 236cm

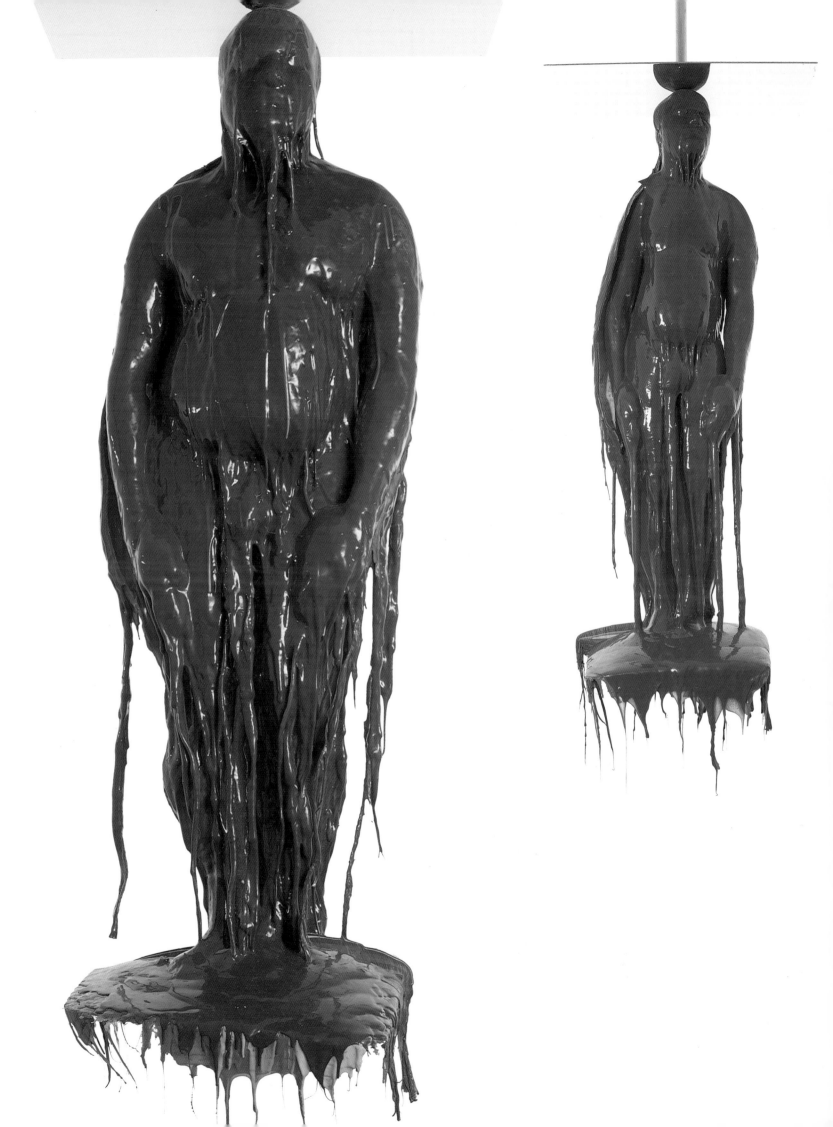

32 Eternal Spring Sunflowers I
1998
Stainless steel, glass, frozen silicone,
sunflowers and refrigeration equipment
219.7 x 90 x 90cm

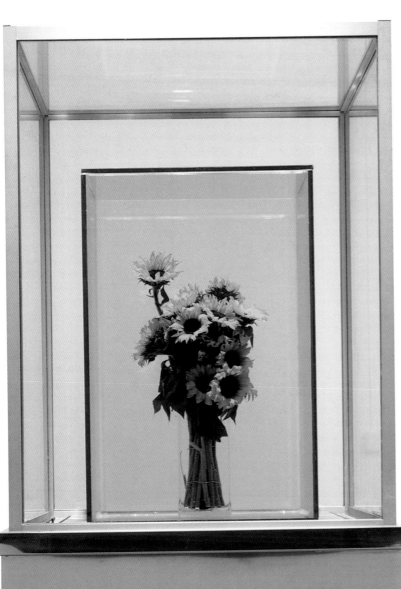

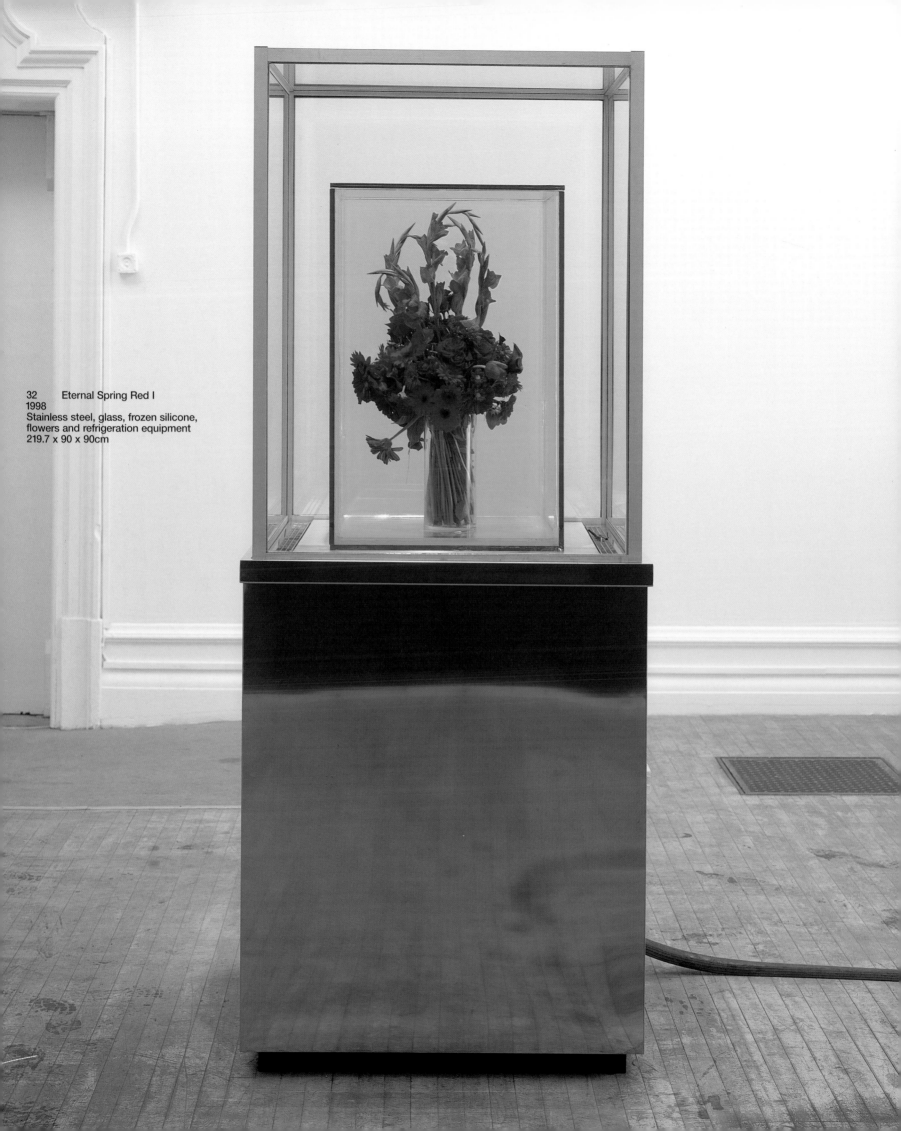

32 Eternal Spring Red I
1998
Stainless steel, glass, frozen silicone,
flowers and refrigeration equipment
219.7 x 90 x 90cm

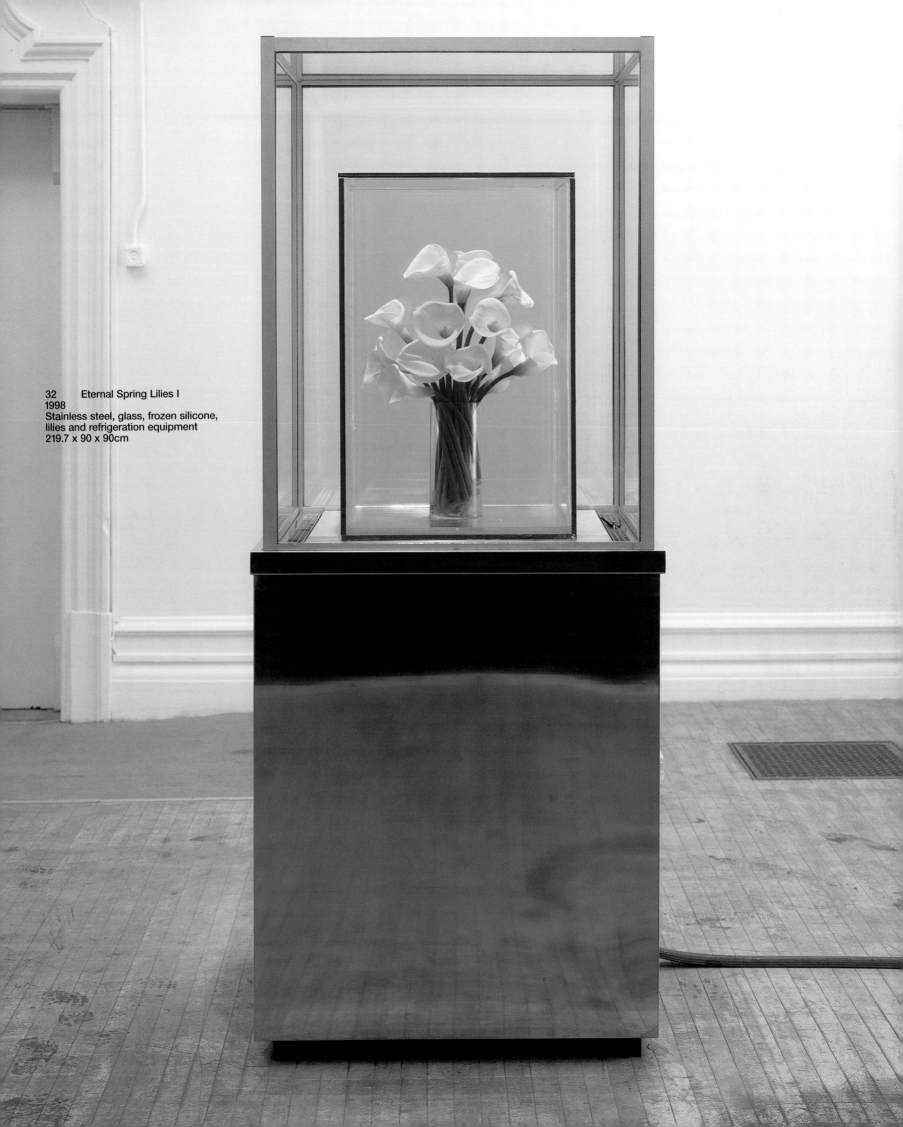

32 Eternal Spring Lilies I
1998
Stainless steel, glass, frozen silicone,
lilies and refrigeration equipment
219.7 x 90 x 90cm

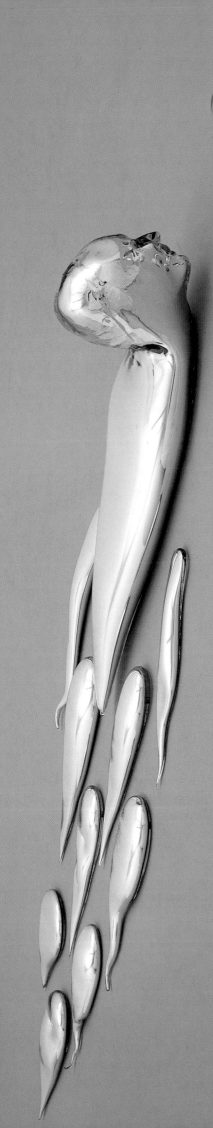

33 Blind Still Leading the Blind
1996
Glass and silver
290 x 65 x 30cm (11 parts)

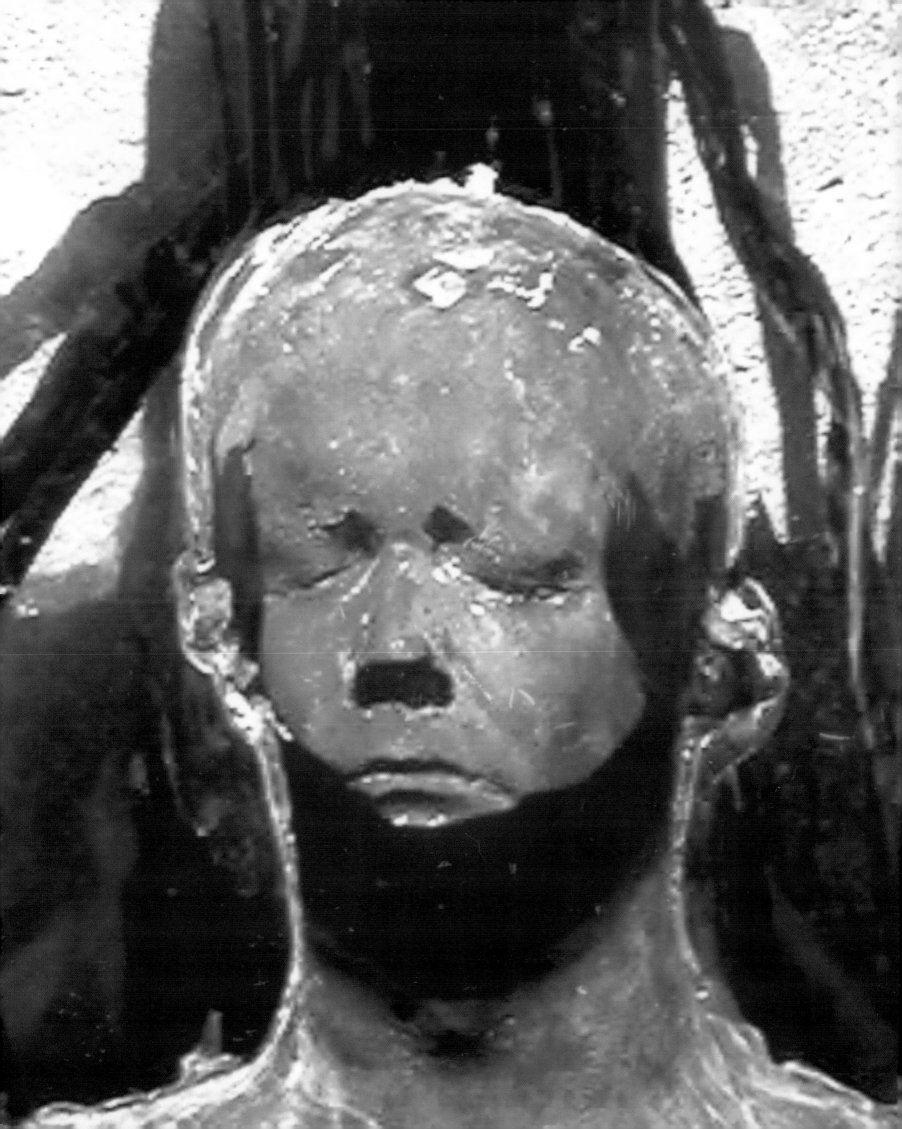

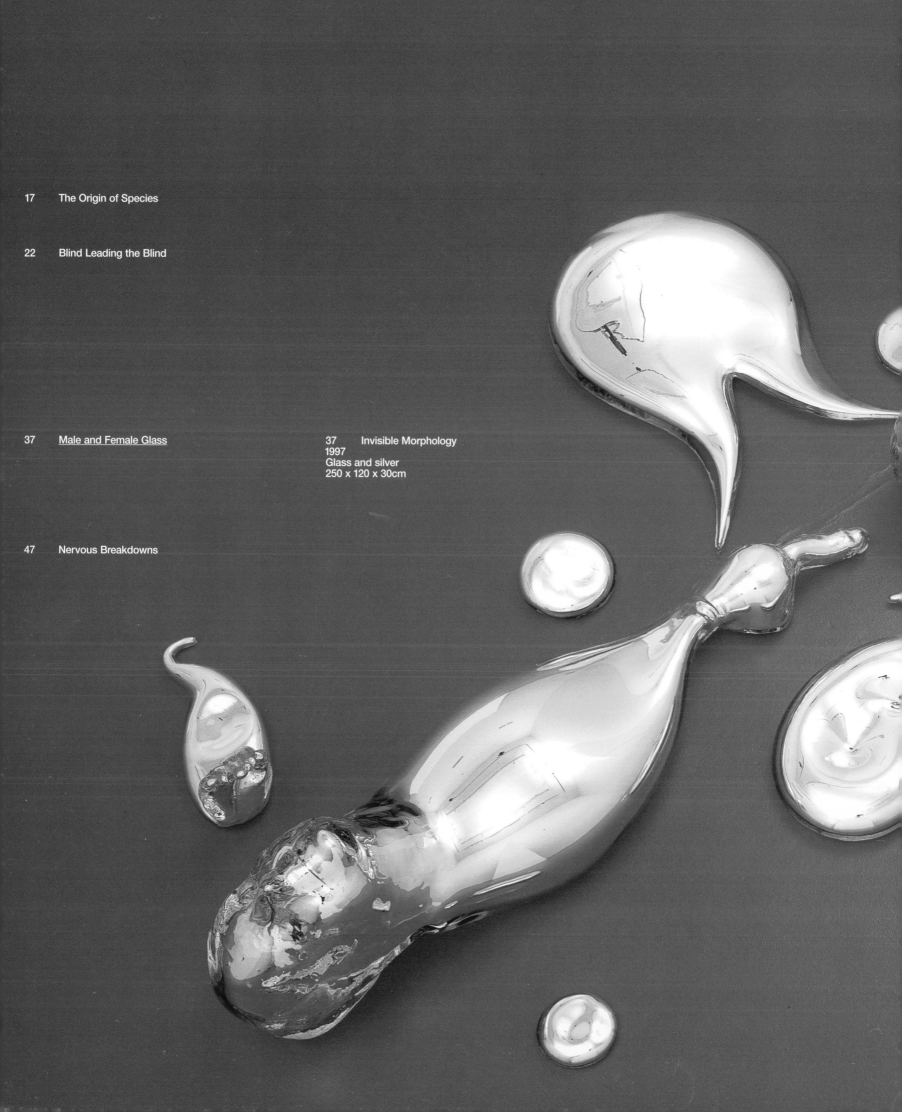

37 Invisible Morphology
1997
Glass and silver
250 x 120 x 30cm

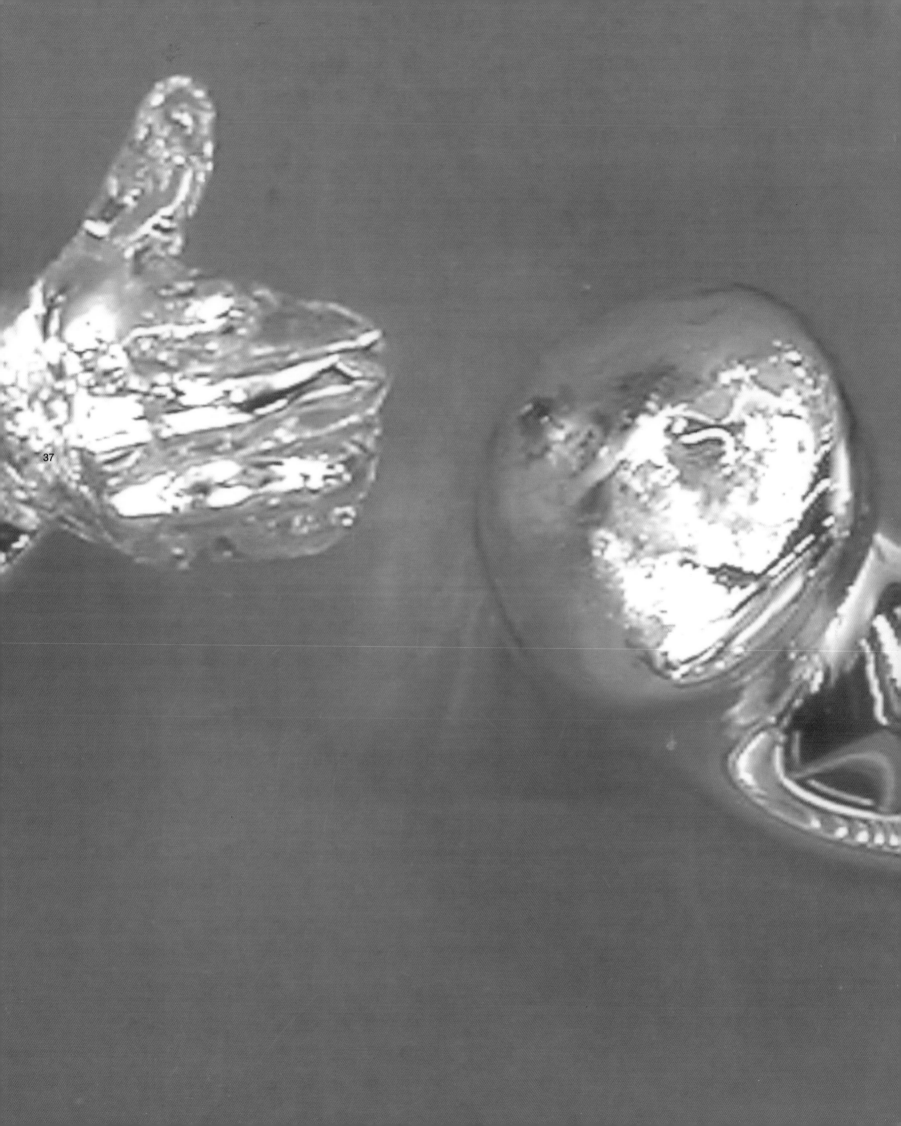

37

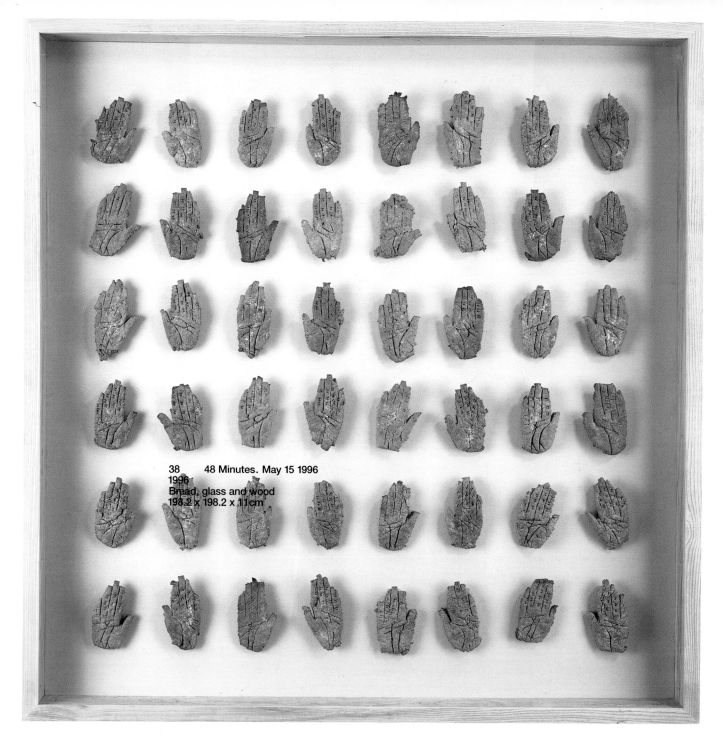

38 48 Minutes. May 15 1996
1996
Bread, glass and wood
198.2 x 198.2 x 11 cm

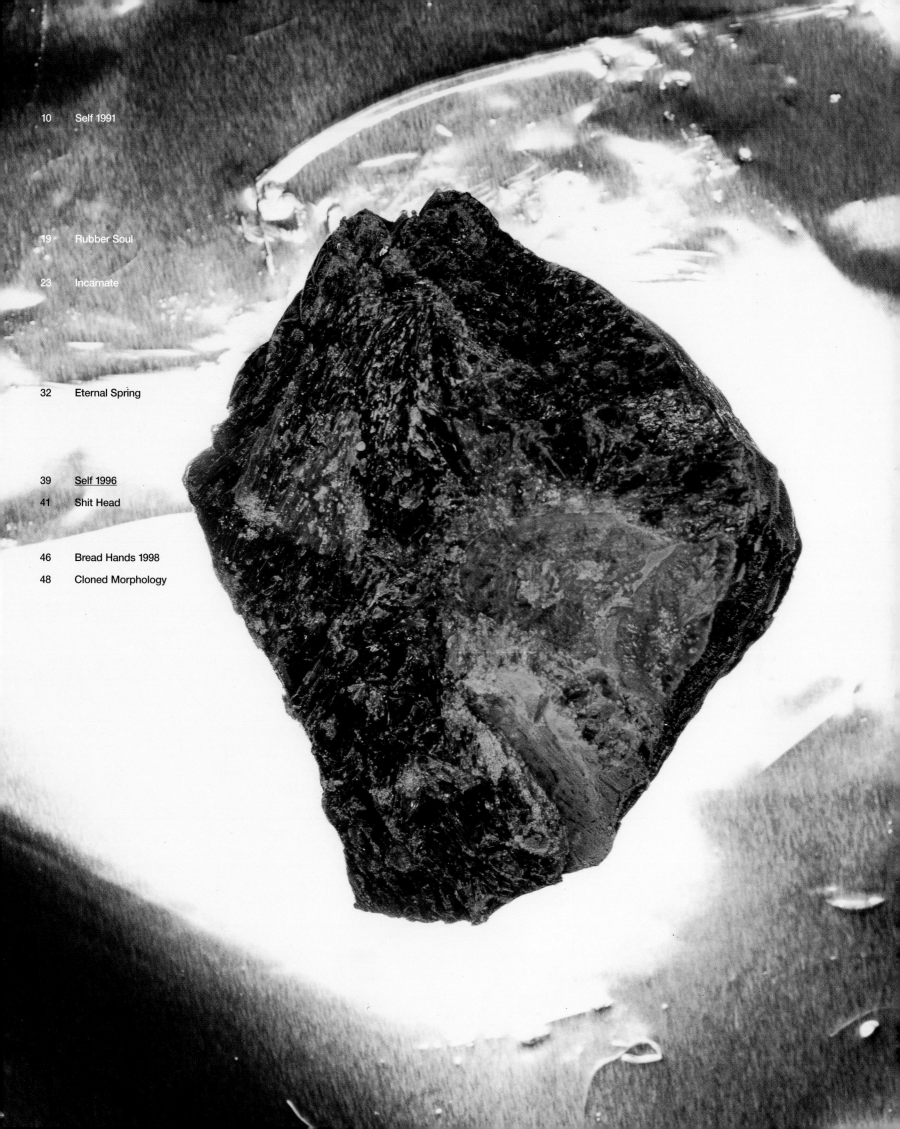

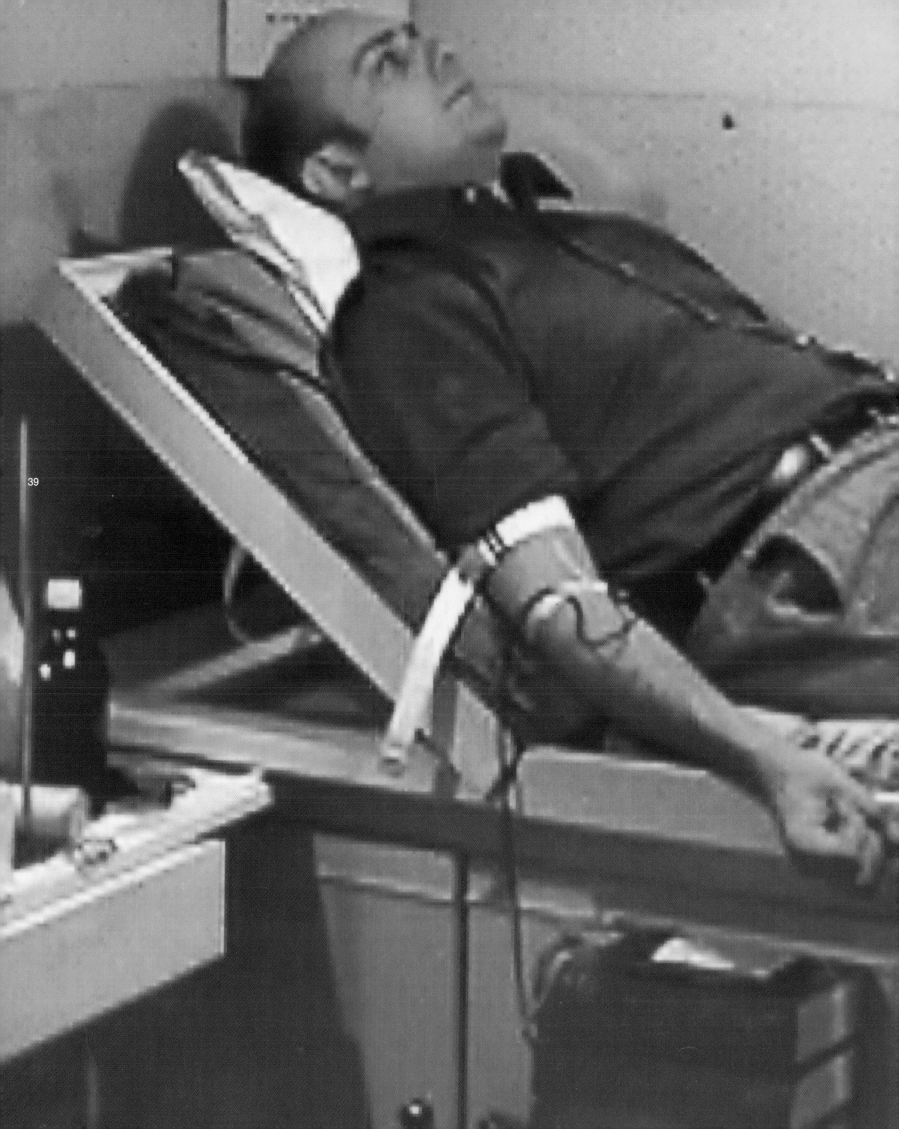

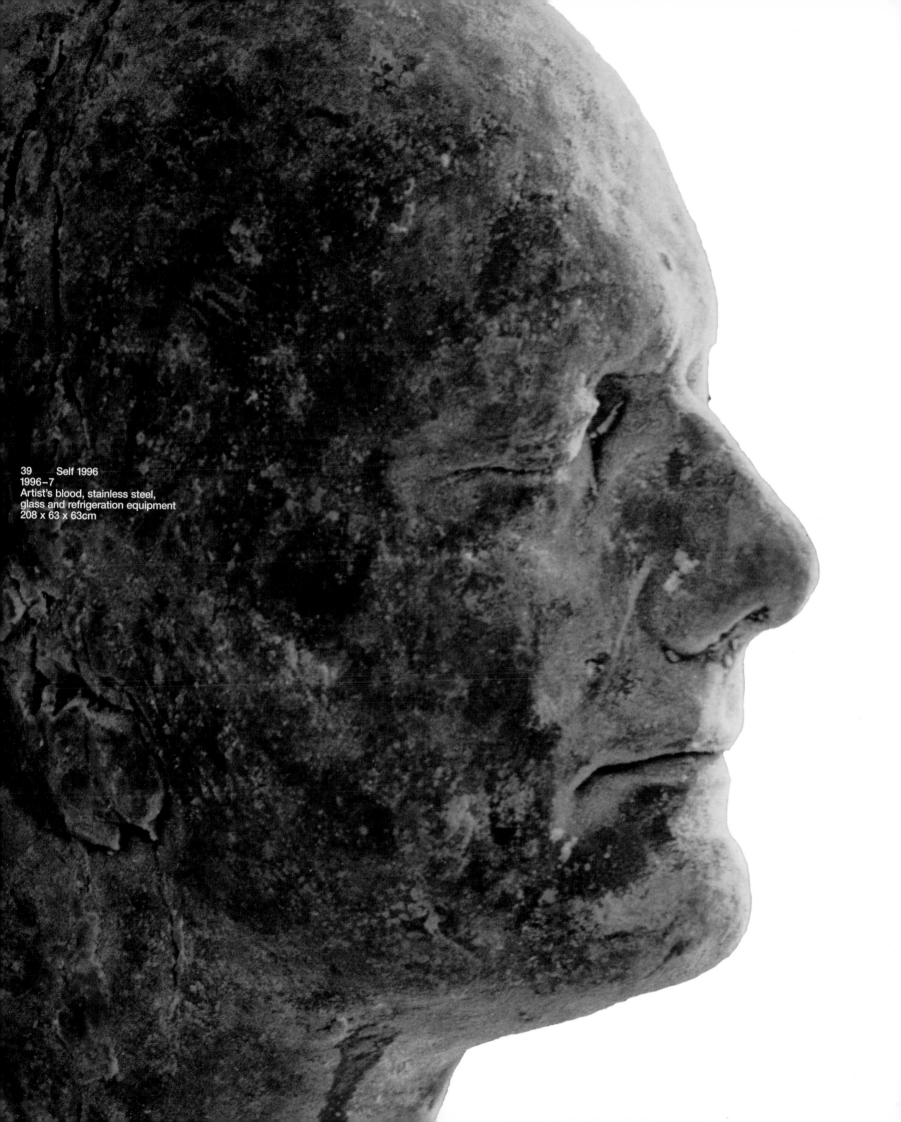

39 Self 1996
1996–7
Artist's blood, stainless steel,
glass and refrigeration equipment
208 x 63 x 63cm

Every five years until his death,
the artist will create a new
Self using fresh blood and a new
mould of his head.

2001 Self 2001 2006 Self 2006 2011 Self 2011 2016 Self 2016

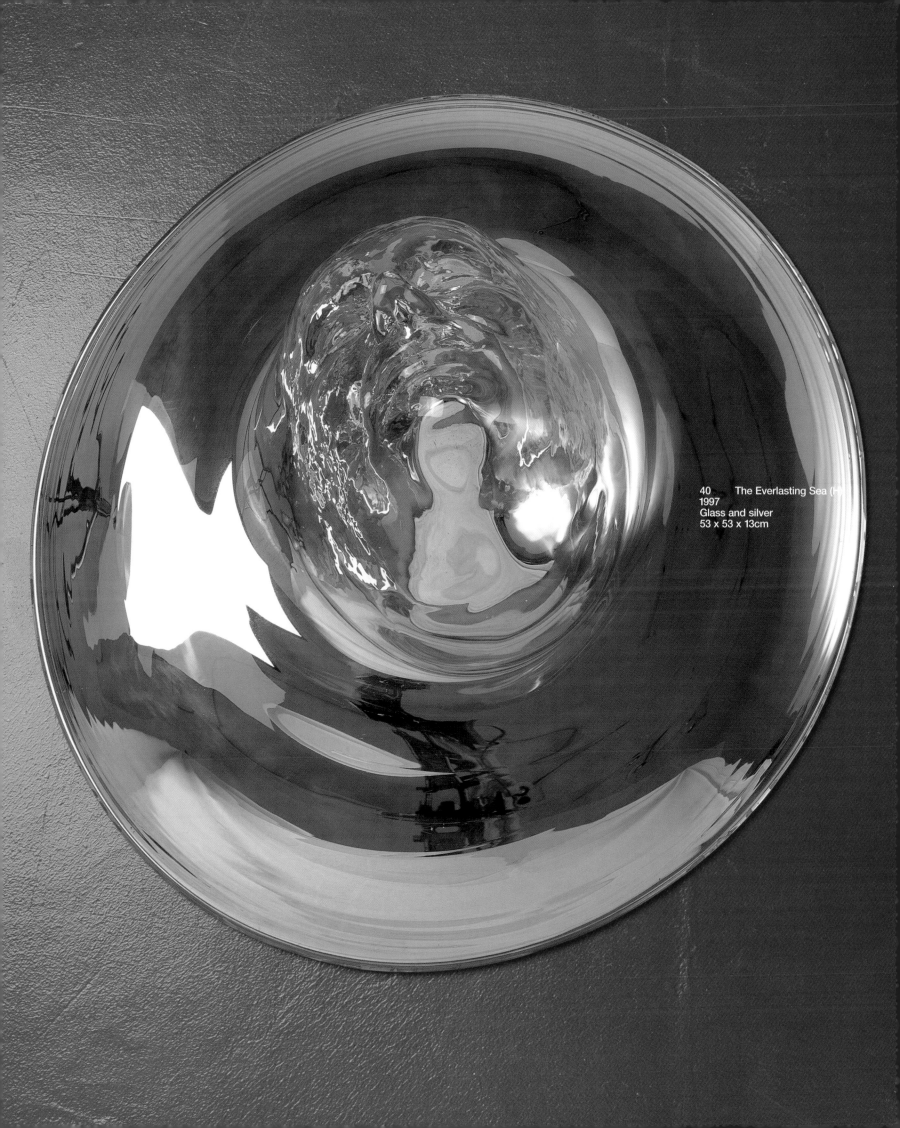

40 The Everlasting Sea (H
1997
Glass and silver
53 x 53 x 13cm

41 Heads of defeated enemies, shrunk to approximately one-third natural size by removal of skull.

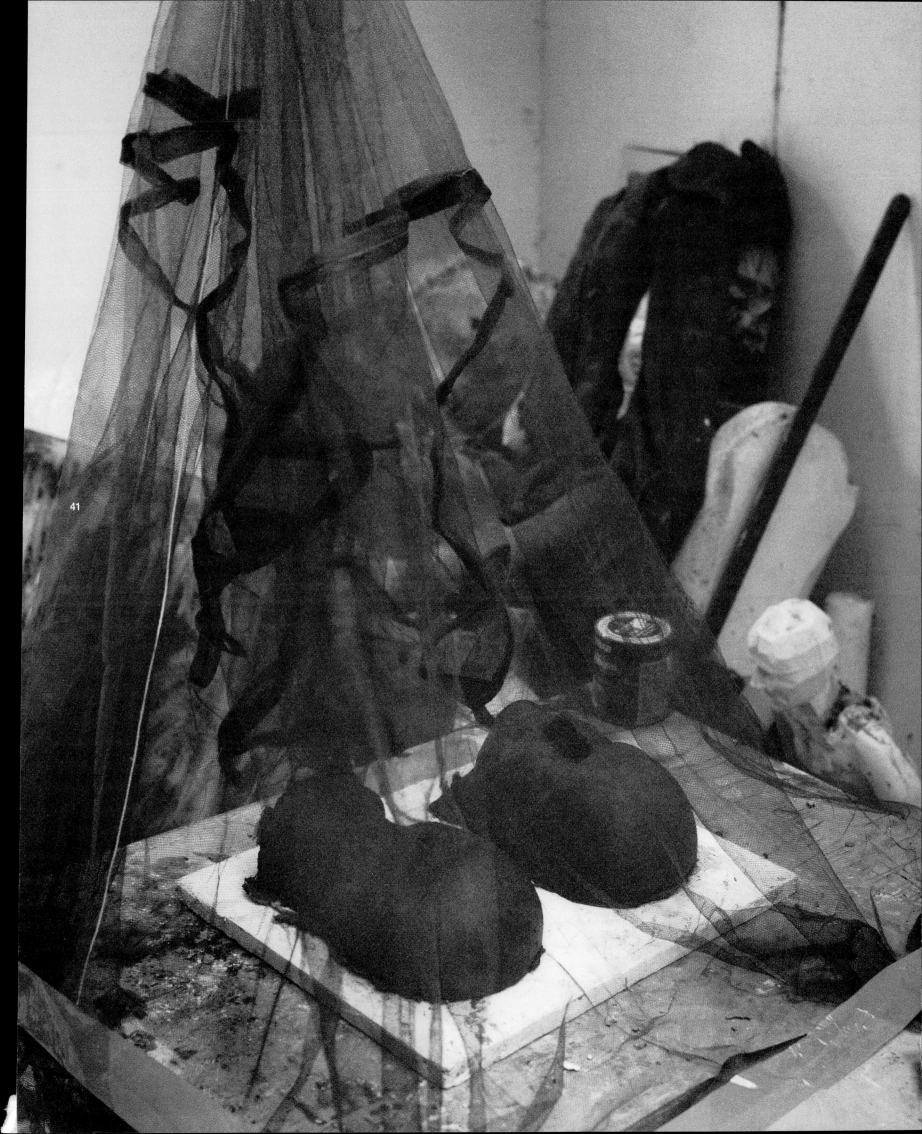

41 Shit Head
1997
Artist's faeces
23 x 15 x 19cm (shown actual size)

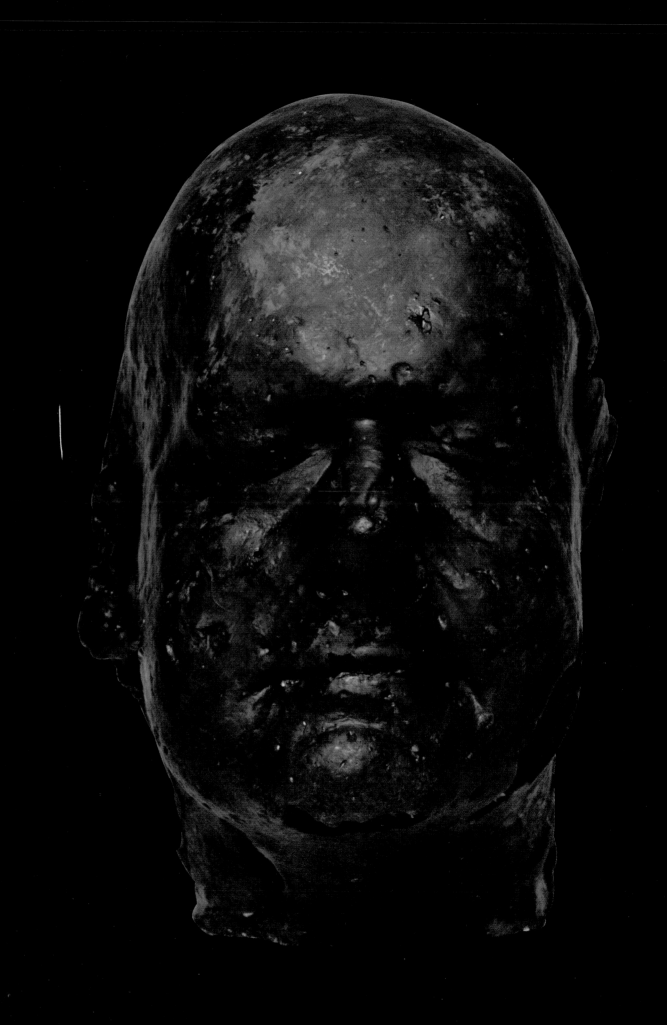

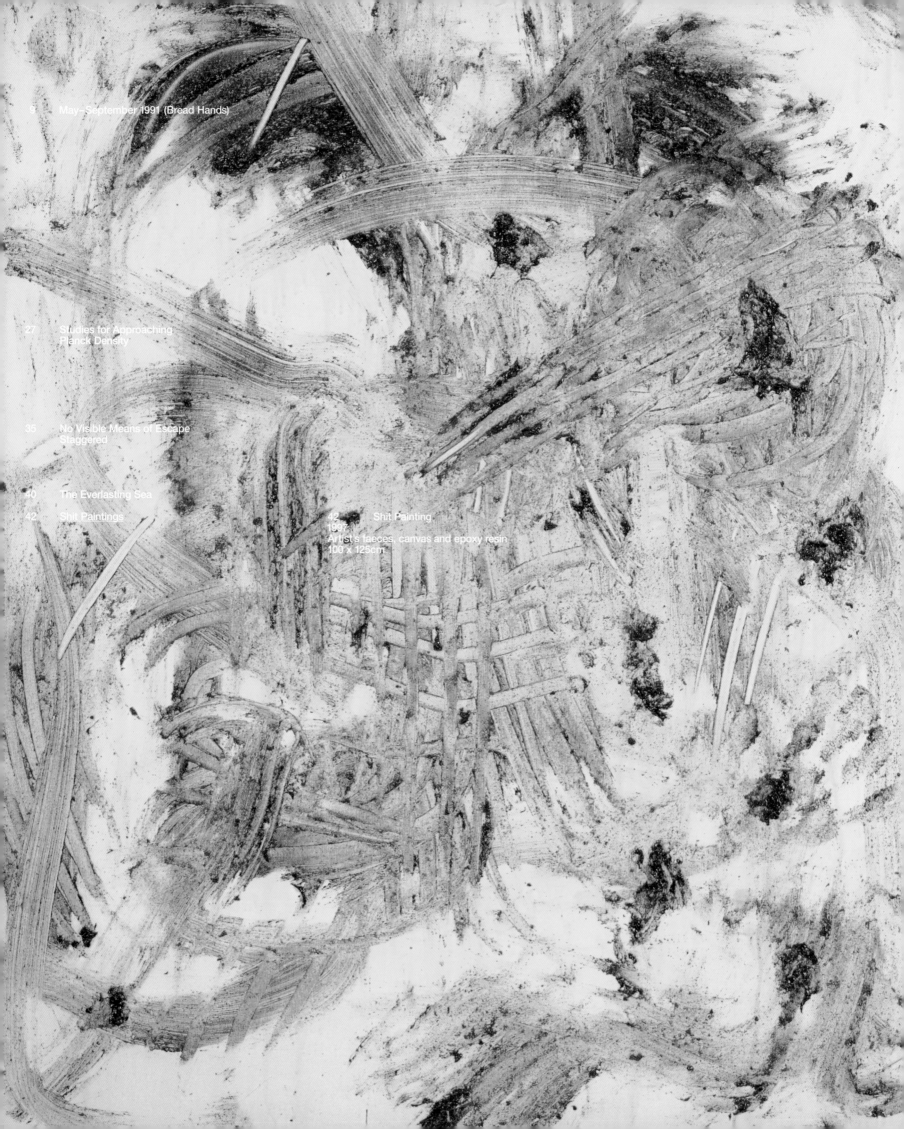

42 Shit Painting
1997
Artist's faeces, canvas and epoxy resin
100 x 125cm

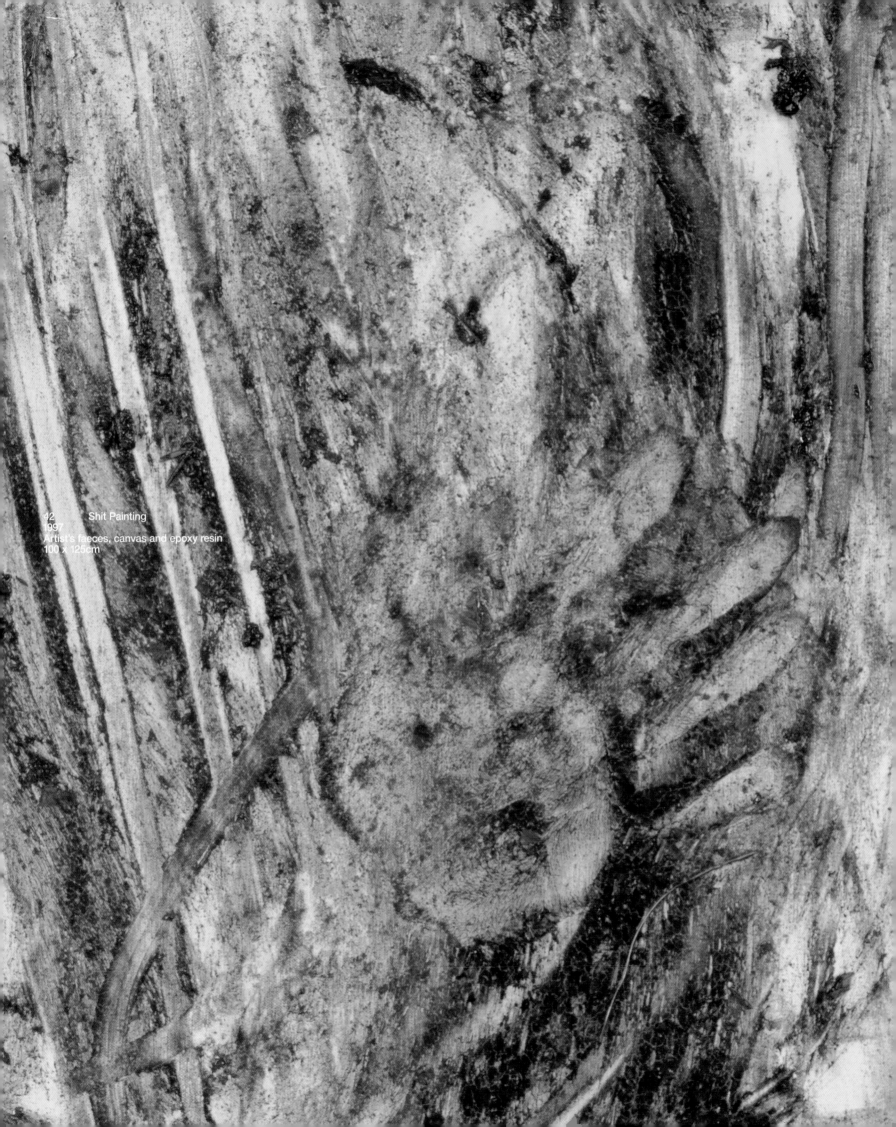

42 Shit Painting
1997
Artist's faeces, canvas and epoxy resin
100 x 125cm

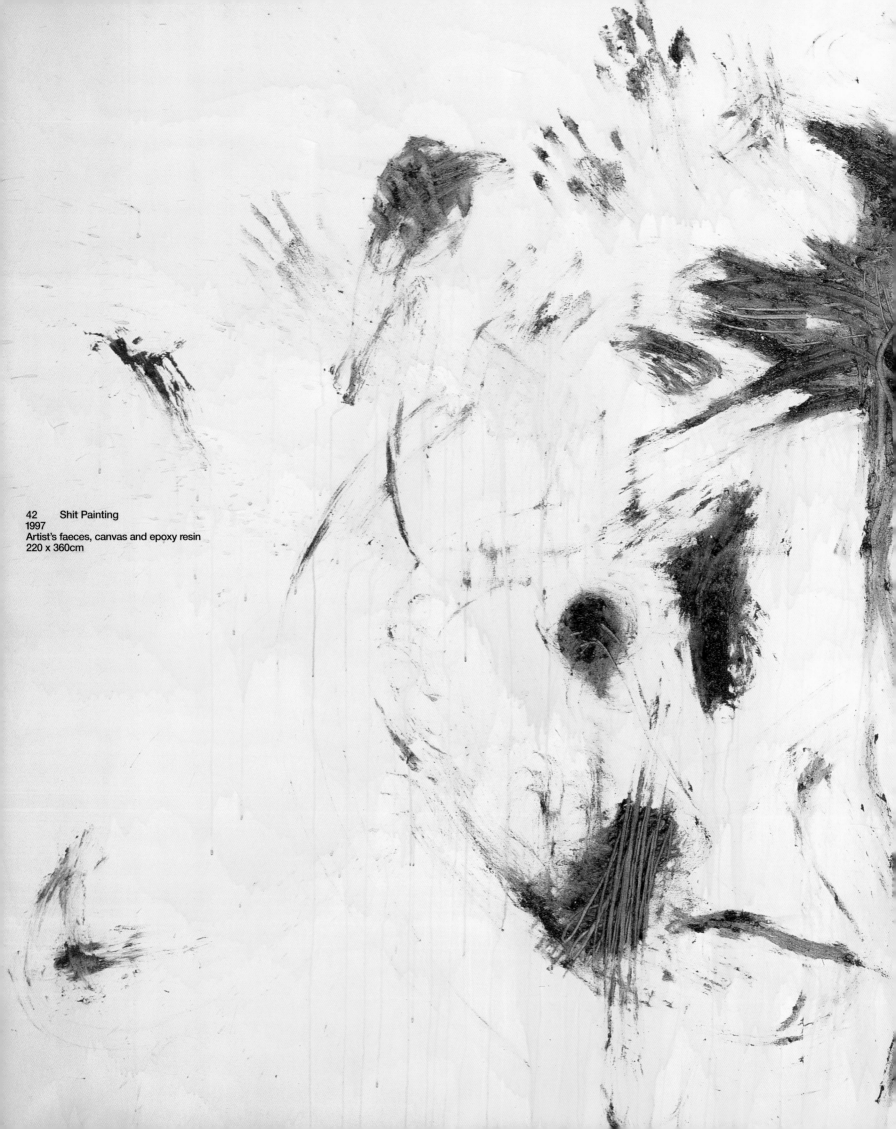

42 Shit Painting
1997
Artist's faeces, canvas and epoxy resin
220 x 360cm

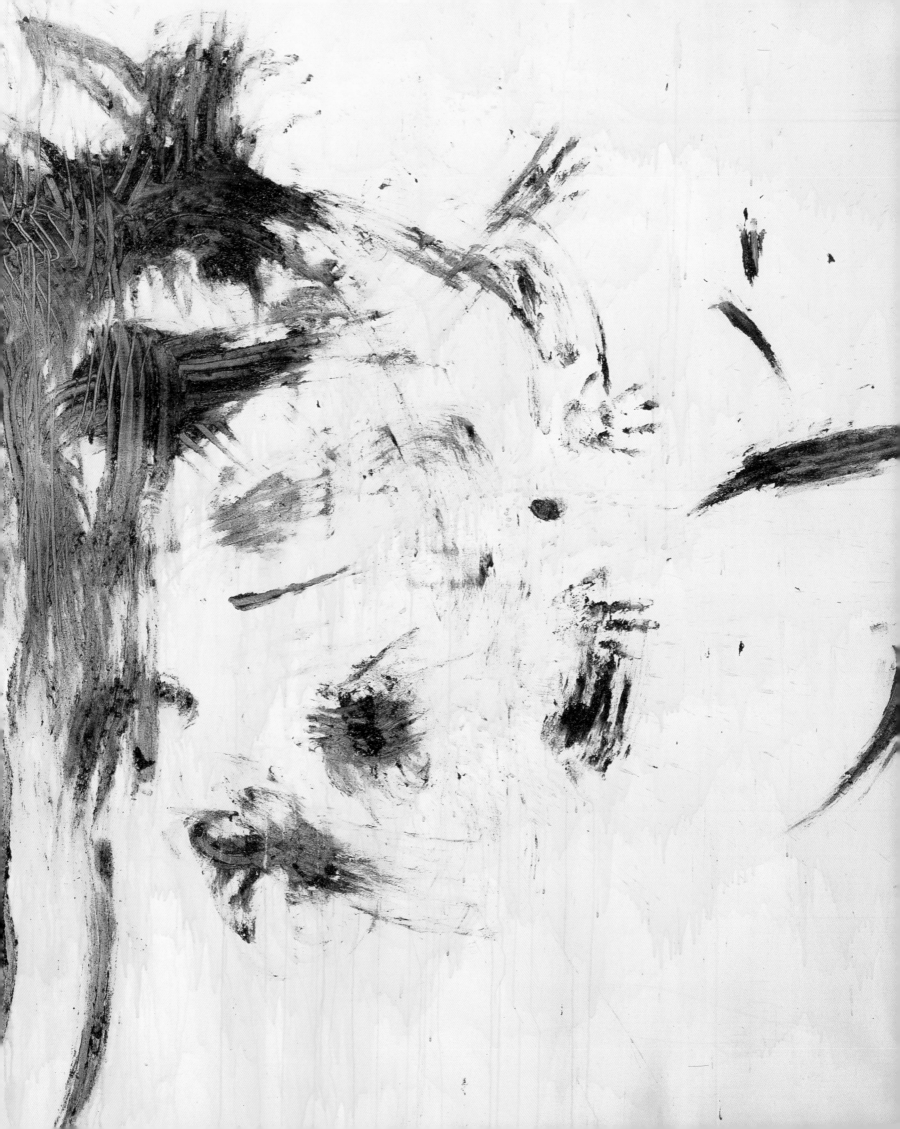

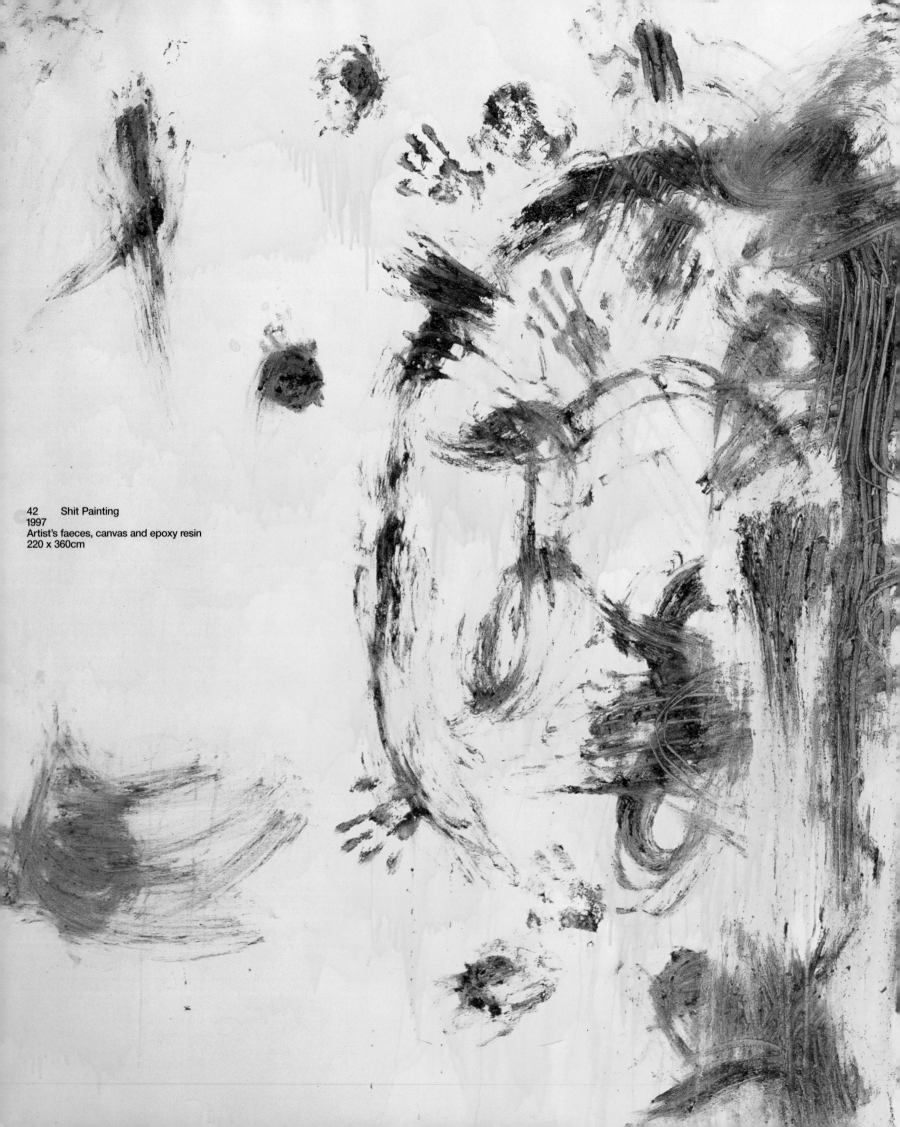

42 Shit Painting
1997
Artist's faeces, canvas and epoxy resin
220 x 360cm

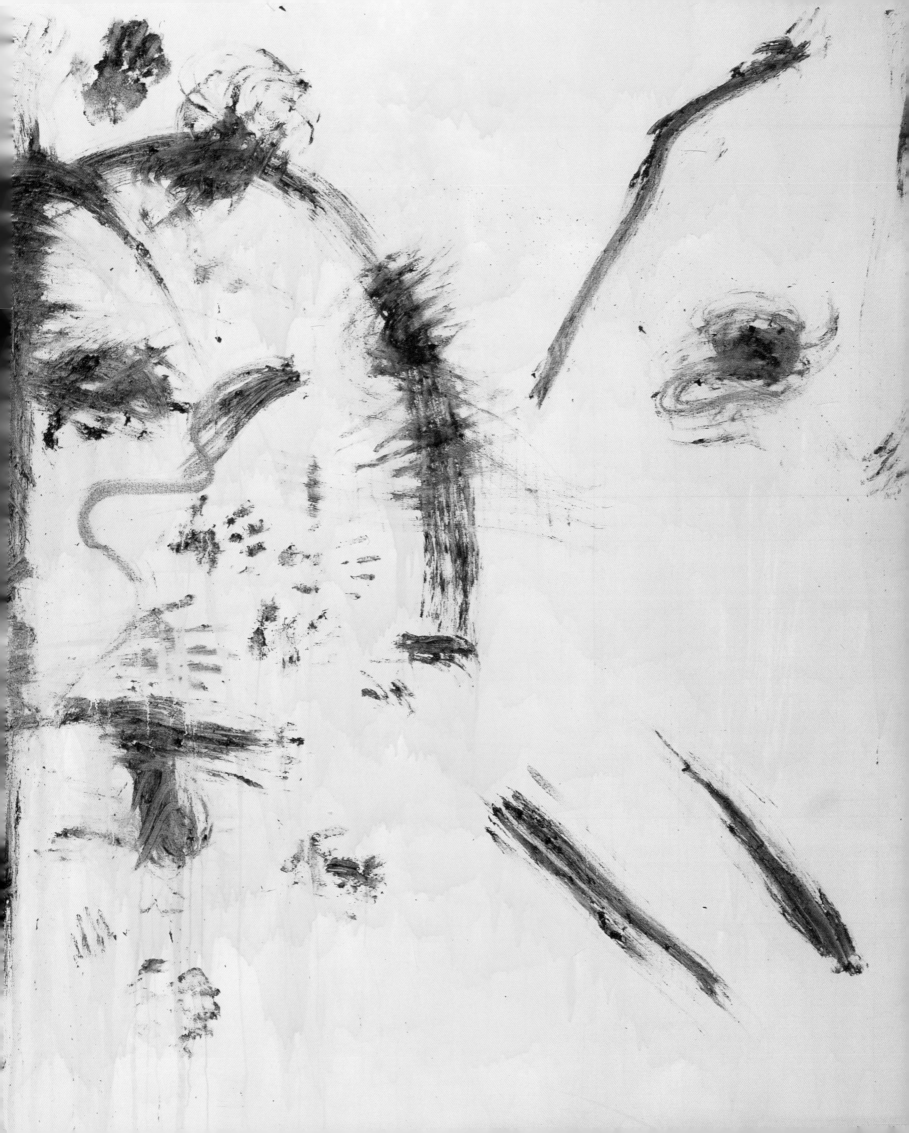

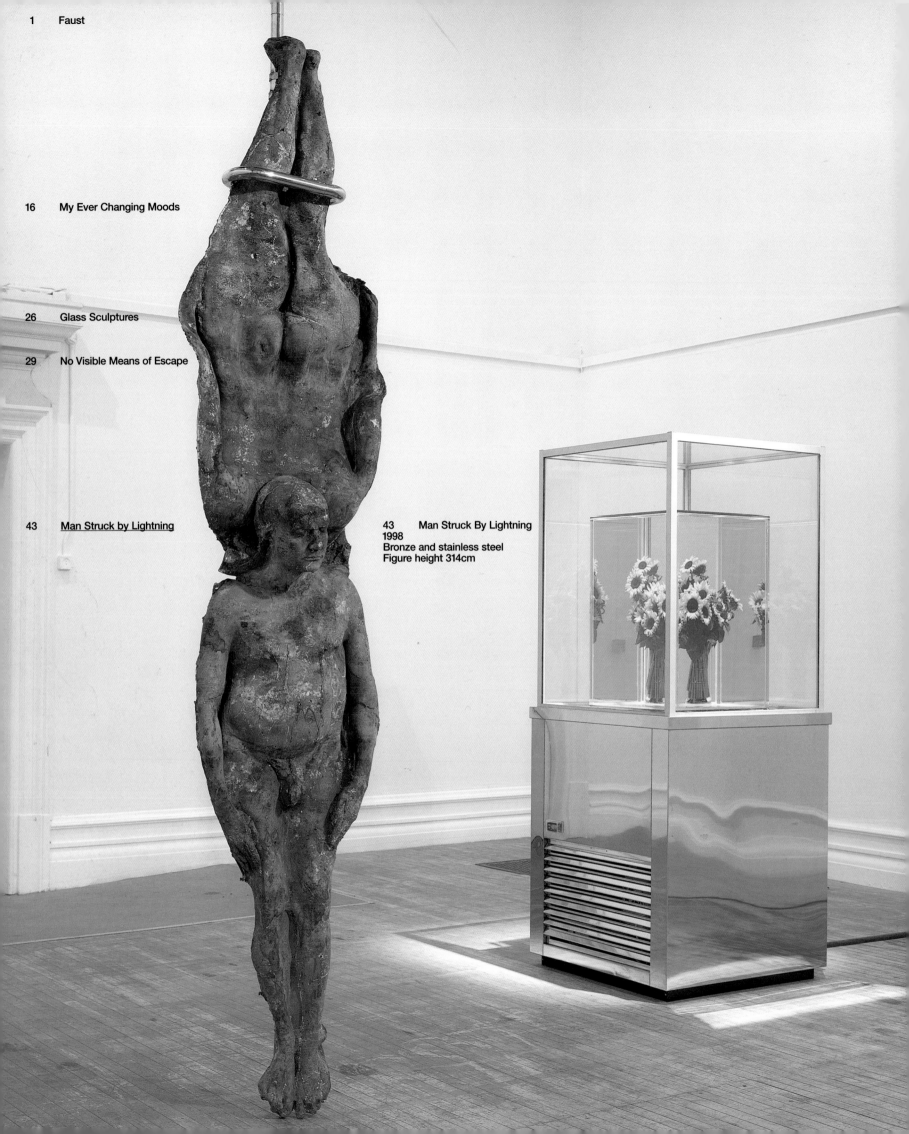

43 Man Struck By Lightning
1998
Bronze and stainless steel
Figure height 314cm

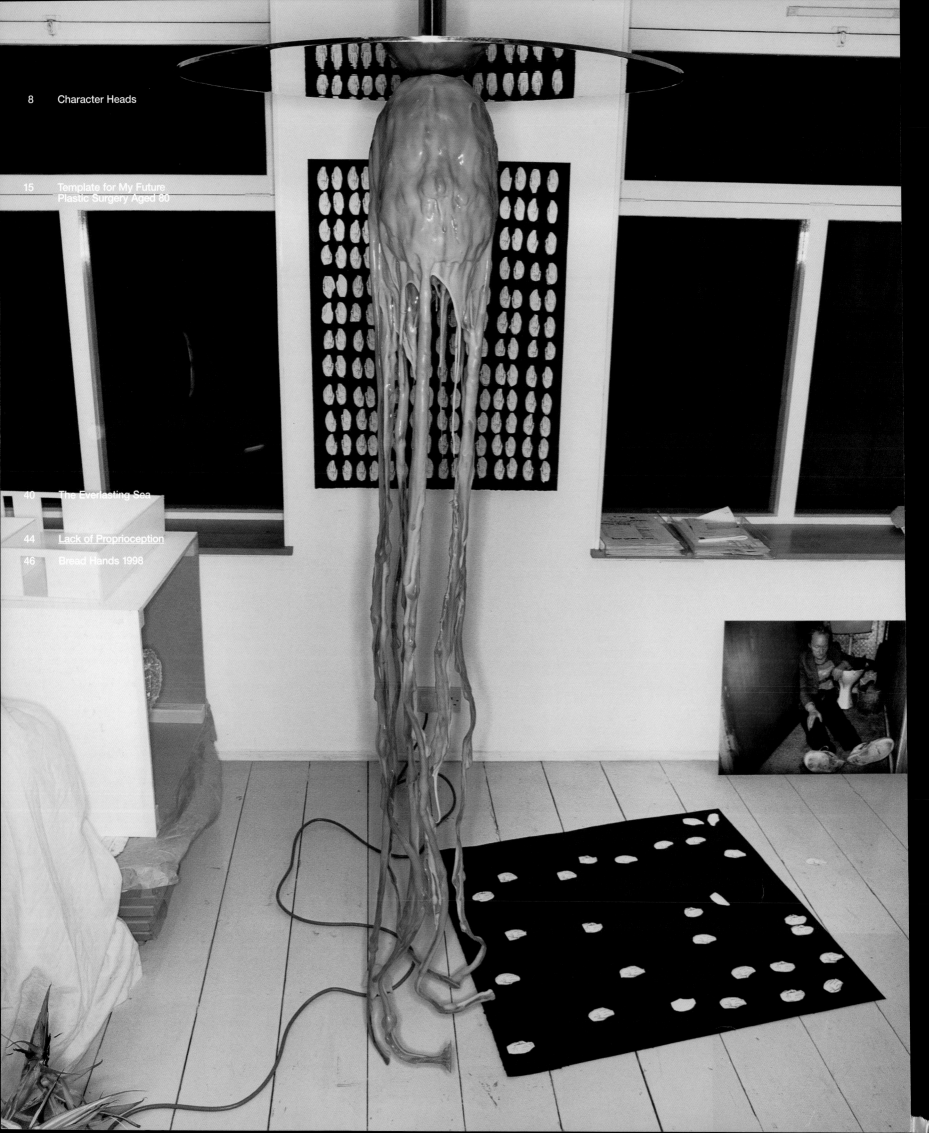

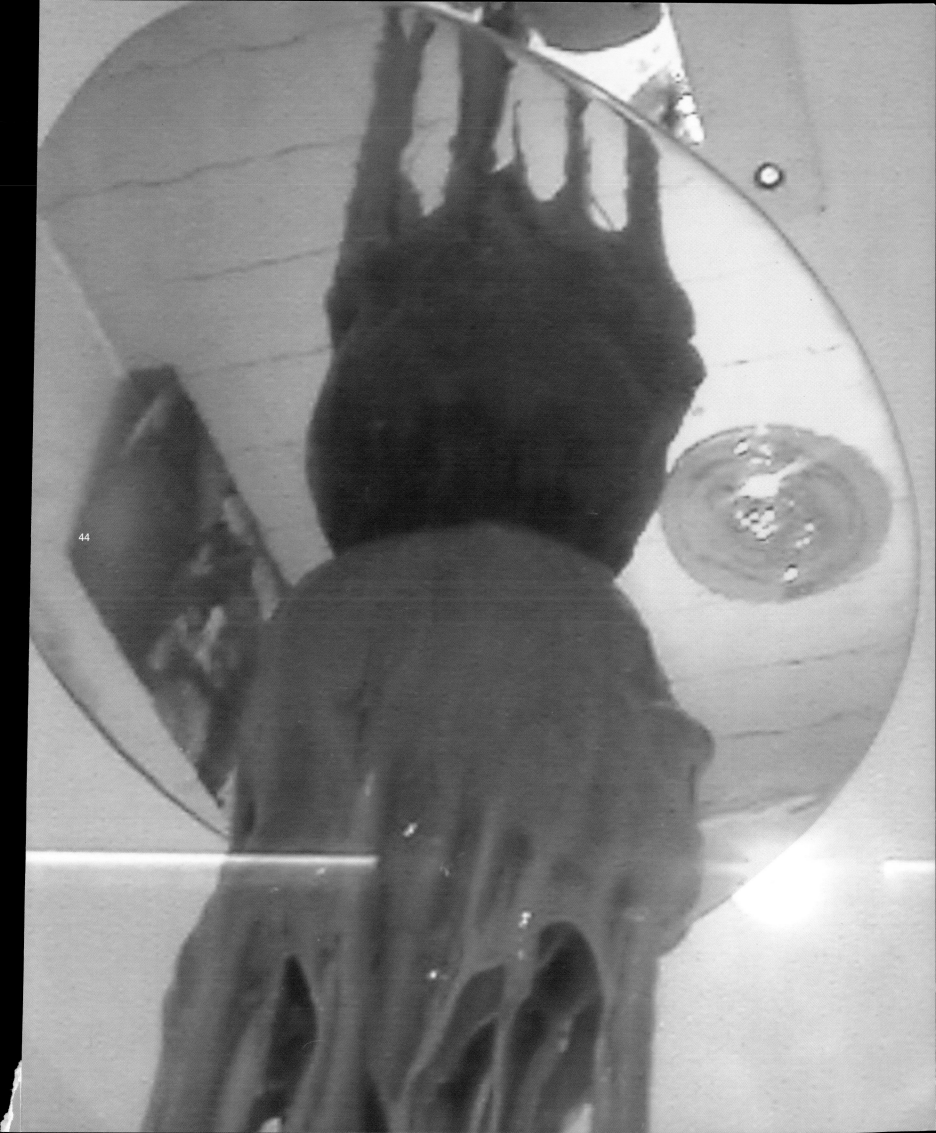

44 Lack of Proprioception
1997
RTV 75-60 polyurethane rubber
and stainless steel
Figure height 180cm

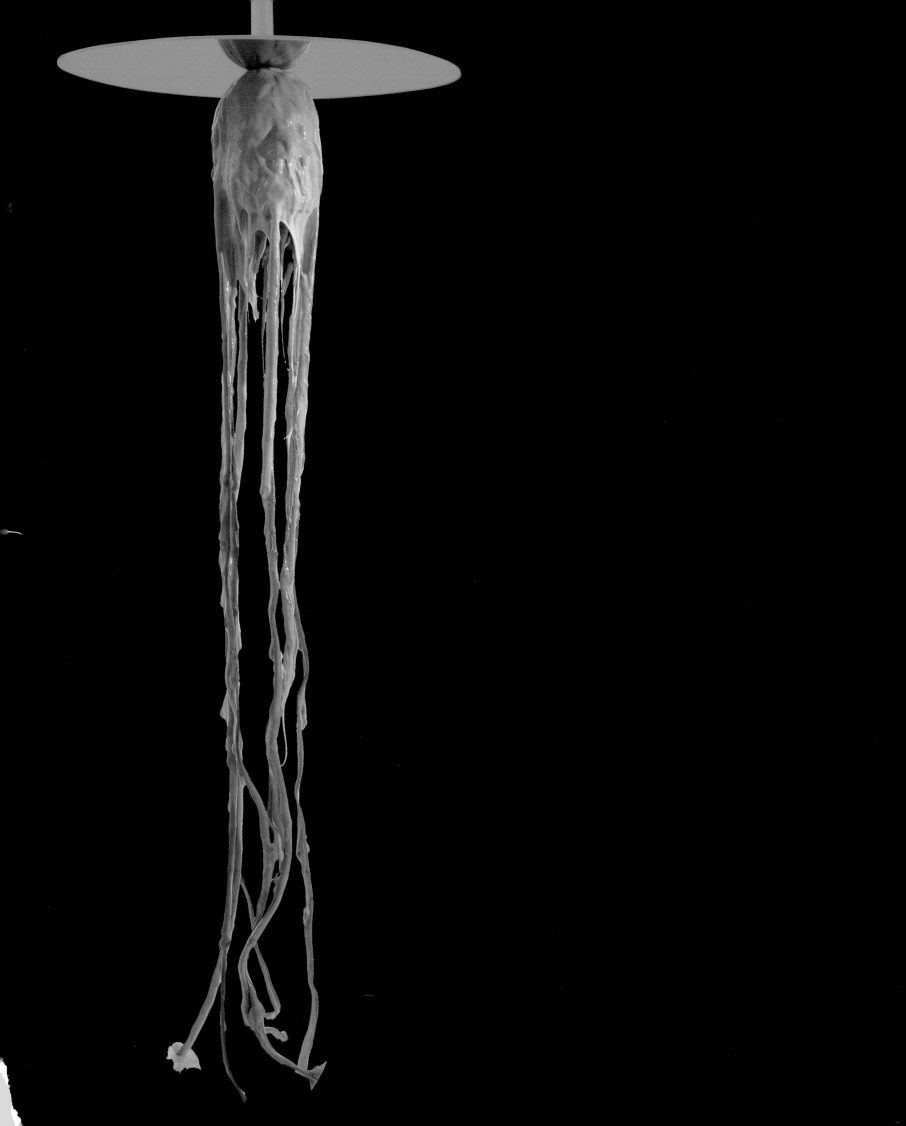

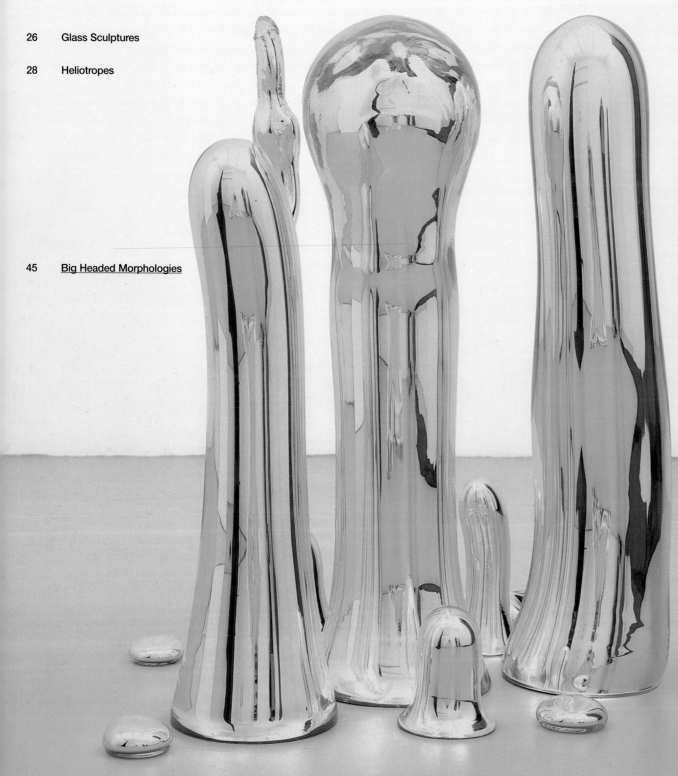

45 Shooming Morphology
1998
Glass and silver
90 x 90 x 66cm (14 parts)

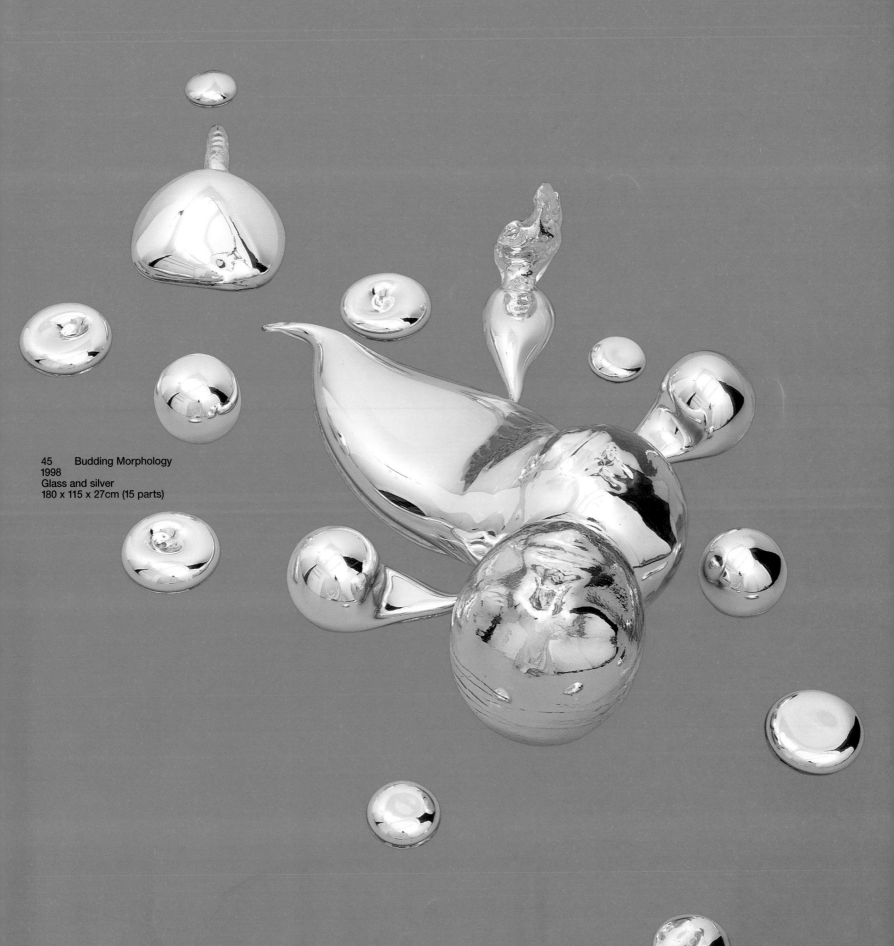

45 Budding Morphology
1998
Glass and silver
180 x 115 x 27cm (15 parts)

45 Intuitive Morphology
1998
Glass and silver
104 x 28 x 30cm (8 parts)

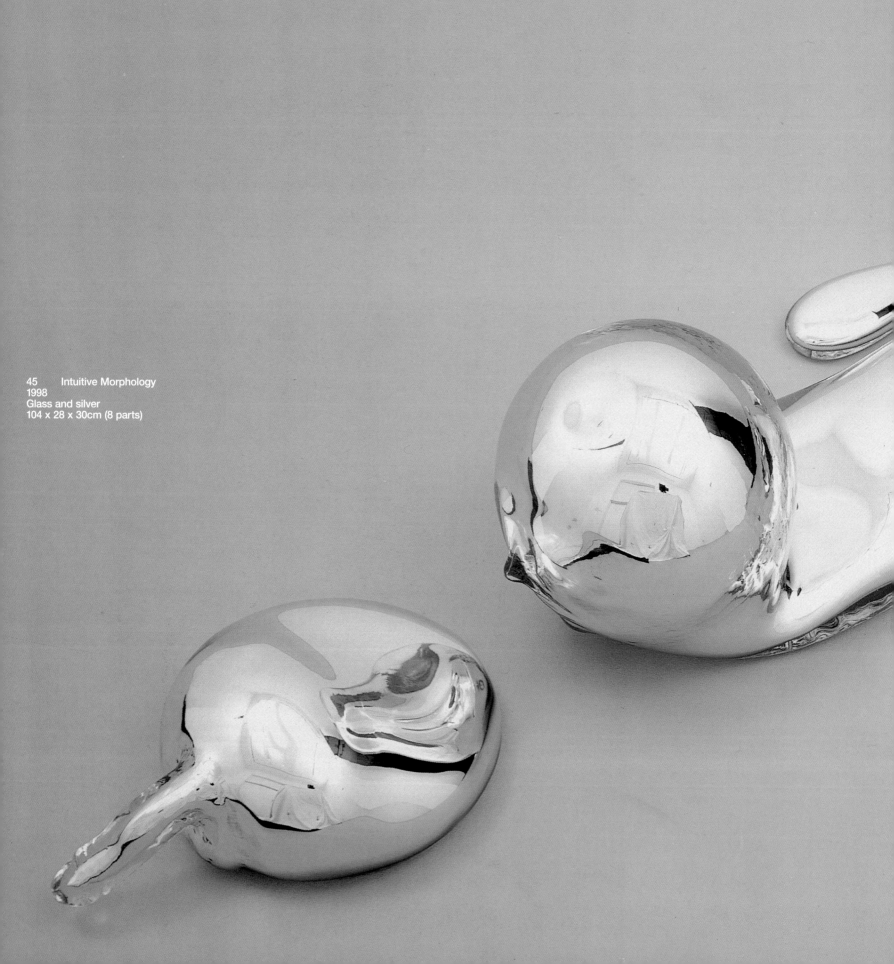

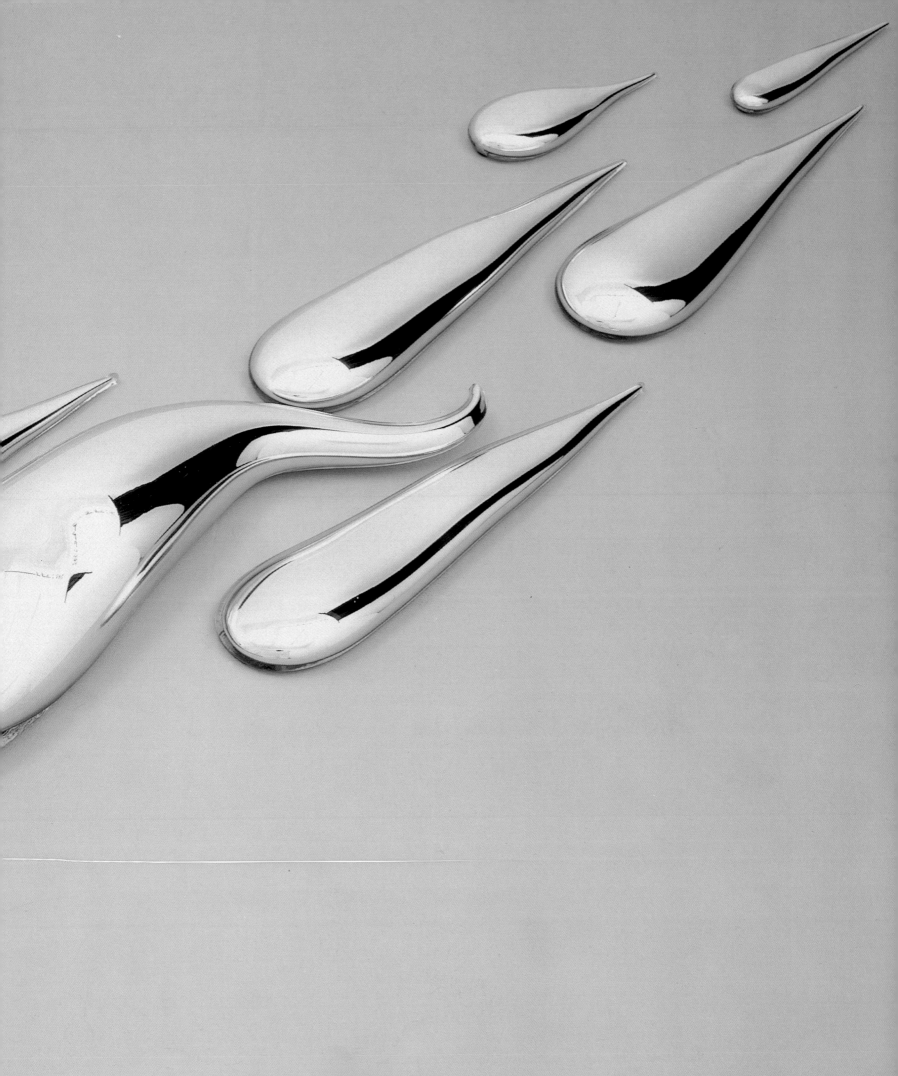

45 Globular Morphology
1998
Glass and silver
130 x 100 x 30cm (13 parts)

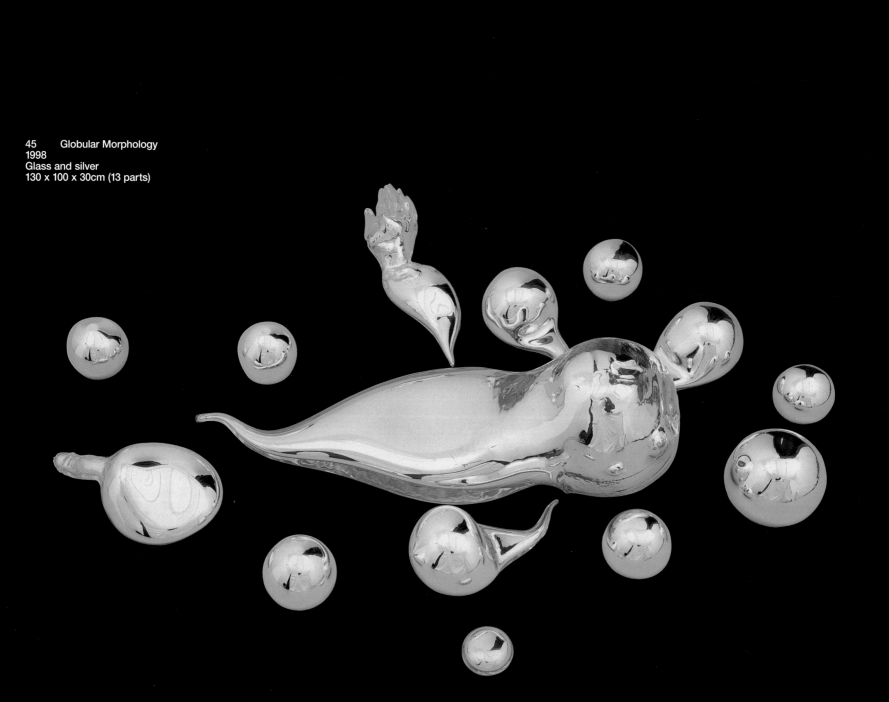

46 Bread Hands 1998

46 A Gross Five Days.
 January 8–12 1998
1998
Bread, glass and wood
305 x 244 x 11cm

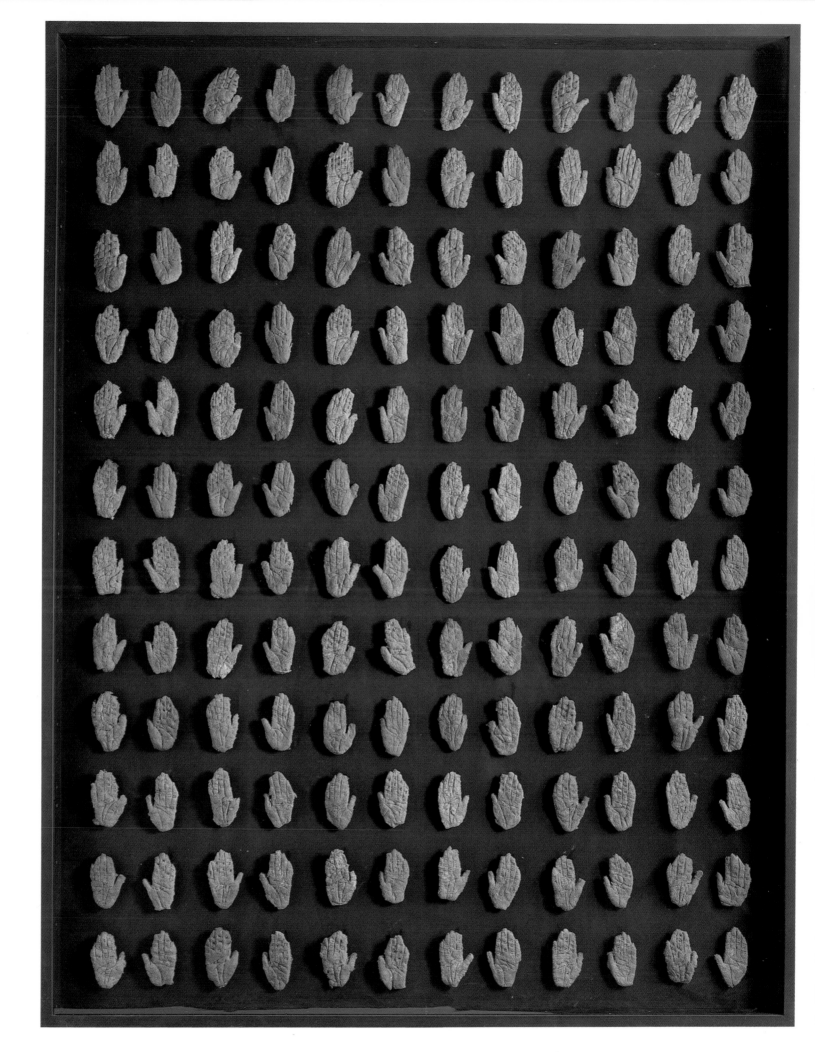

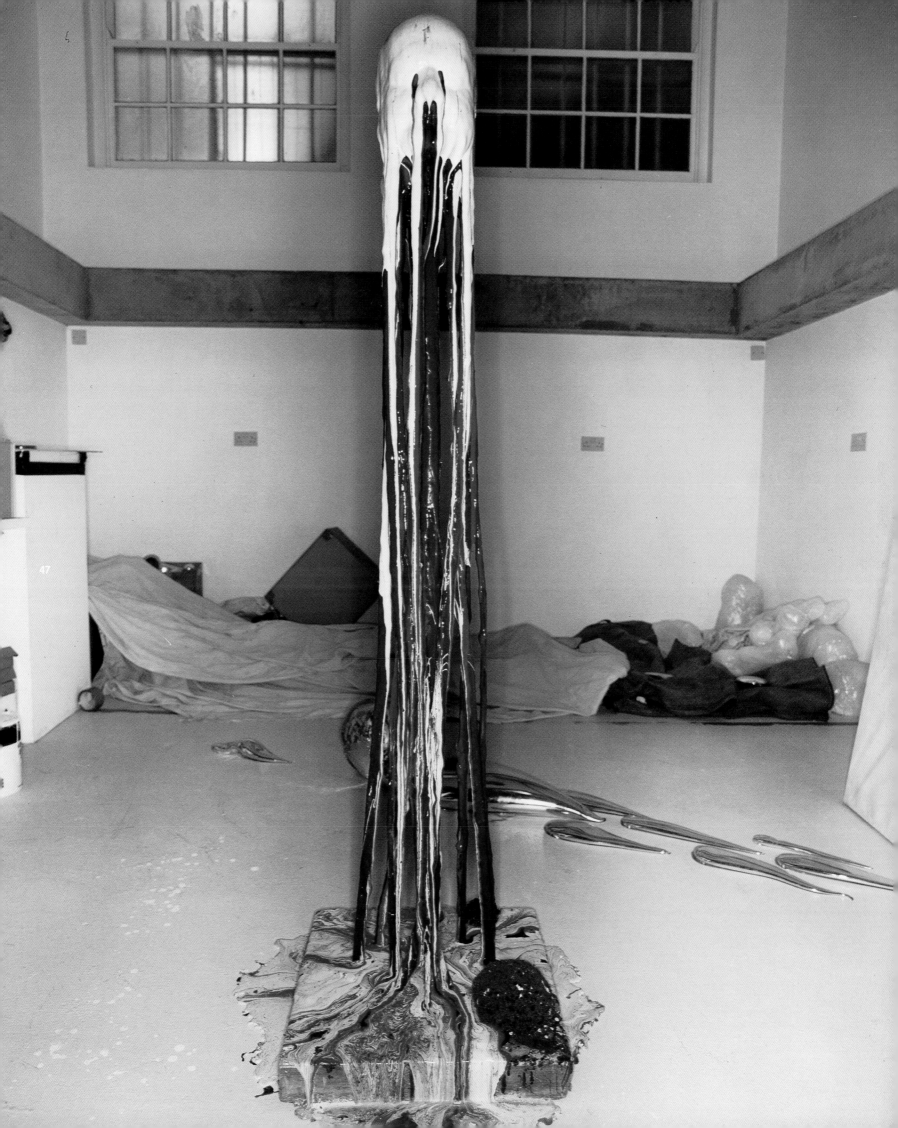

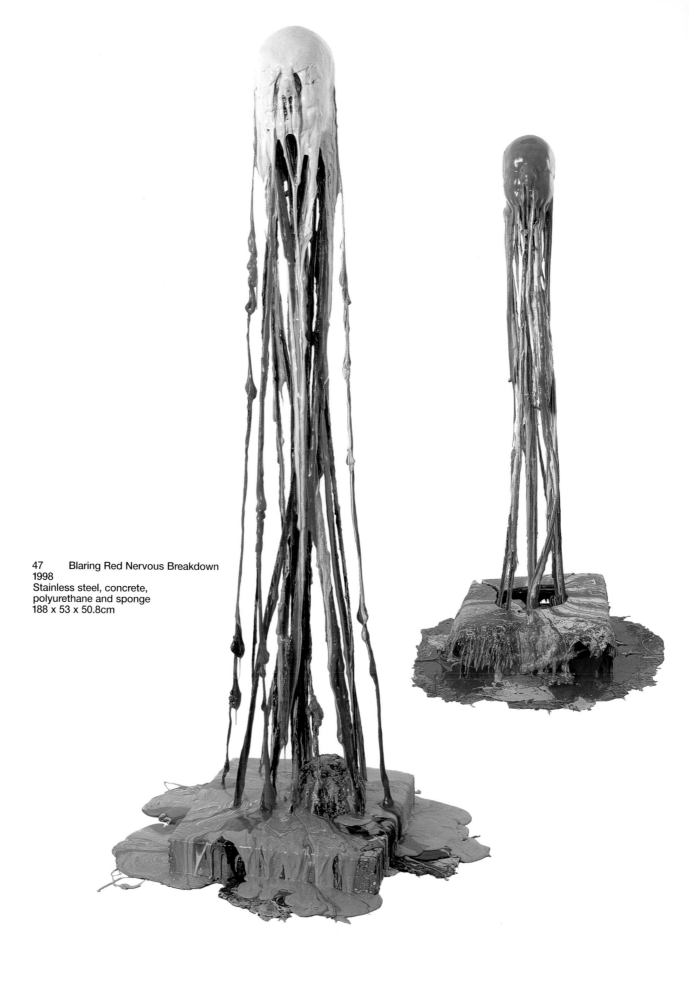

47 Scarlet Nervous Breakdown
1998
Stainless steel, concrete,
polyurethane and sponge
188 x 50.8 x 50.8cm

47 Blaring Red Nervous Breakdown
1998
Stainless steel, concrete,
polyurethane and sponge
188 x 53 x 50.8cm

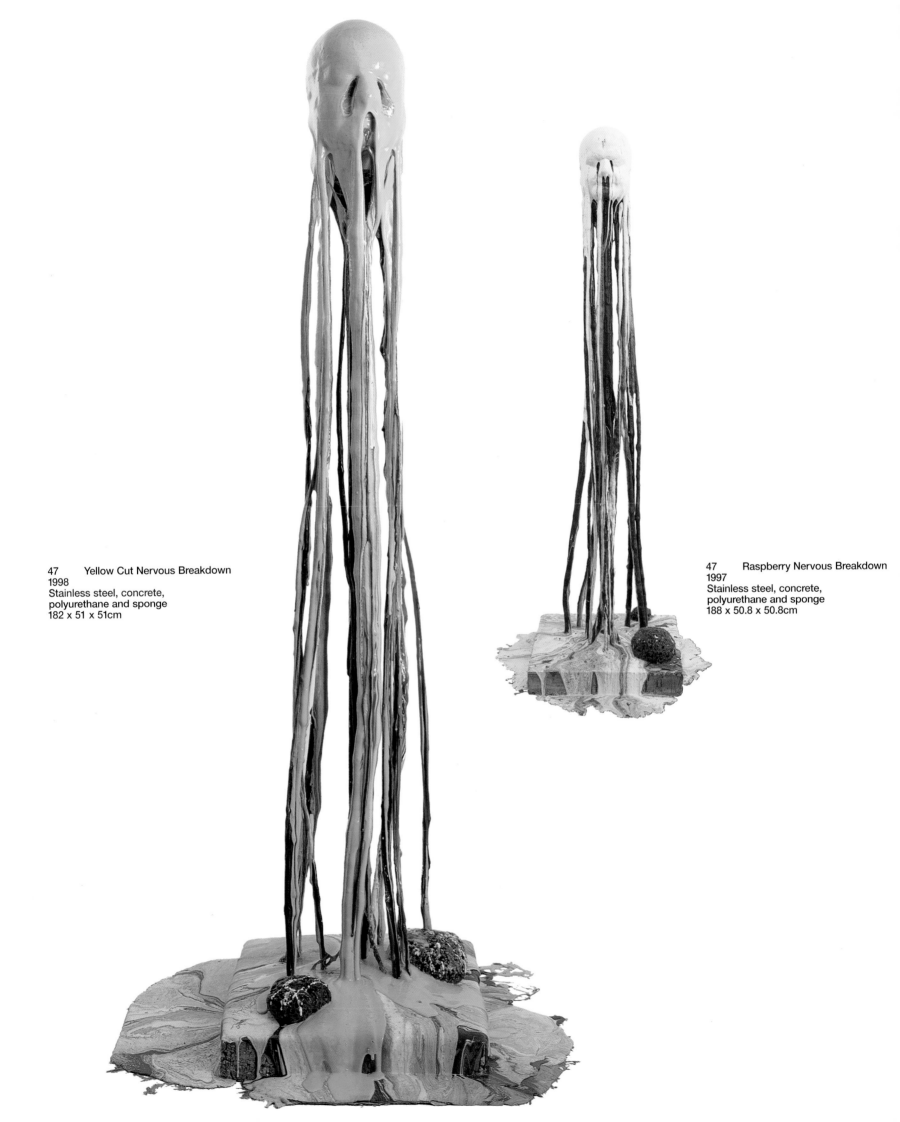

47 Yellow Cut Nervous Breakdown
1998
Stainless steel, concrete,
polyurethane and sponge
182 x 51 x 51cm

47 Raspberry Nervous Breakdown
1997
Stainless steel, concrete,
polyurethane and sponge
188 x 50.8 x 50.8cm

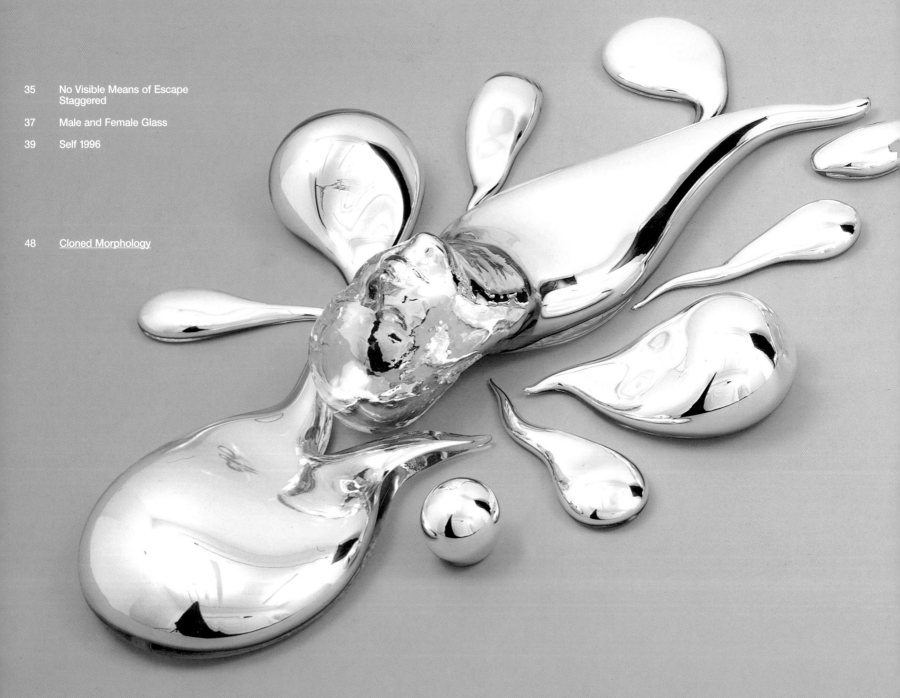

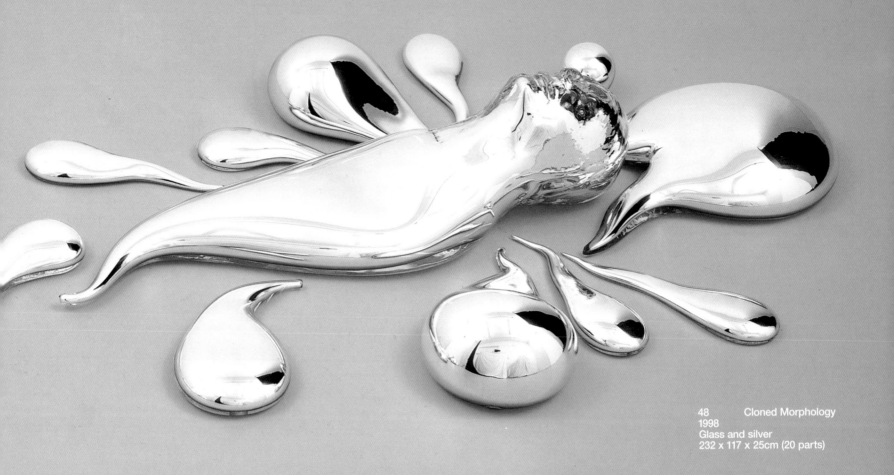

48 Cloned Morphology
1998
Glass and silver
232 x 117 x 25cm (20 parts)

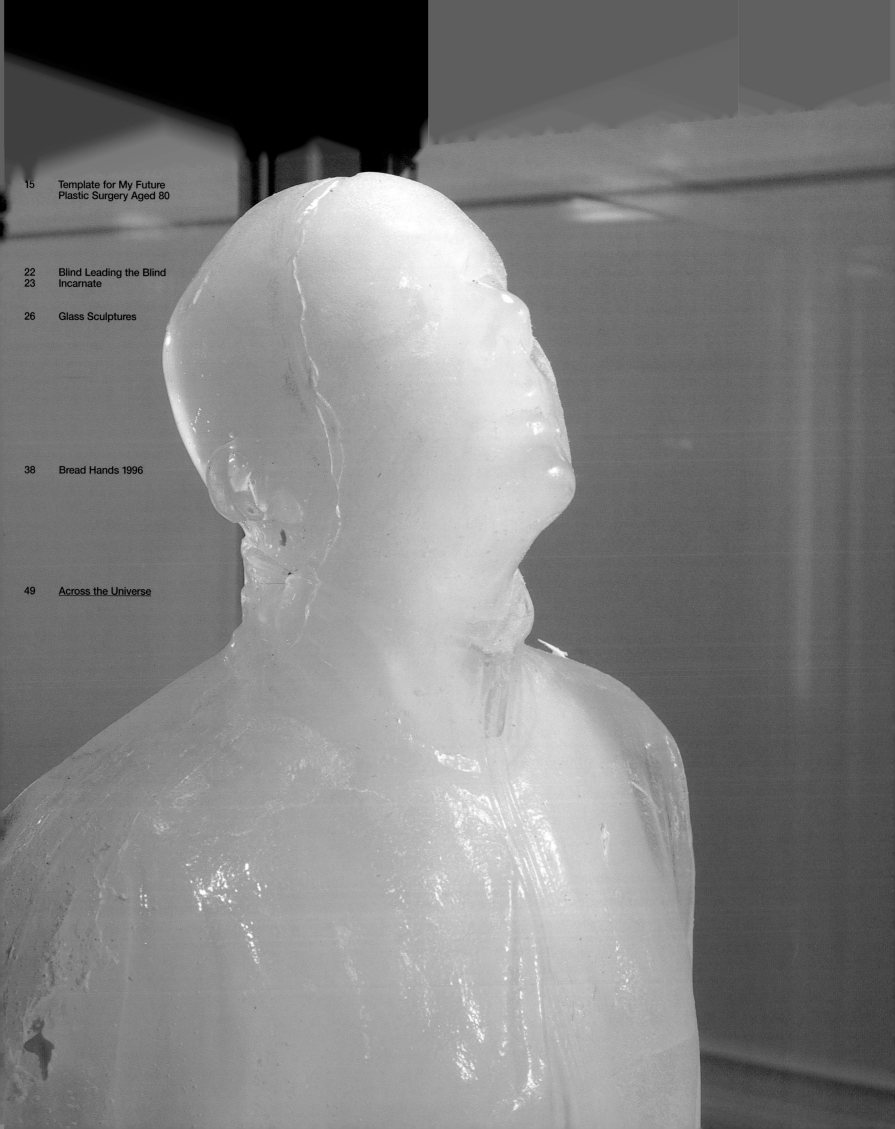

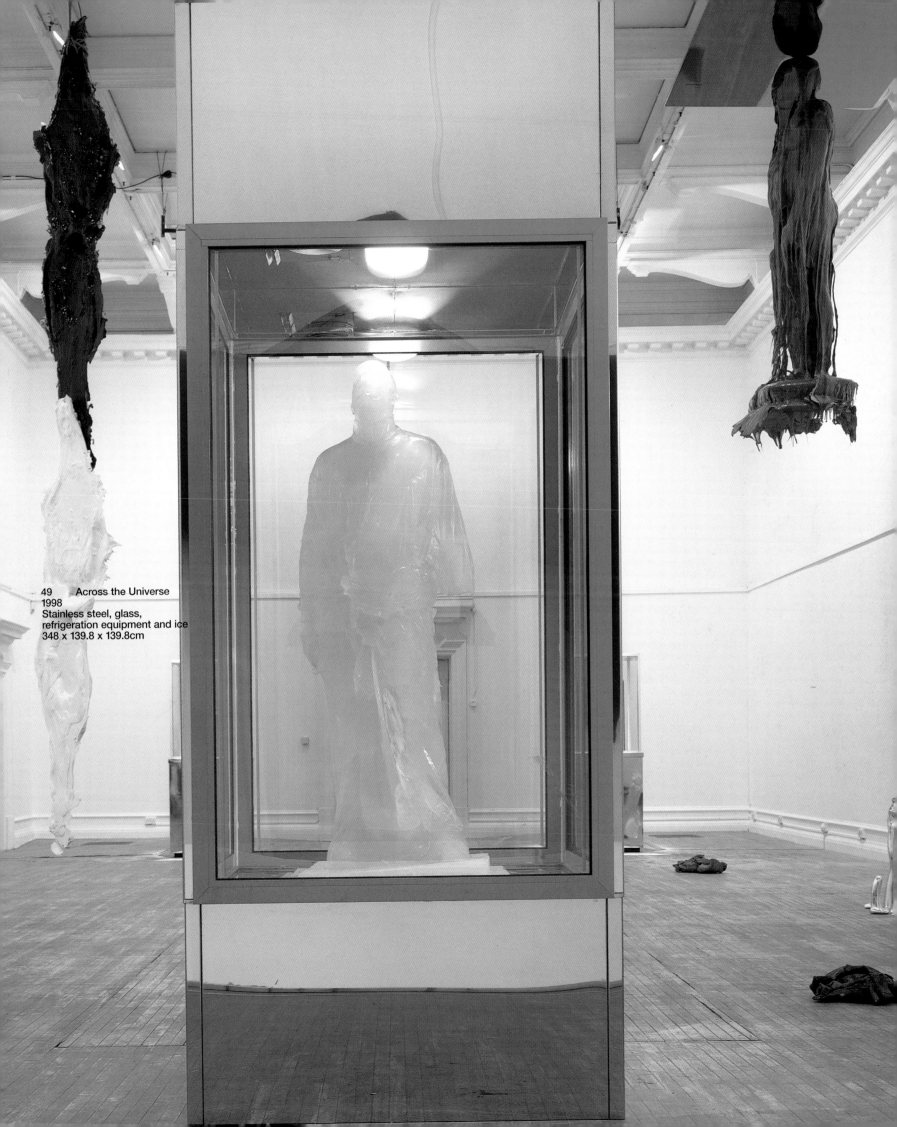

49 Across the Universe
1998
Stainless steel, glass,
refrigeration equipment and ice
348 x 139.8 x 139.8cm

49

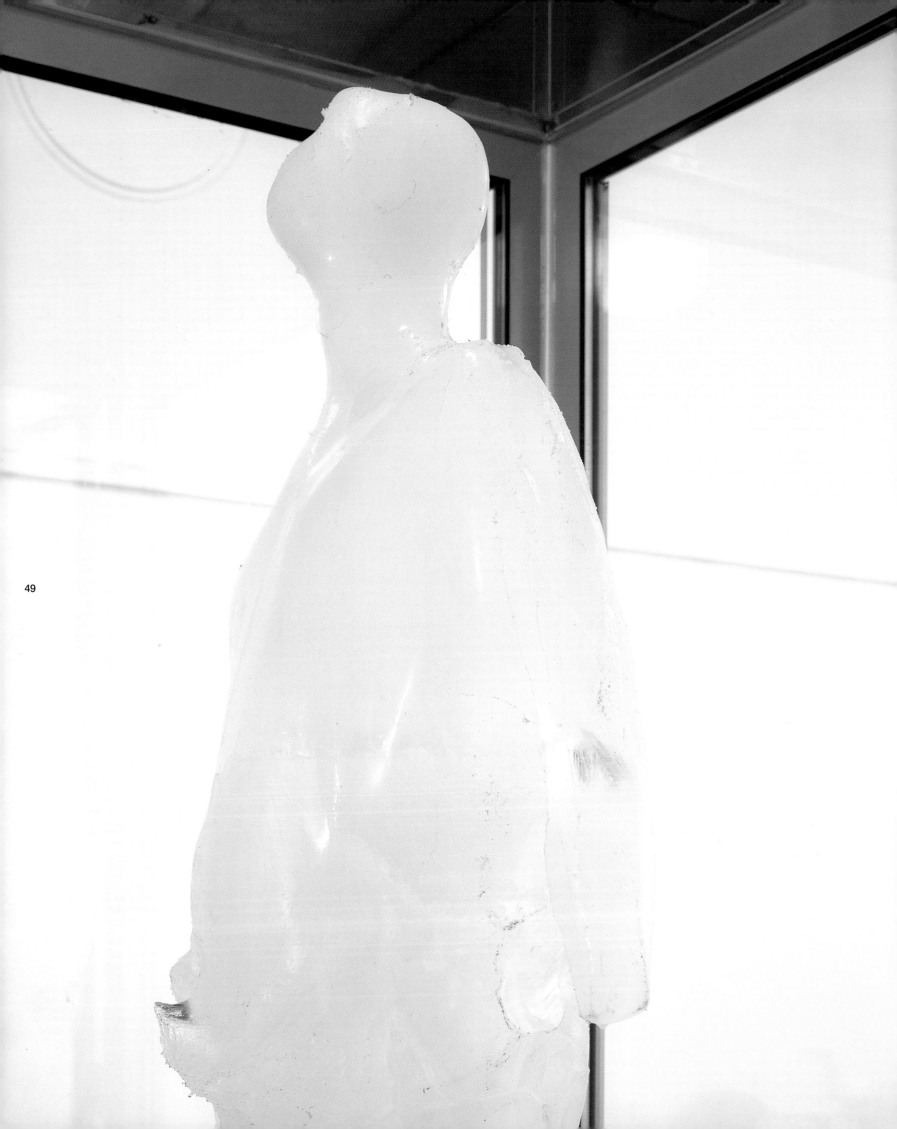

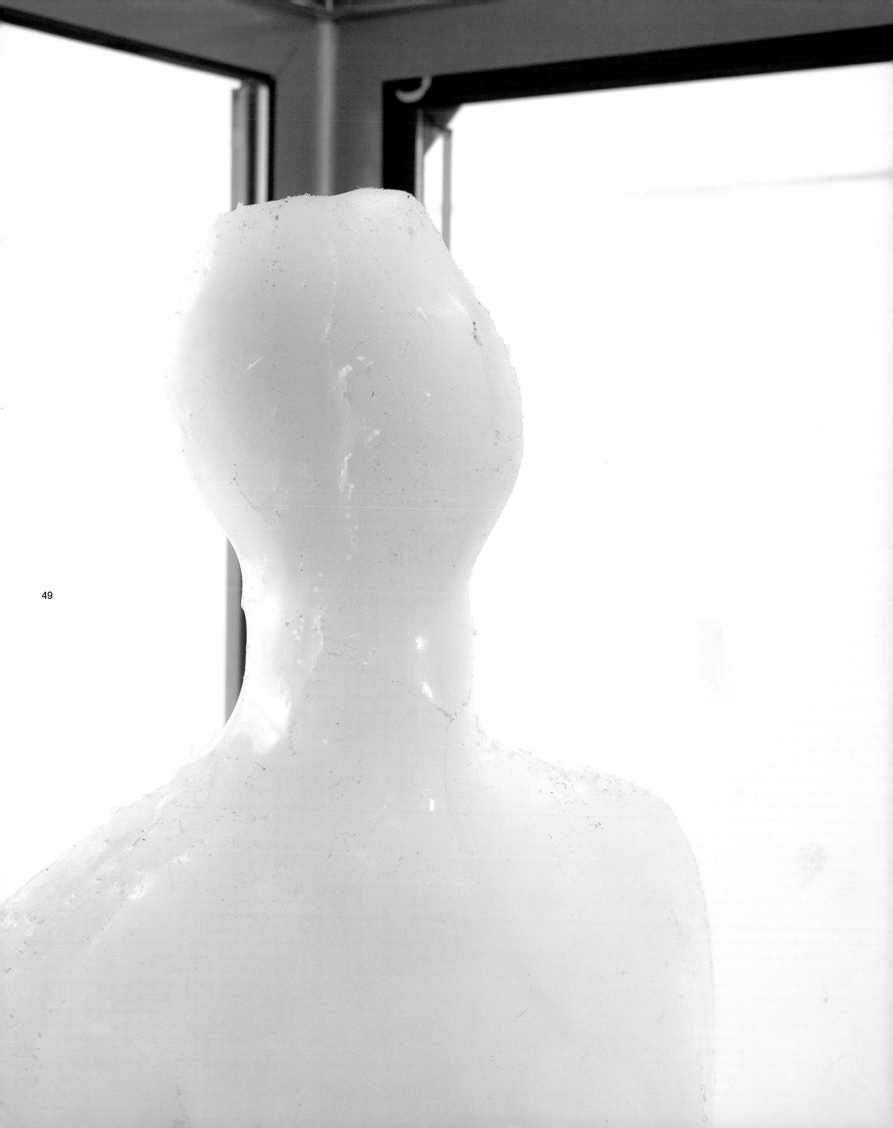

49

A Universe of Opposites
David Thorp

One of Quinn's earliest works is a sculpture of a head called Faust. It remains an obvious starting point to an understanding of his sculpture. Made in 1987, it is arguably Quinn's first mature work and was the first made from cast lead. The Faust head was modelled from clay and then cast in lead using the lost wax method. The final form includes the rods and cones used in this process and its appearance combines the rigidity of the cast with the organic form of a head. Evidence of the process is left in the finished work because the technique of its making is a constituent of the sculpture and is used by Quinn to express its meaning, the deal between immortality and death.

Quinn frequently uses particular materials for their symbolic meaning. Wax is one that especially interests him; it reappears significantly in the process of later works. Wax has a mutability, it is changeable and, once used, can always be melted down and used again as something else. For its life to last, however, it must trade its form and be reincarnated, just as every work of art trades on a million others. The transformation from the mutability of wax to the permanence of metal articulates the Faustian trade-off.

Quinn's approach to materials owes something to Joseph Beuys inasmuch as it recognises that certain materials have an intrinsic meaning that transcends the everyday and contributes to the way the work communicates. Beuys' use of felt and fat, for example, is part of the overall meaning of his work. His materials are located in a history that is culturally and personally determined.

Quinn has discussed his feelings about materials on several occasions. Speaking about lead in an interview with *Dazed & Confused* magazine in 1995, Quinn said:

Lead is a very heavy, very dense material yet it also contains a rather obscure symbolism as well. It is poisonous while simultaneously being the beginning of change in alchemical principles where lead is transformed into gold. So in some sense it has the innate potential for transformation, it contains the possibility for perfection though as a substance it is flawed.

And speaking about bread in the same year he said:

Making bread has been a constant human activity since ancient times. It is one of the energies of life, a fuel to be used up daily, yet… capable of surviving the millennia.

After Faust, Quinn began to make sculptures out of bread. The first, called Young Dancer Aged 14, was based on a work by Degas. But unlike Degas' precise and still figure, Quinn's

1 Faust

2 Young Dancer
 Aged 14

work erupts with chaotic life. Its internal spirit bursts through the fine form in an excrescence of energy. The work had been modelled in bread dough which, once baked, took on its own life and developed its own form. The unpredictability of bread rising in an oven invests the final work with a distorted quality. Young Dancer Aged 14 is linked to the Acid House scene, which was at its height when the piece was made. Quinn modelled a smiley face, the Acid House symbol of perfection, in clay and stuck it on the dancer. Its flat impenetrable surface masks the degeneration of the figure, degenerated, then reintegrated through drugs and dance.

Quinn's busts of Louis XVI and Marie Antoinette, and Dr Pangloss (a character from *Candide*), rather than modelled in clay, were also made from bread dough and baked. With each of these works, the changes the dough undergoes as it is baked distances the artist from the final outcome. The sculptures enter the world as living things growing and displaying themselves quite autonomously, with their creator relegated to a back seat, another spectator of the artwork. Quinn is setting a process in motion, but in a sense is not responsible for its outcome; the final look of these busts is manifested in the inevitable gap between art and life. There is, says Quinn, an impossibility about the task of portraiture, which these works try to demonstrate. The artist knows next to nothing about himself – how then can he know more about his subject? For the heads of Marie Antoinette, Louis XVI and Dr Pangloss, their life is real life, but it is buried in the material from which they are composed, in its inert ability to transform in a real way and become something incarnate. The uncertainty of the formal outcome of these heads, once they have been baked, contradicts the consistency that bread has as a symbol. They demonstrate that nothing is sure, that all meaning is mediated and subject to ambiguity. The final casting of Quinn's busts in bronze further contradicts the bread and alters its symbolic meaning. As a meditation on portraiture and the icon, these heads question the construct that surrounds a historical or public figure obscuring their true identity. When Dr Pangloss claims in *Candide* that everything should be exactly as it is, Quinn responds ironically, with a grotesquely distorted bust that must be his portrait by definition, because it is called *Dr Pangloss*.

Quinn began using bread dough in the late 1980s and used no other material while he was exploring its properties, although some of the works were finally cast in bronze. During that period he started making something that he has returned to consistently throughout his career: bread hands. In the same interview quoted above, Quinn went on to say:

Over the last six years bread hands have been a constant feature of my artistic output. Each hand is traced from mine onto bread dough which is then cooked. During the cooking the bread rises in uncontrollable and unpredictable ways, rendering each hand unique. Using the lines of the hand as an emblem of destiny these works symbolise the ever-evolving complexity of human life, that from the same simple starting point, an infinite variety and unforeseen complexity is possible.

Quinn dries the bread hands and seals them with varnish and, recently, he has been irradiating them to kill off bacteria. The preserved

3 Louis XVI
4 Marie Antoinette
5 Dr Pangloss

Dis-incarnate
(And whose body is it anyway?)
Mark Gisbourne

One imposes far too narrow limitations on art when one demands only that well-ordered, morally balanced souls may express themselves in it. As in the plastic art, so in music and poetry too there is the art of the ugly (raw–sublime) soul, beside the art of the beautiful soul; and the mightiest effects of art, that which tames souls, moves stones and humanises the beast, have perhaps been mostly achieved by precisely that art.

Friedrich Wilhelm Nietzsche (1844–1900)[1]

In the dyslexia of a dream or a daily reverie, all the imaginative and intellectual boundaries between what is 'man-made' and that which 'made man' palpably dissolve, undoing all the easy reconciliation(s) of reason.[2] The eliding of the physical boundaries between a less familiar inside and the known outside, of matter as both material and the illusory immaterial, is of an integral character in the body-based artworks of Marc Quinn. It is for these reasons above all that the artist is Nietzsche's child.

To dissolve, like to discharge, is to break asunder, to pull apart, to expose and clarify a reversal, and in so doing to highlight the closed or hidden aspects of that which is denied.[3] In short, and quite literally, it is to *dis*-embody and make that which was otherwise concealed manifest.[4] Hence Marc Quinn is concerned with manifest incarnation, with what is called 'flesh made man', and thereafter the wastage and exigencies of the human body as man-made. In Quinn's art, life is always being measured against what it is not (death), or at least not yet; and what it is not (as life) is valued and elevated to a far higher material equivalence.

Marc Quinn does not ennoble the 'base' or what was once considered to be ignoble, or even place *Eros* (material sexuality as bodily functions) above *Agape* (the spiritual or higher being), but rather he democratically integrates them with lucid intentions and meaningful comparisons.[5] For Quinn, life's material and immaterial condition(s) are exposed by a continuous analysis of human transitory and ongoing processes, and it is this which characterises the scientific aspects of his art. It is a direct corporeal art born of his own body, whose meaning resides in the Nietzschean will to a life that must be truly lived through active bodily processes.[6]

A creative concern with incarnation, both of self and self as 'other', is the investigative question that this artist pursues: the 'why am I

10 Self 1991

7 First Bread Hands

here-ness' of his art. It is the frame within which all Quinn's works can be encompassed, since it engages with the most fundamental of conditions in the generation and regeneration of human life. Likewise an engagement with his body is a commitment to the shell of our verifiable and actual physical containment. While his work may be read as a simple engagement with issues of personal identity, it is in fact an *exemplum* of universal identity; as 'man-made flesh'. Incarnation (from the Latin 'caro', meaning 'flesh') represents the fusion of two natures of the human and the divine, or put in more modern terms, the sacred and the profane, the material and immaterial nature(s) of man.[7] The relationship is reciprocal and mutual as in essence and existence, both being required to complete the other. This mutuality of the artist's work is evident from the beginning as in Self 1991.[8]

Self consists of nine pints of Quinn's blood – the amount contained in an adult human body – frozen in a mould of the artist's head and placed in a refrigeration unit. There has been a tendency to see the work too literally, either as some form of visceral self-portraiture in the age of AIDS, or as the sanguine 'humour' expressing its anger or resentment towards our atopian existence in the modern world.[9] The second reading affords something of an extra incentive in the doubling of the metonymic use of 'humour' as in 'a rush of blood to the head'. The wish to place the work in an immediate historical juxtaposition to others like Delville's plaster death mask of William Blake and to the portraiture of Francis Bacon illustrates for the most part a rather out-of-date 'it looks like it so it is' type of art history.[10] Whereas with a more direct significance, what the work shares with Blake and Bacon primarily is a basic concern with the incarnation and existential condition of mankind.

All too often these 'spot the sources' strategies typify easily-found iconographic readings at the expense of Self having a greater iconological content and meaning.[11] For the stress placed on personal identity as simply a self-portrait ignores the underlying and far more universal or incarnational reading, the understanding of 'to transfuse' as in transfusion (to pour into another vessel), and the shared grouping of blood which can be transferred from the life of one to sustain the life of another. Self therefore exposes far wider possibilities than just Quinn and his own human contingency. It is the compounding of opposites both present and indistinct at the same time, which underpins this artist's interest in incarnation and the two-sidedness of the material/immaterial realities found in human life.[12]

In Self the artist empties the interior material content of himself in exposure to others not merely for shock value or provocation, but to reveal the shared ephemerality of human life and its internal processes; those contingencies that all of us possess. After all, through some accident or other exigency, the refrigerator might be turned off and that which was is no more; having ebbed away, it would become amorphous and indistinct. It is at this point that factual material life and our sense of being are exposed and confront each other.

The Bread Hands, both in their grid-like forms, and as a wall installation shown at the Grob Gallery in 1991, also reveal notional incarnation. At that time they filled a wall that

stood directly opposite Self 1991.[13] Taken further, they brought into direct relation the sculptor's own dilemma of the motive force behind his creative making – the head – and the practical means of its realisation expressed by the hands.[14]

Like a sort of 'hand-baked' palmistry, the bread hands point both to generality and specificity as the so-called 'life-line(s)' and 'love-line(s)' present on the human hand are contused and ruptured through the oven-baking process. Thus the elided hand print as index indicates a presence of that which is not there, something not visible to the eye but nonetheless known; rather as a weather vane evokes the hidden visible of the wind or a footprint in the sand infers the presence of man. The synonym of the Bread Hands and life in these works is indicated by simile in the various ways that real processes conjure separation and difference from within their original similitude or sameness.

Marc Quinn has returned to these issues several times, as in The Origin of Species (1993), when again using the mould of his head, the artist substituted coconut milk for the blood plasma of Self 1991. Quinn's intention in this case was to reveal the interchangeability of materials. Coconut milk, which has sometimes been used in desperate medical circumstances as an emergency and temporary substitute for blood plasma, was by this means able to vindicate the transmutation potential present in diverse and apparently unrelated natural sources. And, by using Charles Darwin's famous 'Origin' of the species, the ongoing 'nature' of things becomes a continual cipher of the evolutionary and mutational processes at work in us all.[15]

17 The Origin of Species

In the latex body mould You Take My Breath Away (1992), which gives the appearance of sloughed skin of the artist, we find an ironic eschatological reversal of the flesh that was made man – something like a parody of an embodied person as a disembodied shard or fragment that has been left behind. In a more obtuse way, it also parodies the first incarnation narrative of Adam, when God summoned up life from the inert materials of the created world.[16] Quinn's Incarnate (1996) makes his concern with incarnation explicit. In this work he followed an old black pudding (Bury Pudding) recipe to create a blood sausage, but replaced the usual pig's blood with his own. Tied at both ends like a salami, he boiled the sausage in a saucepan and then dried it, thereafter it was presented on a bed of salt in a white ceramic dish. Like the bread sculptures, Quinn again evokes the transmutational power of the cooking process. A cannibalistic sense of shock that ensues when you see the work again functions on several levels of parody from those purely literary,[17] to the downright anthropological.[18]

11 You Take My Breath Away

23 Incarnate

Quinn is also interested in stasis and regeneration which deals with the generative specifics within different living processes. This was evident in a work like Rubber Soul (1994), a frog-based sculptural project he created for the Egyptian Gallery at the British Museum.[19] Rubber Soul reversed the opacity of Self in favour of transparency, by which Quinn used a perspex mould of his head. On a platform at the place of the pineal gland centre between the hemispheres of the brain – inferred as a hidden visible – he placed a North American Wood Frog. The frog was in a state of suspended animation or hibernation, familiar to the animal when the

19 Rubber Soul

temperature reaches minus three degrees, and remained in a continual state of system shutdown throughout the exhibition. The animal represented a living death not unrelated to the ideas associated with Pharaonic mummies and the status implied by commemorative sculptures immediately around it. At the end of the exhibition the frog was revived and went off to live a happy life at London Zoo where it still resides.

The issues related to the pineal gland and its supposed reptilian origin – the living archaic within ourselves – pointed directly towards the facile Cartesian rationalism that supposedly ordered the exposition of the gallery around the sculpture. The pineal gland, an uncomfortable, and some argue, functionless node at the centre of the brain,[20] had a particular relevance, since René Descartes in his mechanical and hydraulic-based physiology had made reference to the gland as the site of the imagination and soul.[21] There is also more than a hint of an ironic cryogenic self-delusion in the work.

The idea of paradoxical forces and/or vital fluids and the changing transposition of life and its origins from one thing to another, be they physiological, sanguinous, or botanical, is what brings together such works as Self, The Origin of Species, and Rubber Soul. From apparent death comes life, and even what is dead has the appearance of life, as in his recent works Eternal Spring Sunflowers I and Eternal Spring Sunflowers II. In these works, two identical refrigeration units contain bunches of cut sunflowers. To all intents and purposes the flowers are dead, but these are flowers that can never die since they are in a temperature-controlled botanical stasis, a state of equivalence of suspended growth (they are cut) and death (they will never decay).

32 Eternal Spring

The Romantic affiliation to Van Gogh's sunflowers meditates upon the immortality of the artist and of artists in general. For as sunflowers form a sort of portrait of absence for the Dutch artist, the sunflower work as a 'work' similarly reveals Quinn's own self-portraiture as a concept and realisation in his appropriation of a familiar motif. This is to say all artworks operate as part and whole, part for the purposes of identification of the maker, and as a whole in what they share within the universality of artistic aspiration.

What we have alluded to so far expresses the artist's interest in man and mechanism, what it does not discuss is the contingency which sustains these living processes. The artist's delight in an actual or inferred dependency, be it on electricity in the case of the refrigerated or other units, and/or metaphor as élan vital (vitalism), engages with the contingent aspects of human life. The use of electrically-controlled machines in Quinn's work not only suggests an entropy implicit within the sustaining of self, but a necessary reliance on the administrative will of others to guarantee its continuation.

A concern with human expenditure and with material aftermath or residue is among the most striking features of Marc Quinn's work.[22] The human body as the literal body is also a humanist site of intervention, of dissection, and thingness.[23] In his series of works called No Visible Means of Escape (1996–7), which in turn refer back to his You Take My Breath Away, paradoxically what is represented is a metamorphic Houdini-like moment of escape. A disgorged body of outer appearance, free of

29 No Visible Means of Escape

its 'escapee' the visceral or 'vital' interior, the fragment, shard, sloughed skin, hangs lumpen-like and in such a way as if subjected to great violence; though whether it is a punitive violence or that of escape – an animal or carnal-like shedding – is difficult to ascertain. A despoliation of the material body deals directly with issues of power where the primary coercion or expenditure is physical rather than psychical, for that which is discharged is precisely what is missing.[24] Rather like *Le pendu* (the hanged man) of the Tarot pack, the works No Visible Means of Escape are frequently hung upside down, inverted and folded back on themselves.

In a series of studies called Studies for Approaching Planck Density (1996–8), a reference to the famous physicist Max Planck, Quinn has engaged with the Planckian notion of absolute density and saturated matter; these are works which stand in direct opposition to his concern with transparency and fluidity. Made as hollow wax casts of his body, a reference back to the materials used in early anatomy studies,[25] they are placed in a bath of hot water, then taken out and left slowly to collapse into themselves. The process employs a deliberate sense of the gravity, weight, and entropy, which acts upon the human body. Cast thereafter in lead, they illustrate the compounded opposites of hard and soft frequently used by the artist, and stand in direct if less fluid relations to the glass works which are also placed on the ground.

Another theme of entropic expenditure has again appeared recently in his work Across the Universe (1998), a refrigerated unit containing a life-size frozen cast of Quinn. Using a freezer which exploits a given of refrigeration, namely that water will move by evaporation to the coldest position in a closed system, the ice gradually evaporated throughout the show to be inhaled by the viewers and visitors to the exhibition space. This again reinforces the mutual aspects of his famous Self which have already been referred to.

A tendency towards seriousness and gravity intimated so far should not neglect the *schlock*-horror and the black humour also to be found in the artist's work. For a work like Across the Universe humorously mocks the famous transporter system of the USS Enterprise, just as readily as it points to the dissolving away of the body and its subsequent regeneration in another location. In this way Quinn is able to realise many layers of potential reading for his art.

In his recent series called Stripped, both horror and the use of materials which possess a *schl*-ocking effect are given free rein.[26] The artist poured different coloured liquids over the head of the body-cast, allowing the rubberised liquids to run down the body. He then used a steel plate and affixed it to a bracket and rod connecting it to the ceiling, from which it hangs as a rubberised shell cast of his body. This has the effect of stressing the work's sense of hollowness or of being stripped. The effect is both viscous and sticky in appearance but actually inert to the touch. Somewhat reminiscent of strange grottoes and hanging stalactites, these works reinforce the use of gravity in his work. Working through a sense of geological time, the Stripped works are in some ways opposite to those called No Visible Means of Escape, for the inside is outside and the body becomes distended and monstrous by the use of bright lurid colours. If they are horrific it is horror from the mind of Dr Frankenstein,

the house of horrors where the monsters are always 'man-made' rather than 'made man'.[27] A similar reading might also be applied to works like Purple Nervous Breakdown and Raspberry Nervous Breakdown, where a decollated head is spiked on a vertical upright and the same pouring treatment of bright nauseating colours hangs down to the ground in long ribbons from the jowls and neck of the disembodied artist.

The elision of the subjective and the objective which Kristeva and Lacan located in the mirror stage,[28] is also apparent in Quinn's use of *copraphilia* in Shit Head (1997) and the recent portrait and landscape format excrement works. The use of excrement, at least by allusion to, is not new in itself, finding precursors in Dali and Gilbert and George. Quinn has taken this much further by using his actual un-canned excrement (*pace* Manzoni), and in so doing recalls the neo-Dada-cum-anarchist Sam Goodman and Boris Lurie installations of the 1960s. However, whereas they simply piled up their spent excrement on a plinth and presented it as some form of anarchic happening,[29] Quinn accepts his excrement as a human given and uses it as a material of *art-making*, in this way elevating what is normally considered facile to the equivalence of his use of blood.

In Shit Head, again following a mould of the artist's head, the work is constituted of the artist's dried faeces. Having been placed in a hot and controlled drying unit, the head shrinks to half its natural size. Like an abject portrait it parodies the idea of Self as portrait, given that by the Lacanian reading the subject 'I' is formed as a linguistic emergence from abjection.[30] The same is evident in the Shit Paintings, which operate somewhere between a dirty protest and incarnation. Though usually in vertical portrait format, they also include the horizontal landscape form, no doubt intended to reaffirm the inside (self-identification) and outside (the other than me). In these, Quinn directs us to the child, the finger, and the surface, for it is in the pre-socialised stages of childhood that the infant plays with the potty and the faeces which he/she has mysteriously generated.

The work 12.5% Proof, which caused public resentment and has now been largely destroyed, contained a cast of the artist in a glass unit sited in front of a church in Arnhem.[31] In a Mallarmé-like throw of the die, the glass cleared randomly for a sixtieth of a second and you were given a view of the figure inside. While it was clear, you could see red wine spurting from every orifice of the cast body of Quinn. Down the glass walls of the container the wine ran as if somehow in a state of visceral possession of the unit. The work was therefore somewhat ambivalent as to its status of being either sacred or profane. On the one hand it possessed a Nietzschean Dionysia/Apollonian dichotomy, on the other were pseudo-biblical references to martyrdom and eucharistic or Passion-like sources. In merely having the body-cast appear and disappear as if in random horror, the artist was able to disarm the mind of the glimpsing viewer, who was not able in a comprehensive way to grapple with or mediate an understanding of what they had seen. Liquids and material substances that flow or are evacuated from the body always retain an ambivalentstatus, as either expenditure or in the case of illusory blood (red wine), a draining away of the vital signs of life. Such an image conjures a paradoxical mixture of delight and distaste.

And, when imagined within the unmediated incarnation of human life, anything from terror to abomination can ensue.

Quinn's relation to the past apparently evoked by the many levels of referential content in his work is that of the dense palimpsest, and not merely that of iconographical appropriation. History for him is no more than a source of continually over-inscribed moments of consciousness which generate a matrice of infinite possibility. Hence, the artist's interest in the Baroque or in Surrealism is of a generic and not a specific character – merely parallel and yet distinct affinities with ideas related to the body and consciousness. He can therefore be said literally to disinter or disembody the past. To dis-embody is 'to take away, from, or out of the body', to extrapolate or extricate, and this is frequently how it operates in the work of Marc Quinn.

In his sculptural works called Emotional Detox: The Seven Deadly Sins, shown at the Tate Gallery in 1995, the artist dealt explicitly with catharsis, a 'ridding himself' of his addiction to alcohol. In a certain way the works reflect a disembodying of a personal history and dependency, the dispossessing of himself to find the 'other' as a new 'self' within him. Being cast in wax and lead gives a key aspect to these works in as much as the materials have a historical and symbolic role within alchemy. What was a chemical dependency on alcohol is purged by an alchemical and magical symbolisation, the base metal of addiction turned quite literally into a gold(en) freedom. These classical bust-type works form a family of serialised hand, body and face gestures, which comment upon the material and immaterial, the real and the imaginary, and deal with 'deadly' consequences – the poisonous status of lead leaves this beyond doubt.

The distorted grimaces and face poses of Emotional Detox share something also with the earlier Character Head I and Character Head II (1990), notwithstanding the distinction between the toxicity of lead and the potentially nourishing use of bread in the earlier works. Character Head I and Character Head II's comic gazes generated by the cooked bread dough are quite literally arrested as if frozen, but paradoxically at the same time pointing to the history of physiognomic science and facial expression.[32] The tradition of facial expression and its proposed use by art and artists has a long history from Charles Le Brun (1619–1690), the court painter of Louis XIV, through to Amand Duchenne de Boulogne, whose photographic myology studies a hundred or so years ago used electrically charged rods applied to the faces of his patients for the purposes of obtaining an understanding of our facial muscular expressions.[33] Quinn's appropriation, however, of his sources is as usual multiplicitous rather than simply specific.

The toxicity and liquidity of the body found in Quinn's investigations as in the old 'humours of medicine' also have a place in his art. For mood and consciousness, as well as healthy being and personality, were shaped by the forces of the sanguine (blood), choleric (yellow bile), phlegmatic (phlegm), and the melancholic (black bile) – the last of course being the immaterial fiction of consciousness while the former are actual material entities produced by the body.[34]

The issue of fluidity is present in Quinn's Morphologies, made of mirror-like blown glass, which have all the appearance of their biomorphic

forbears within Tanguy and Surrealism. Using blown glass in appearance they may also allude to long-established alchemical and poisonous references, perhaps, by visual simile to quicksilver/mercury – they are certainly mutational forms that must be placed on the floor. Beginning with The Etymology of Morphology, literally the original signification of a shape or form, we find particular interest on the part of the artist in mutation.[35] The less value-laden appeal of mutation and biology over evolution and anthropology seems to be uppermost in Quinn's artistic investigations. In Blind Still Leading the Blind (1996), the glass forms seem to be crawling across the floor, their globular shape and materials reminiscent of the mutant residue continually blown apart and then reintegrated in the movie Terminator 2. There is also a connection to Blind Leading the Blind (1995), executed as a complex three-quarter length penis erect lead-cast and disembowelled portrait of Quinn a year earlier; the comparison also reiterates the hard/soft and the opacity/transparency issues that we have already discussed. In works like Blind Still Leading the Blind and The Genesis of Morphology the use of a fluid form or morph also refers back to the reclining ecstatic figure of Saint Teresa by Bernini, something that does no more than illustrate the multi-layering of references in Quinn's work. In Golden Moreish Morphology (1998), or Puff-Headed Heliotropic Morphology (1998), we have vertical forms which are on the one hand like the cast limbs of relics, while at the same time just as readily like the globular miasma of Barbarella.

An interest in mutation and morphology may also reflect, as in so much of Quinn's work, the problem of his (and many others') confidence and disillusion with certain types of old-fashioned historical narratives, with forced classification and outmoded taxonomies. He places nature and natural history above the over-determined or positive factualities of today's reductionist life sciences. The natural world redresses itself and possesses its own co-equivalences, it becomes compromised when suborned by the rhetorical consumerism of the so-called 'natural' in the modern world. For rhetoric conjoins and separates things at the behest of whim or persuasion and little more,[36] whereas the natural world and the human body have their own correctives. Quinn's art is therefore one of self-exposure, generosity, and personal vulnerability. In so doing his body stands by extension as a pointer to others – the 'self' and 'other' as an interchangeable reality for us all.

Endnotes 5

1 Friedrich Wilhelm Nietzsche, *Menschliches Allzumenschliches* (1878); Eng Trans., R.J. Hollingdale, 'On the souls of artists and writers', in, *Human All Too Human: A Book of Free Spirits*, Cambridge University Press, Cambridge and London, 1986, p. 182 (Aphorism 152).

2 'What we do in dreams we also do when we are awake: we invent and fabricate the person with whom we associate – and immediately forget that we have done so'; from 'Maxims and Interludes', in *Beyond Good and Evil: Prelude to a Philosophy of the Future*, Eng. Trans., R.J. Hollingdale, Penguin, Harmondsworth, 1971, p. 63 (Maxim 138).

3 As prefix *dis* meaning: (1) in two, asunder, apart; (2) meaning 'not' or a reversal; (3) indicating a removal or deprivation; (4) used intensively.

4 Similarly, without coincidence *Dis* is also the symbolic and abstract site of death – the underworld – from which life itself takes on so much of its meaning. *Dis* (probably from 'dives') was the Roman god of the underworld called Hades by the Greeks.

5 The theological binary *Eros/Agape (material/spiritual)* is more commonly understood today by the transgressive dichotomy of the sacred and the profane; see Georges Bataille, *The Accursed Share: An Essay on the General Economy*, volumes II and III, Zone Books, New York, 1991, pp. 19–26, 27–41.

6 This is contrary to those writers who have been tempted to see Quinn's work in morbid and pathological terms; see Mark Sanders, 'Invasion of the Body Sculptures', in *Dazed & Confused*, issue 13, 1995.

7 *Encyclopaedia Britannica*, 15th edition, volume 6, 1994, pp. 277–8.

8 First shown in *Out of Time*, Jay Jopling/ Grob Gallery, London, 1991: while no exhibition catalogue was published, the installation shots of the exhibition remain. It became better known when it appeared in *Young British Artists II*, Saatchi Gallery, London, 1993; see Sarah Kent, *Shark Infested Waters: The Saatchi Collection of British Art*, Zwemmer, London, 1994, pp. 73–6.

9 Sarah Kent, *ibid*. p. 73.

10 James Hall, *The Guardian*, Friday, September 24, 1993.

11 Iconology is used here in the Panofskyian sense of epistemological content advancing the *interpretive* over the merely *descriptive* (called iconography); though this writer is well aware of the narrow status of archival humanism upon which the *iconology* system was originally founded; see Erwin Panofsky, *Meaning in the Visual Arts*, Penguin, Harmondsworth, (1953) 1987, pp. 97–8.

12 David Thorp, *Marc Quinn: A World of Opposites*, published to coincide with the exhibition *Marc Quinn*, South London Gallery (28 January–8 March), London, 1998.

13 In this way they pointed obliquely (though maybe not intentionally) to the eucharistic rubric of different hand positions in the consecration of the body and blood of Christ in the Mass.

14 The archaic status of the hand and hand print as an indexical sign for prehistoric cave paintings and the wall, traditionally associated with forms of shamanistic practice, reiterate the paradox of the incarnational sacred and profane; see Andreas Lommel, *Prehistoric and Primitive Man*, Thames and Hudson, London, 1966, pp. 17–24.

15 Charles Darwin, *Origin of the Species by means of Natural Selection*, London, 1859.

16 *Jerusalem Bible: Book of Genesis 2:7* 'thus he breathed into his nostrils a breath of life, and thus man became a living being.'

17 One is reminded a little of Shakespeare's *Titus Andronicus*, where Tamora (the captive 'Queen of the Goths') inadvertently and at the behest of Titus eats her own sons.

18 Claude Lévi-Strauss, *The Raw and the Cooked* (1964), in *Introduction to a Science of Mythology*, Eng. Trans., John and Doreen Weightman, volume I, London, 1978.

19 The Egyptian cult of Osiris, of death and regenerative life, may have been indirectly alluded to here; see Robert Graves (intro.), *Larousse Encyclopaedia of Mythology*, 1970, pp. 9–48; the use of a frog also suggests an Egyptian biblical reference to the 'plague of frogs', *Jerusalem Bible: Book of Exodus 7:26–8*.

20 Marc Jeannerod, *The Brain Machine: The Development of Neurophysiological Thought*, Harvard University Press, London, and Cambridge. Mass., 1985, pp. 3, 7–8.

21 René Descartes, *Traité de l'homme*, Leiden, 1664 (orig. Latin).

22 As Georges Bataille puts it, 'the body is strictly a subordinate element which is of no consequence for itself, a utility of the same nature as canvas, iron, or lumber.' From 'The Eaten Animal, the Corpse and the Thing', in *Theory of Religion*, Zone Books, New York, 1992, pp. 39–40.

23 Barbara Maria Stafford, 'Dissecting', in *Body Criticism: Imaging the Unseen in Enlightenment Art and Medicine*, MIT, Cambridge, Mass., London (1991), 1994, pp. 47–129; see also Michel Lemire, 'Fortunes et infortunes de l'Anatomie et des préparations anatomiques, naturelles et artificielles', and Jean François Debord, 'de l'anatomie artistique à la morphologie', *L'âme au corps*, ex. cat., Galeries Nationales du Grand Palais, Réunion des musées nationaux. Gallimard/Electra, Paris, 1994, pp. 70–101, 102–17.

24 For considerations of punitive violence see Michel Foucault, 'The body of the condemned', in *Discipline and Punishment*, London, 1991, p. 31; for vitalism, an idea first propagated by Aristotle, see the writings of Hans Driesch (1861–1941); the term *élan vital* is taken from the writings of Henri Bergson (1859–1941), *L'Évolution Créatrice*, Paris, 1907. Lemire, *op. cit.*, pp. 89–91.

25 'Les modèles de cire…', pp. 89–91.

26 Julia Kristeva, *Powers of Horror*, Columbia University Press, New York and Oxford, 1982.

27 Michael Grant, 'James Whale's "Frankenstein": the Horror Film and the Symbolic Biology of the Cinematic Monster', in Stephen Bann (ed.), *Frankenstein: Creation and Monstrosity*, Reaktion, London, 1994, pp. 113–35.

28 Jacques Lacan, 'The mirror stage as formative function of the "I"', in *Écrits*, Tavistock Books, London (1977), 1982, pp. 1–7.

29 *NO! Sculpture Show/Shit Show*, Gertrude Stein Gallery, New York, 1964; see also, Boris Lurie and Seymour Klim, *NO! art, Pin-ups, Excrement, Protests, Jew Art*, Edition Hundertmark, Berlin and Cologne, 1988, (ills. 56–64) pp. 55–64.

30 Lacan, *op. cit.*, p. 3.

31 *Sonsbeek '93*, Arnhem, 1993.

32 We are also reminded particularly of the temporarily insane Austrian Court sculptor Franz Xaver Messerschmidt (1736–1783), whose distorted and 'mad' facial grimaces were an accepted deviance within physiognomy; see *Franz Xaver Messerschmidt: Character Heads 1770–1783*, ex. cat., ICA, London, 1987.

33 Jean François Debord, 'Le mécanisme de la physionomie humaine: la vie et l'œuvre de Duchenne de Boulogne', in *L'âme au corps*, *op cit.*, pp. 412–19.

34 For a discussion of the humours as they have been depicted in the visual arts, see R. Klibansky, Fritz Saxl and Erwin Panofsky, *Saturn and Melancholy*, Edinburgh, 1964.

35 Theories of mutation are a means of explaining change rather than those of evolution which generally tend to stress the progressive or purposive, as can be found throughout Enlightenment thought; see Georges-Louis Leclerc Buffon (1707–88), *Histoire Naturelle*, 36 volumes, 1749–88.

36 For an excellent judgement on the role of rhetoric, see Paul De Man, *Blindness and Insight: Essay in the Rhetoric of Contemporary Criticism*, University of Minnesota, Minneapolis, 1983.

Telephone conversation
Brian Eno and Marc Quinn

Marc What's quite interesting about that is it's the idea of where is the art, like when you dissect someone you can say the same thing 'where is the life?' I mean it's not part of the… it's somehow embodied or related to the physical thing but it's not actually part of it.

Brian Yes, well, I think I agree. I think it's possible to imagine forms of art that are to do with all the things that were previously considered extraneous to an art world. I mean so much of twentieth-century art is to do with the fact that anyone could do it.

Marc That's really interesting. I was at this art and science thing the other day, basically, and there was this guy and his theory is that the difference between art and science was that essentially every scientist is replaceable, you know, if you had enough scientists working on a project, that they would come up with, you know, all the theories of science, in other words science is something there, abstract waiting to be discovered, whereas art is very much individual. I'm not sure I agree with him actually.

Brian I wonder.

Marc I think there's something in the air in art as well and people kind of embody it more or less.

Brian Yes, I think what might happen is you might get a very particular version of something.

Marc And I think the other thing is that you know if Newton hadn't existed, or Einstein, would science be the same today? And I really don't think it would.

Brian Well, I think it quite possibly wouldn't. I mean things get discovered at vastly different times and because of that they can develop entirely differently.

Marc Yes and that's very much that whole chaos and complexity theory about how, from a simple beginning, things develop a sort of unforeseeable sort of complexity and the wildly different results you get from the same process just with different initial starting conditions and in fact those starting conditions, that difference, can just be time.

Brian Even if there's only two options to each branching in a very short time, you get millions of different possible results. That's one of the things I like about all that – it seems to be like the things that happen to you in life.

Marc I like the idea that you can get inspired by mis-hearing. Basically your misunderstanding of something sets you off on your own path.

Brian This is why I always think that artworks that don't completely succeed are often more interesting than ones that are brilliant and unapproachable. Sometimes I think you can really make new things from being impressed but critical of something, that, basically, it sets you off on a train that you'd never have reached yourself.

Marc It's like that thing where all great artworks have an area of ambiguity or a space in which the viewer can project themselves and then that gives it a life through time as different people see different things in it.

Brian Yeah, there's enough space for people to work inside it. That's quite interesting because I nearly always find that the work that I like best by people is transitional where they aren't something that they were before but where they hadn't quite got to the next bit. So there's a real kind of grasping feeling where you sense the smell of the future. In fact it's not completely formulated yet. So it's an invitation to you to kind of try and imagine, you know.

Marc Yeah, but everything actually, I mean the whole idea that we exist in this fourth dimension of time I think is incredibly important.

Brian Ah ha, but do you think there are two different theories about what produces value in art? One is that a thing has an intrinsic value and that it radiates out from it and the other is that you confer value on it by knowing about the processes involved. So works that have to do with time have a historical resonance that you as a viewer pick up on.

Marc Well you could say, I think that there's probably no such thing as absolute value but some of the conferred values are so to do with the context of being alive that you can't imagine a situation where it won't, where that won't occur. I mean the context that you know you're born, you'll live, you'll die, the context that you have a body, these confer value but they're kind of like almost constants. I mean a creature that didn't have a body, or some kind of alien, would not really understand at all, and in a way that whole thing of looking for an absolute is kind of meaningless because you can't really imagine something from another context.

Brian Do you think that's true? I mean a lot of artists do exactly the opposite. They try to make things that are completely separate from those issues. Things that deliberately set out to defy those issues in a way.

Marc Like what for instance?

Brian Well, I'm trying to think, having said that – I guess something like Rothko, I mean…

Marc Yes, but what – would an unemotional alien make any sense of Rothko at all?

Brian No, you're absolutely right, not at all, but this is a very interesting question. What would an alien think about almost any work of art?

Marc I think that's one of the reasons I use figurative art because I think that's one context that will survive a certain amount of time.

Brian Well, the context won't change but our feelings about it might.

Marc Yes, but it will provide a way in. I like the idea of how things grow upon you through habit. For instance, if you leave a pair of trousers between the door of your bedroom and the bed you start to walk round it then you might put a newspaper on top of that or a magazine, eventually you've got this great big pile that you're walking around so it kind of imposes itself and becomes part of your life without you even really thinking about it, and I think that in the way that people think and are emotionally we do that the whole time. And it's chaos theory isn't it, a tiny grain of sand introduced at some point creates a huge mountain later on. And that's kind of what I'm thinking about when I'm making those sculptures where you've got all that rubber poured on the outside of them and it builds up in sort of geological layers, and the forms completely transform and you get this kind of weird lumpy thing and then to cut it off the… figure is kind of like an act of self-consciousness and the sudden realisation of this habit.

Brian You had one in the Royal College.

Marc That's right. They're like stripping off all that kind of habit in a way. Inside and outside I think is a kind of an interesting idea, like for instance sculptures that are made out of bread, without cultural knowledge we look at them and see it is an expressionistically sculpted bronze, but in a

way it's a mirror, in the same way that a cloud which seems to be in the shape of an elephant is.

Brian Yeah, we put the expression into them.

Marc But it's something to do with that whole way of understanding the world through classification.

Brian Yes, or new ways. New categories through-out the inventive peoples – whoever thought there would be a category about things like this.

Marc But it sometimes in a way is somebody's habit as much as something else.

Brian That… is just like a pile of clothes. It could have been a… about something else, the Locust of the Taxon could have been somewhere else. [Laughs]. I know what you mean. Actually this is one of the interesting things about science – you know the impression again with science is that it deals with the natural order.

Marc Yes, exactly.

Brian In some sense it does, we could have looked at it in quite different ways—

Marc Do we only think we know what the natural is because what we've found through science and the different kind of science could account for the very different natural order? You know every different civilisation and every language is about the same thing but just a different way. There's not one way of looking at the world. Do you remember that thing we were talking about about a year and a half ago where in the end they decided to go for a big black rectangle? It was the site of a nuclear waste dump and they had to try and find out how to signal this for 10,000 years which is how long the radiation would last and they decided they couldn't use language and they couldn't use signs like skull and crossbones and things like that because, actually, in some cultures that's good luck so one wouldn't know what was going to happen and eventually what they decided to have was a great big black slab of granite and due to the sun this would become incredibly hot and would kind of warn people to keep away. Although I suppose that's assuming that the climate doesn't change.

Brian It's extremely hard because you have to assume we may have been through ten Dark Ages between now and then.

Marc Yeah, I mean, people, they sort of know that wouldn't happen, but people probably thought that in Roman times.

Brian Ah, well, but it's even more likely to happen now. As… 10,000 years ago people used to write on stones which have lasted 10,000 years, 2,000 years ago they wrote on paper which can last for 2,000 years… 500 years ago they started to write on paper which starts to fall apart after about 500 years, then they started using magnetic tape, about 50 years ago, which falls apart in about 40 years. Then they started using computers ten years ago or twenty years ago which are now unreadable because one of the biggest problems actually, it turns out, in government in America at the moment, is that so much of their old data is totally unreadable. The turnaround of things is so much quicker these days. In about three or four years things have shed their meaning.

Marc I went to this thing the other day and there was this interesting… this art and science thing, but there was this interesting sentence, I'll just read it to you. 'The evolution of form. Are organisms dynamic self-organising processes following certain general principles of order, or are they simply carriers and slaves to a selfish genetic code?'

Brian Read that again, I just missed the very first word.

Marc 'Are organisms dynamic self-organising processes following certain general principles of order, or are they simply carriers and slaves to a selfish genetic code?'

Brian Right, well, those two aren't exclusive, of course.

Marc Yeah, they might be both mightn't they?

Brian Yes, because, the code, in my opinion, it says here's the code for how this thing will be a self-organising… the code isn't the code for form, it's the code for a process and then the expression of those processes is what produces the form.

Marc It's a bit like your generative music.

Brian That's the difficult thing I always have when explaining that to people and they sort of say, so, you design all the music in advance? So I say, no, I design a set of conditions and then the thing expresses.

Marc In a way that is making… in a way you're making that idea of context explicit and in many ways our lives are like that.

Brian That's right, we… each one of us has a sort of gamut of possibilities. I mean you're not going to come out as a zebra or a worm, you are going to come out as a human being, but within that there are lots of possible human beings you could be.

Marc Which is why that whole thing about clones is such a red herring for me. I mean it takes no account of the nurture process of somebody. In fact it says that if you played a piece of… a programme for creating generative music twice, that you'd get the same result. I mean a clone is not… it has an identical programme but that's as far as it goes.

Brian Yes.

Marc My reservation about cloning is that it is a profoundly conservative thing. You're cutting out our natural selection and the chances and accidents that occur there. If you had a world that was all cloned you'd have a world that had no possibility of transformation or change and that's profoundly sad.

Brian Genetic novelty.

Marc Yeah, you're not letting those dynamic self-organising processes work. You're thinking that your intellect is superior to nature.

Brian And there'll probably be terrible blind spots as well, you'll breed for one aspect and then a completely unwanted thing will go along with it.

Marc I don't know if you ever saw that frog sculpture that I did at the British Museum.

Brian Yes I did, it was in a glass case.

Marc And I mean this frog that you freeze, and it technically dies, and then you warm it up and it comes alive in the context of all these Egyptian mummies, for me it really rammed home that idea that, however great your civilisation, there's so much complexity in nature that is beyond any reason.

Brian By the way, did you ever bring it to life again?

Marc Yes, it's in London Zoo. There was also a